Great Buildings of the World

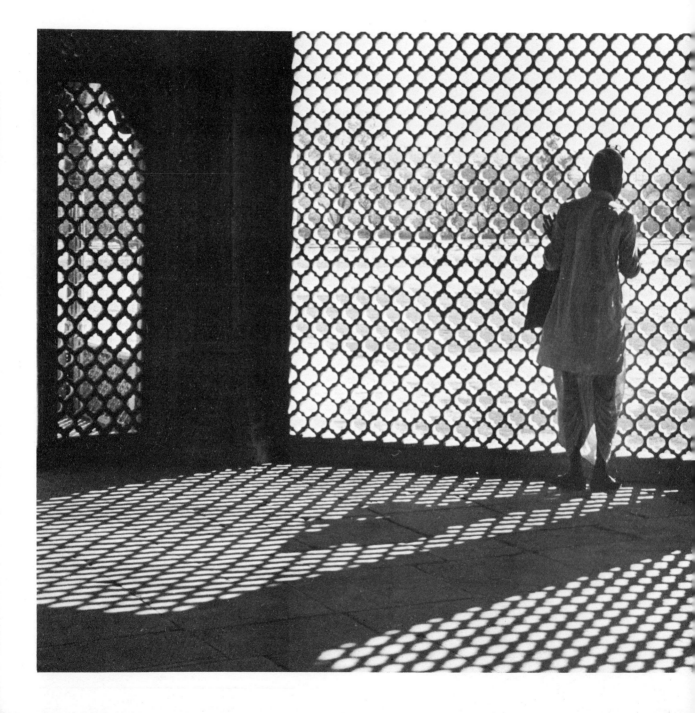

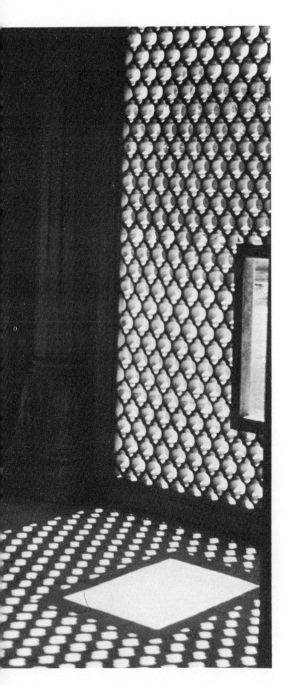

Great Buildings of the World

Indian Temples and Palaces

Michael Edwardes

Paul Hamlyn
London.New York.Sydney.Toronto

*Frontispiece: Fretted marble windows of a
pavilion in the Red Fort, Delhi.*

Published by
The Hamlyn Publishing Group Limited
London · New York · Sydney · Toronto
Hamlyn House, The Centre, Feltham, Middlesex

Printed and bound in Great Britain by
Morrison and Gibb Limited, London and Edinburgh

Contents

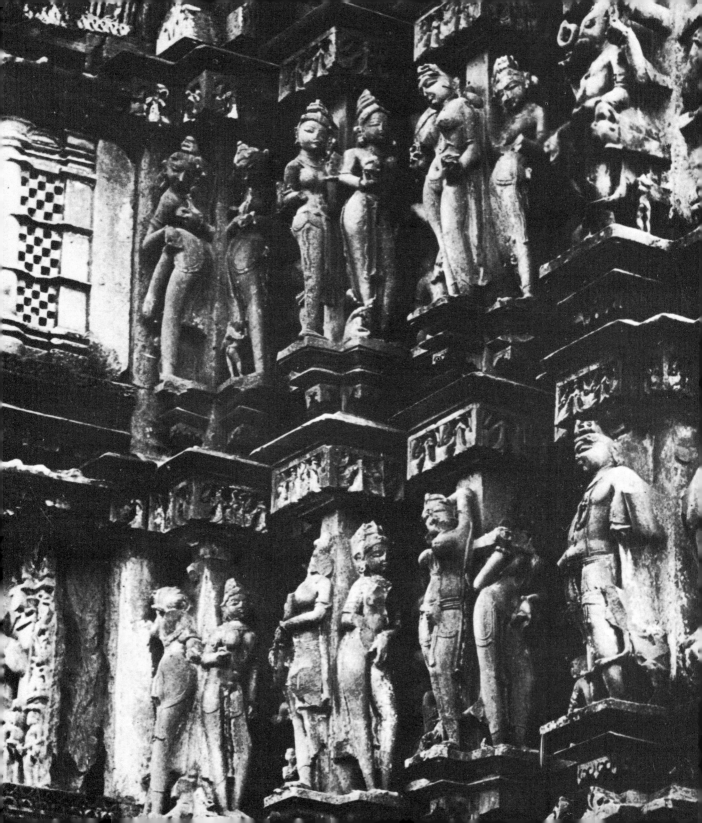

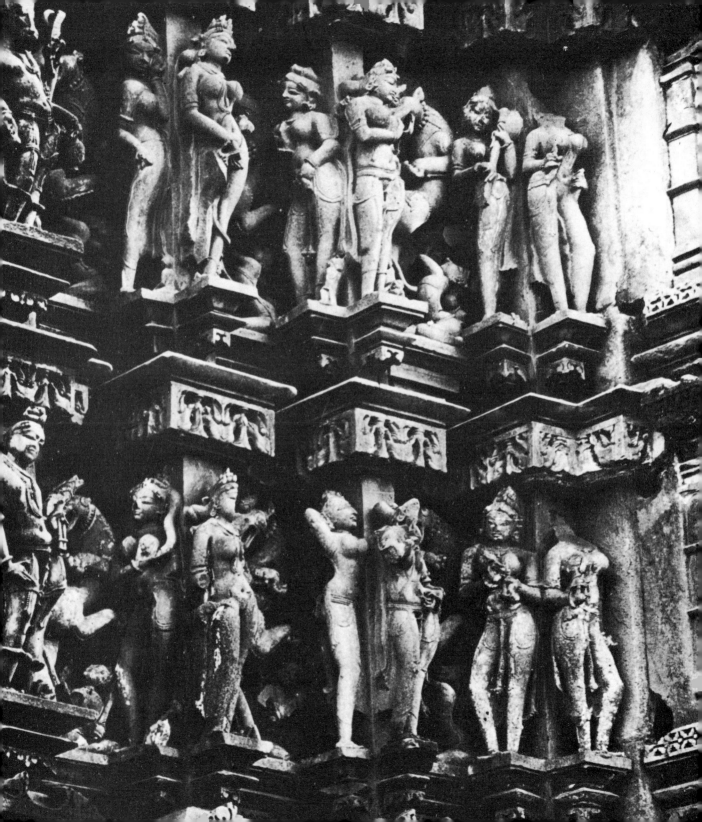

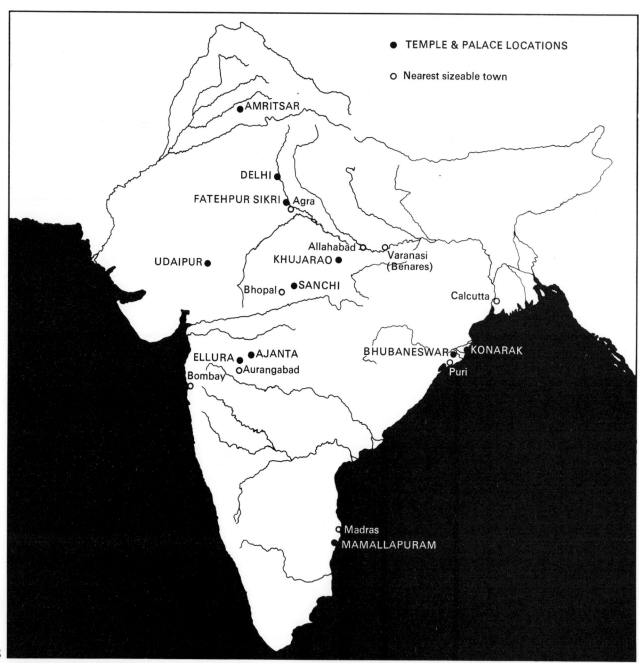

TEMPLE & PALACE LOCATIONS

Nearest sizeable town

AMRITSAR

DELHI
FATEHPUR SIKRI Agra

Allahabad Varanasi
KHUJARAO (Benares)

UDAIPUR

Bhopal SANCHI

Calcutta

ELLURA AJANTA BHUBANESWAR KONARAK
Bombay Aurangabad Puri

Madras
MAMALLAPURAM

8

Introduction

Ever since Indian art became a subject for serious scholarly study, there seems to have been a conspiracy to make its appreciation as difficult as possible for the intelligent but non-specialist reader. There has been–and still is–an unnecessary emphasis on the religiosity of Indian art. But that does not mean that it is possible, by exploring esoteric religious texts, to discover any common denominator that 'explains' the whole of Indian art, which ranges from the simple realism of early Buddhist art, through those cinemas of sculpture, the medieval Indian temples, where terrible gods and sensuous goddesses give a continuous performance of immense theatricality, to the Persian forms and abstract decoration of Mughal architecture. Insistence on the obscure and the mysterious, aided by the almost complete anonymity of Indian art, has removed the human dimension from the picture and succeeded in perpetuating the feeling that, though Western art of any period and place is somehow alive, all other art is archaeology. It is, of course, not only art historians who are to blame for this. We are all, to a greater or lesser extent, victim of our own milieu. The Indians who built the temples illustrated in this book needed no elaborate explanations to help them understand the purpose and the meaning of temples and their adornments. They shared with the Christians of medieval Europe a concept of art as worship. Today, such a concept is foreign to Westerners, who no longer live in a traditional society. We do need some explanation, though not as much as we are often offered.

Unquestionably, it *is* a help to know something about the gods for whom the temples were erected, for divinities are always extensions of men's hopes and fears. These hopes and fears are not eternal. They change in degree, if not in essence, for non-religious reasons. Economic growth, political ambition, technological development, war and cultural aggression–all these kill off old gods, create new ones, and above all influence the visible expressions of worship, the houses of the gods, and their representation in stone and paint. It is the historical environment that partly accounts for the immense diversity of Indian art.

This short introduction emphasises environmental factors as well as 'spiritual' interpretations, history as well as metaphysics. Metaphysics cannot be ignored, because Indian society was one in which

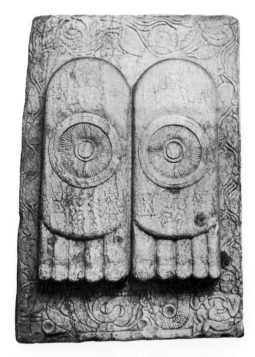

The footprints of the Buddha. When the Buddha was considered to be no more than a great religious teacher, he was commemorated at Buddhist shrines only by symbols such as these footprints, bearing on their soles the chakra, *or Wheel of the Law. From the drum of the Buddhist stupa at Amaravati. First century AD.*

9

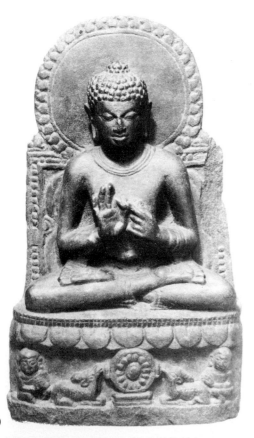

religion affected action at every level. The classes into which society was divided were sanctioned by religion; rebellion was expressed in religious terms. In much the same way, the architecture of Indian temples cannot be divorced from Indian religion. The men who built the temples did not erect them as exercises in the science of building, nor did the sculptors who adorned them produce art as art. Their purpose was the primary purpose of all traditional art, to teach men the great truths about the universe. That was the first criterion which a building or a piece of sculpture or a painting had to satisfy.

But there were other criteria. Though the conventions and proportions of buildings and of sculpture came to be systematised in special manuals, the ambitions of both secular and religious élites strongly influenced the manner in which these conventions were expressed, much as they did in the medieval Christian church. So too did individual genius. Fortunately, the discipline of Indian tradition was never stifling. Within the essential framework – designed to produce images worthy of worship and buildings reconstructing the world of the gods – the artist and architect were allowed real freedom of expression. Guilds of workers, like those who created the medieval cathedrals, were dedicated to the construction and embellishment of temples. A guild tradition was passed on either orally or through the manuals of guidance; but always the individual craftsman brought his own vision to his work so that tradition did not wither into dull formalism or sterile copying.

Indian art was always close to life, reflecting, and using, the forms of nature and man. In the early Buddhist sanctuaries everyday life is displayed in the sculptural decoration. In the painted caves, the Buddha wears the form and symbols of the aristocracy of the time. In the medieval temples, the life of the gods apes that of the king. Not all Buddhist art was close to ordinary people – the Buddhism of Ajanta was probably not quite as democratic as that of Sanchi – but essentially, Buddhism was an egalitarian religion. The Hindu temples of Mamallapuram and the later ones of northern and eastern India, however, were class structures designed for the use of the upper strata of Indian society. The masses went on worshipping their own gods in their own ways, in places of worship which owed nothing to the patronage of kings or wealthy merchants. Yet popular religion sometimes broke in on the aristocratic world, especially at periods when it seemed to threaten it. This, in part at least, accounts for some of the sculpture at Konarak and Khujarao

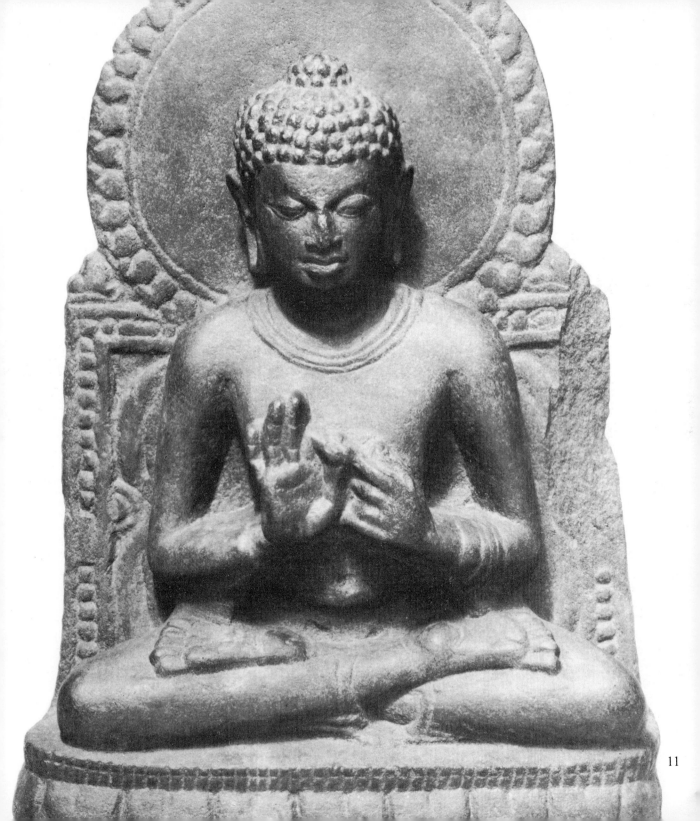

11

Rishabhadeva and Mahavira. Contemporary with the Buddha, Mahavira, the founder of Jainism, headed a similar rebellion against orthodox religion. His teaching, however, was much more ascetic and harsher on the individual seeking salvation. Jains believe that, before the Mahavira, there were 23 Tirthankaras or sages, the first of whom was Rishabhadeva. Orissa. Twelfth–thirteenth century.

and links these buildings with their contemporary world. In fact, it is the correlation between the life of the times and the structures themselves which supplies the most adequate framework for an understanding of Indian art.

The cultural milieu which produced the monuments at Sanchi was one dominated by the rich mercantile class of the cities. Its sources lay in the use to which Buddhism had been put by the state. The Buddha (*c.* 560–480 BC), like his contemporary, the Jina Mahavira (*c.* 540–468 BC), founder of Jainism, was a member of the *ksatriya* or warrior class, and both were opposed to the brahmanical or priestly orthodoxy which, by its claim to magical powers, dominated the social order and in many ways imposed its will upon the rulers as well as the mass of the ruled. Buddhism and Jainism appealed to the downtrodden, to the lowest levels of the social order, and also to the merchants who were not accorded the social status which they felt their economic importance justified. In the time of the Maurya emperor Asoka (273–232 BC), Buddhism became identified with the rulers, though it was not made into the religion of the state. On the contrary, Asoka's Buddhism was personal. Nevertheless, he did a great deal to spread its specifically social ideas, particularly those of tolerance and non-violence. This was sound statesmanship and basically an attempt to reconcile conflicting tensions in the social order which had existed before he assumed power. He did give an immense push to the actual practice of Buddhism, though the social tensions re-emerged after his death.

Asoka's influence upon temple architecture can be seen in the development of the stupa, a massive hemispherical structure surrounded by a balustrade and surmounted by a wood or stone umbrella. Essentially it was a funerary mound, such as had been common from prehistoric times, and it was firmly established in the minds of the people as a place of sanctity and magic. Now, it was given a new interpretation and a new purpose although it remained, in a sense, a funeral mound, for in the centre was placed a relic of the Buddha or of some Buddhist saint. Under Asoka, these magical structures were placed wherever important local gods were worshipped, just as, later, Christians constructed shrines on the sites of heathen cults. This is why, at Sanchi for example, local deities such as *yakshas*, as well as more important gods, became the gatekeepers and servants of the Buddha. After the collapse of the Asokan empire many of the stupas disappeared, probably because local deities re-asserted themselves in the minds of the people. Buddhism survived

Brahma. The first person of the Hindu trinity and absolute creator of all things. Although Brahma continued to be represented in Hindu temples, his worship declined from the first century onwards while the two other members of the trinity, Visnu and Siva, acquired vast followings. Chandella. Eleventh century.

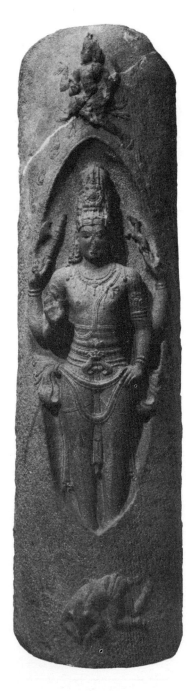

among the commercial classes, and through their patronage new stupas were erected and old ones refurbished.

The original attraction of Buddhism for the lower classes was probably confined to urban centres; in the course of time, it became less democratic and therefore less popular with the masses. It seems highly unlikely that the great rock sanctuaries which began to be excavated about the first century BC were intended to attract the ordinary worshipper. The early Buddhist caves lay along the trade routes of western India, and others were even more remote from the centres of population. As well as providing a retreat for monks, they were summer resorts for the rich and a refuge for travellers. The caves provided protection from the heat and from the monsoon rain, and there is evidence that they were also places of entertainment where the visitor could be amused by dancers and courtesans. The cost of excavation and the money required for the upkeep of these caves reflect the increasing class orientation of Buddhism, which, in conjunction with other factors, led to its decline.

The progressively more international character of Indian trade from the first century BC onwards brought new ideas and art forms to India. This was particularly apparent in the north where, besides the continuous contact of trade, Hellenised kingdoms (successors to the empire of Alexander the Great) existed. The most important effect of this cultural interaction was upon Buddhist ideas and their expression. Originally, the Buddha had been accepted as only a man, a great teacher undoubtedly, but a human being nonetheless. Though in the sculpture which told the tales of his life before he achieved the state of Enlightenment he could be represented in human form, thereafter he was represented only by such symbols as footprints, a wheel, or an empty throne. This symbolism was far too austere for converts. Even the presence of the old gods and goddesses in the antechambers was no real substitute if the main hall was empty. A real saviour god was called for—and a god that was not an abstraction but a visible being.

This growing need was satisfied by a new type of Buddhism and a Buddha himself in human form. All kinds of influences are apparent in both the new philosophy and the new sculpture. The first personified representations of the Buddha that have survived have much in common with the Greco-Roman form of the god Apollo. The chronology and origin of these Buddha figures is still the subject of controversy; suffice it to say that the foreign influences which introduced the figure of the Buddha to Indian art were of tremendous

14

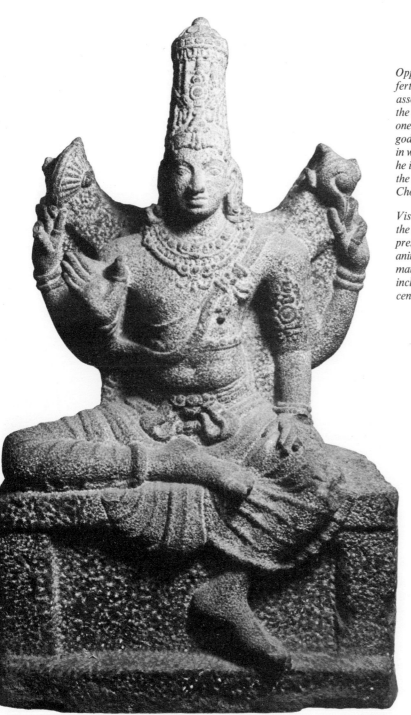

Opposite, Siva Lingobhava. The lingam, a fertility symbol of great antiquity, came to be associated with Siva in very early times and is the most popular representation of the god. This one shows the anthropomorphic image inside the god's own symbol and is an expression of the myth in which Siva reveals to Brahma and Visnu that he is the origin of them both. Brahma is shown at the top of the lingam and Visnu at the bottom. Chola, South India. Tenth century.

Visnu. The supporters of Visnu made their god the most important of the Hindu trinity. As preserver of the universe, the god assumed various animal and human forms in order to save mankind from evil. These avatars or incarnations include the Buddha. Pallava, South India. Eighth century.

importance to its development.

While these changes were taking place in the philosophy and social appeal of Buddhism, as well as in its iconography, the religion against which Buddhism had originally emerged as a revolt was also changing. Brahmanism, as it is properly called prior to this period, was becoming what is today known as Hinduism. From a multiplicity of gods, a Trinity emerged – Brahma the creator, Visnu the preserver and Siva the destroyer – representing the cycle of nature. Of the three, Visnu and Siva won large followings, and in future years the two main sects of Hindu belief came to be those associated with their worship, the Vaisnavas and the Saivas. The general population of gods, goddesses, and other spirits good and evil remained undiminished, but they began to regroup around the most popular major deities while continuing to attract local devotion. Many of these local deities were rationalised into 'aspects' of the two main gods, so that Visnu and Siva acquired what can only be described as regional names and personalities.

One representation of Siva, however, was universal. This was the lingam, or phallus, whose worship became current about the first century AD. Siva-worship incorporated a large number of fertility cults, and the lingam and its female counterpart, the yoni, were obvious fertility symbols.

Though Buddhism and the new Hinduism were in essence antagonistic, they continually influenced one another until, in the end, Hinduism triumphed by absorbing the Buddha. He became the ninth incarnation of Visnu, the last – so far – of the bodily forms taken by the god at times of great stress or evil so that he may enter the world of men and save them from the consequences.

The absorption of the Buddha into a reorganised version of the religion he had rebelled against took time. Certain social classes continued to support Buddhism, others Jainism, primarily as a claim to social identity but also, in the case of rulers, as a means of reducing or controlling the influence of the brahman or priestly class.

In all this, naturally enough, the architecture of religion played an important role. The supporters of each religion sought to maintain its prestige by constructing temples. Rulers none too secure in their dominions might perhaps persecute one religion while conciliating the others with donations and patronage. It depended not so much on religious conviction as on political reality, and it is this which accounts for the survival of regional styles. In fact, it was not until a new central authority emerged in India in the fourth century AD

16

Siva and his consort, Parvati. The goddess represents the shakti *or cosmic energy of Siva. In Hindu ideas, the god is the personification of the passive aspect which is known in the West as Eternity; the goddess its apparent opposite, the activating energy which is creative power. Pala. Ninth–tenth century.*

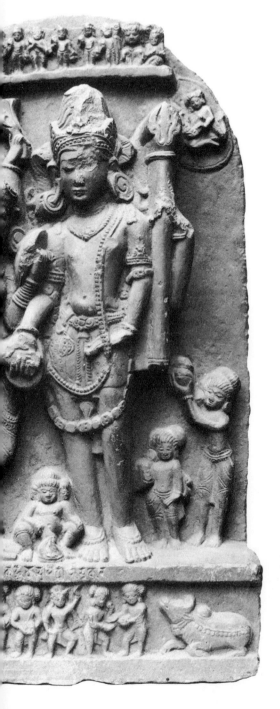

that the beginnings of a 'national' style appeared – though this phrase must be carefully defined, because it does not mean that there was in India any *universal* style. What is important is that, during the Gupta supremacy (fourth–fifth century), the general form of the Hindu temple was established, though very few examples have survived.

In this period, the rock-cut sanctuary still remained architecturally acceptable and some of its finest examples – such as those at Ajanta and Ellura – date from Gupta times. There are also a number of free-standing Buddhist structures from this time, including Temple 17 at Sanchi.

Until Gupta times no real distinction existed, except in sculptural adornment, between the temples of any of the Indian religions. Nevertheless, it seems highly probable that, by the late fifth century, the conception of the Hindu temple as an architectural reconstruction of the home of the gods had emerged. Already, the simple funerary mound of the stupa had changed to a much taller structure, reaching towards the sky rather than clinging to the earth. The new Hinduism was turning the mound into a sacred mountain. The plinth of the temple was regarded as the altar, the superstructure as the home of the gods (Mount Meru), and the sanctuary was a cave in which the image of the god was placed. This was called the *garbhagriha*, or womb-house, where in the darkness the worshipper was born again in contemplation of the god. This concept was not formally elaborated until the seventh or eighth century and not fully realised until medieval times.

The essential technological change in the Gupta temple was the discarding of the traditions of wood construction. Buildings were not only made of stone but conceived in that material by the architect. Round forms began to disappear and the emphasis fell on the straight lines of horizontals and verticals. The *chaitya* window was on the way out as a functional necessity and becoming merely a decorative motif. The stone arch, though known, was seldom used. Pillars and horizontal beams were utilised in construction, and the ceilings were of alternating stone slabs. Where vaulting was necessary, it was achieved by corbelling. The columns were of every conceivable shape: square, octagonal, sixteen-sided, round, plain, fluted and spiral. Normally, indeed, the Gupta column combined a variety of shapes. Another favourite device was the bracket, with sculptures of flying deities or amorous couples affixed to its sides.

In Gupta architecture the erotic, which plays such a prominent 17

Siva Nataraja. The god as Lord of the Cosmic Dance. The dance is an act of creation. In one of his hands the god holds a drum, the symbol of sound, representing creation. The flame resting on another palm is a symbol of destruction, and the fact that it is held on the same level as the drum illustrates the counterpoise between creation and destruction. The dwarf under the god's feet personifies evil. South Indian bronze. Tenth–eleventh century.

role in Indian art, is everywhere. Only in part does it represent the old fertility symbolism. The fifth century saw the beginnings of a new cult worshipping female deities which was to develop in a form later called Tantrikism. It influenced both Buddhism and Hinduism. In both, female counterparts to the male gods emerged. In eastern India, a new form of Buddhism appeared in the seventh century called *Vajrayana*; by the time it disappeared from India in the twelfth century, it had been established in Nepal and Tibet where, at least in the former, it still exists. In Hinduism, the gods were given wives who were worshipped in their own right. This seems to have been a popular cult, particularly amongst the lower classes, and when it proved difficult to suppress it was simply absorbed into the orthodox ritual and given official recognition in the temple.

All these trends, slowly crystallising in the Gupta period, became dominant in the centuries that followed the collapse of the Gupta authority. Invasions by barbarian tribes shook the Gupta empire and, though there were short-lived revivals of centralised authority in the seventh and eighth centuries, it broke up into a number of military states which were ever in conflict and ever changing because of it. In these conflicts, the larger cities soon shrank in size, and the merchant classes declined as a result of economic chaos. With their impoverishment, Buddhism and Jainism lost influence.

These changes were not confined to northern India. In the south, new military monarchies appeared and, though the merchant classes were by no means ruined as they were in the north, their role in the state shrank and they became subservient to the new rulers. In the south, a new cultural synthesis was to emerge, producing a distinctive southern culture which not only created a great religious architecture of its own but also, through the bridge kingdoms of the Deccan, produced a cross-fertilisation of southern (or Dravidian) and northern styles. An example of this meeting of styles is the great Kailasanatha temple at Ellura.

With the rise of regional states in the north came a resurgence of Hinduism. The new rulers were a very mixed lot. Some were members of the old aristocracy, feudatories in some cases of the former central power. Others were foreigners and military men of dubious background who, in order to establish themselves in a frankly hierarchical society, had to invent ancestors. This they did by claiming descent from the mythical heroes of the great epics and, through them, from the gods themselves. To back their claims, they needed the help of the priestly class – and were compelled to 19

pay for it. They also needed the support of the lower classes from which the army was recruited. Here, too, the brahman priests had the greatest influence. They offered parvenu rulers not only the support of the gods but control over the people. This alliance between upstart rulers and the brahman class resulted in what was virtually a monotheism in which every local god became identified with the worship of one god, either Visnu or Siva. A sacred tradition was produced to fit every case. Temples became machines manufacturing magical powers. The image of a god became not so much an icon as the visible presence of the god himself. His surroundings were those of an earthly ruler, a palace with its attendants, from priests to dancing girls. The state was a theocracy. Even the rulers' palaces were, like the temples, imitations of the home of the gods.

Identification of the secular with the priestly power meant that every contender had to try to enlist the support of a body of priests. This he would do by constructing some modest shrine. New rulers, achieving power, rewarded priestly assistance by enlarging existing temples or constructing vast new ones. Consequently, the sects of Hinduism became more and more competitive and their temples richer and richer.

The alliance of aristocracy and theocracy led to a hardening of class divisions particularly between the higher and lower classes. Most of the great temples were reserved for the use of the higher classes, and popular cult images were kept away from the major temples. Nevertheless, popular religion retained its place. Some of the popular cults represented anti-establishment movements. A particular example was Tantrikism, which claimed to be a simplification of traditional beliefs and was open to all classes, including women. Tantrik practice centred upon magical symbols and the worship of a particular deity, and Tantrik ritual culminated in the taking of the five Ms – *madya* (wine), *matsya* (fish), *mamsa* (meat), *mudra* (grain) and *maithuna* (sexual intercourse). Essentially, it was a revolt against the accepted standards of a highly formal society, a rebellion in theological terms. On occasion, popular cults were adopted by certain rulers in order to identify the state with popular religious expression.

While the regional states of northern India were turned in upon themselves, and their only external activity consisted of minor wars with their neighbours, a new monotheistic religion was moving aggressively into India. This was Islam, brought by invaders who began to penetrate the country from the eleventh century onwards.

Nanak, the first guru or spiritual teacher of the Sikhs, 1469–1539. In 1499 Nanak had a vision in which god gave him a cup of amrita *(nectar) and told him that he was the supreme guru of god. When asked what had happened, Nanak would only say: 'There is no Hindu, there is no Mussulman.' Sikh miniature. 1850–70.*

Right, building the Red Fort, Agra. One of two miniatures depicting building techniques in the time of the Mughal emperor, Akbar. In the foreground, stone is brought by boat along the river Jumna, which runs by the fort. Masons are splitting stone with wedges while the trimmed blocks are carried up a ramp to the top of the gateway. At the top, chunam *is being prepared. Mughal miniature. c. 1600.*

20

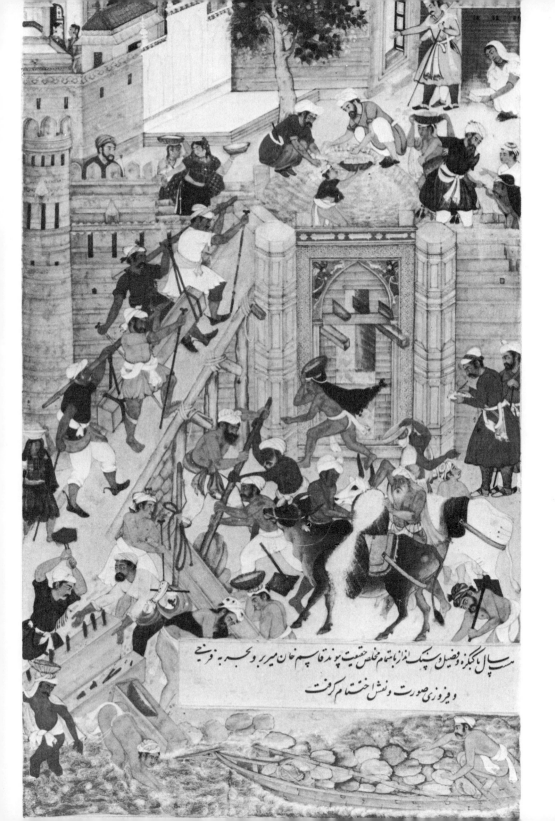

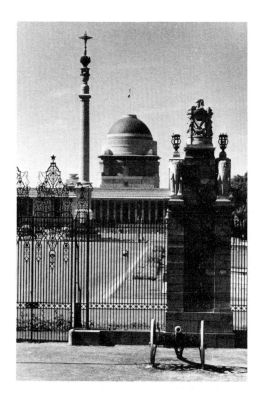

Viceroy's House – Rashtrapati Bhavan, New Delhi; part of a grille in the ceremonial entrance and the Jaipur column. The pylons are of red sandstone, and white elephants support lanterns surmounted by the imperial crown. The base of the column is of red sandstone, but the rest is white until it reaches a bronze lotus flower at the top of the column. On top is a six-pointed star of India, made of glass.

For some time, even when they settled in parts of northern India, these invaders tried to keep themselves culturally aloof. But in the end they submitted to Hindu techniques, forms and ornament, giving back – eventually – a mixed Indo-Islamic vocabulary.

In essence, nothing could be psychologically more different than Hindu and Islamic art. The art of Islam is as abstract as the god who is the centre of its religion, a god without face or form. Yet as Muslims settled down in India, they could not help absorbing something of the culture of the majority surrounding them. They used Hindu craftsmen when mosques were being constructed and saw nothing wrong in the introduction of ornamental styles customary in Hindu temples.

In time, religious ideas also began to interact. Devotional cults of long standing in India emphasised the personal relationship between the worshipper and the object of his devotion. In Hinduism this was known as *bhakti*, and it had profoundly influenced Hindu religious ideas. Islam, too, had its devotional cult, the *sufi*, which was – like that of *bhakti* – essentially a revolt against orthodoxy The appeal of these movements lay in their simplicity, for they emphasised simple living and followed a comprehensible ritual. From a combination of these two movements Nanak (1469–1530) established a new religious community, the Sikhs. It was a long time before the Sikhs needed a religious architecture, but when they did they chose, appropriately, that mixture of Hindu and Muslim styles to which the Mughal emperor Shah Jahan (1627–58) gave his imprimatur.

The antecedents of this architecture were Arab and Persian. The pointed arch and dome were quite alien to Indian architecture. So, too, was the use of concrete, which made it possible to enclose much larger spaces with a ceiling. When Hindu craftsmen were employed to build mosques, tombs and palaces, however, they modified these characteristics and introduced such motifs as the lotus into the geometric and calligraphic decoration of Islam. In at least one case, Indian building routine was followed in a Muslim structure when it served no functional purpose whatsoever. This was in the tomb of Ghiyas-ud-din (1325) at Delhi, where a lintel was placed across the base of the pointed arches.

Oddly enough, though the Muslims were quite prepared to adapt actual Hindu temples for use as mosques as well as taking over their decorative vocabulary, the Islamic tradition remained solidly entrenched in secular buildings such as palaces and mansions. In time, this tradition invaded Hindu architecture, both secular and religious.

Islamic gateways, domes and battlements became almost common-place in the Hindu world. The traditional Hindu temple became a kind of palace, with an inner court, an open hall, and a simple sanctuary. The fusion of Hindu and Islamic styles once more had an effect in the architecture of the Mughals. The palaces of Fatehpur Sikri, for example, contain many features adapted from Hindu temple architecture. Then, as if in return, the imperial style of Shah Jahan–itself a mixture of indigenous forms–was taken up in the late seventeenth and eighteenth centuries by the Rajput princes.

Towards the end of the eighteenth century, European styles were beginning to become fashionable in India. French interior decoration was mixed indiscriminately with elements of the Mughal style. The British constructed Palladian mansions for themselves, and so did some of the Indian princes. As the nineteenth century progressed, all the styles of contemporary Europe moved into India, and were copied. Today, Victorian 'Italian Renaissance' palaces still stand at Gwalior, Indore and Baroda. The end of the century witnessed an artificial revival of indigenous styles which culminated in the Indo-European architecture of New Delhi (1911–30).

The European influence remained superficial, producing no new synthesis of styles then or since. The imposition of alien British rule stifled the vitality of Indian art, ironically enough, by imposing peace and stability upon chaos and anarchy, by taming ambitions and denying to the artist and craftsman the patronage of power. For if there is one factor in the history of Indian art that is constant it is that major styles and their finest expression emerged in time of revolutionary crisis. Perhaps when a new Indian society emerges from the violence of modernisation, some synthesis, some new integration of past and present, will emerge. Until then, what the world knows of Indian art will remain the monuments of the past.

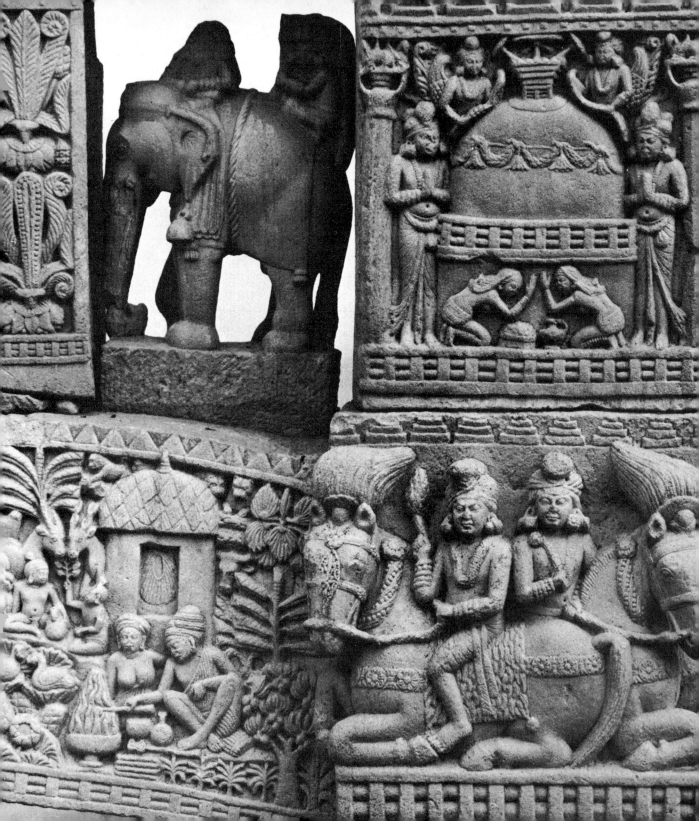

Sanchi

The monuments that survive today at Sanchi represent a short history of the development of the Buddhist faith. It is all there – from the cool asceticism of the founders, with their indifference to the visible world, to the warm involvement in everyday life of an established popular religion.

There is also something more, for Sanchi is an open museum displaying the growth of craftsmanship and technique as sculptors and architects moved from wood to stone and learned to dominate their materials.

The core of the Great Stupa probably dates from the time of the Buddhist emperor, Asoka (273–232 BC). The Buddhist stupa developed from the old practice of burying the remains of princes and holy men under artificial hills of earth and brick. When the Buddha died about 480 BC, his ashes were distributed by his followers and enshrined under eight great stupas, all trace of which has since disappeared. In the time of Asoka, the emperor redistributed the surviving Buddhist relics for burial under stupas in the principal towns of the empire. This made it possible for many more worshippers to direct their love and devotion to the spiritual Buddha through a relic of the living Buddha's mortal body.

The significance of the stupa, then, was what it contained and not the construction itself. The Great Stupa at Sanchi was originally an extremely plain structure, representing a compromise between the austerity of Buddhist ideas at the time and the emperor's desire to spread the faith throughout his dominions as a means of uniting the people and the ruler. As the use of the stupa for Buddhist purposes was itself a concession to popular, pre-Buddhist practices, neither monks nor missionaries saw any reason to embellish the sanctity of the relic under the mound by decorating the mound itself.

The first stupas, therefore, were not particularly inspiring. A hemisphere of large, unburnt bricks covered a mound of earth and stones. In the centre, a small space contained the relic, and on top of the mound was placed a stone umbrella – a symbol of royalty and therefore of honour. The mound was covered with a layer of plaster in which recesses were left to accommodate small lamps at festival times. Some colour and gilding appears to have been applied to the plaster surface. Around the stupa was a processional way, enclosed 25

Part of the bottom lintel of the north gate of the Great Stupa. At the bottom left is a forest hermitage showing contemporary domestic architecture, animals and fruits. At top right is a representation of a stupa with worshippers and heavenly guardians.

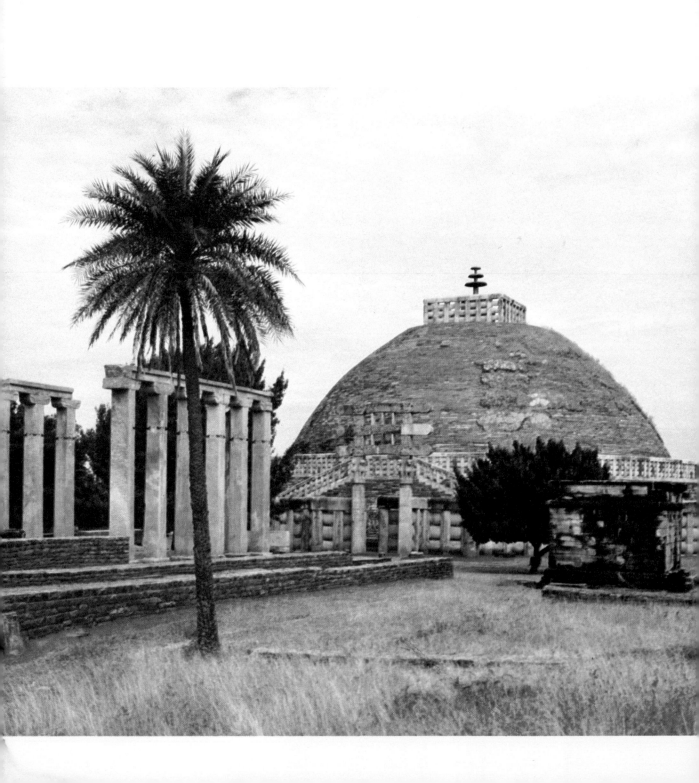

by a wooden railing with entrances at the cardinal points. Some art historians have suggested that the stupa, like the later Hindu temple, was a representation of the universe, the hemisphere symbolising the dome of heaven and enclosing the world mountain which rises from earth to heaven. Their arguments are ingenious but not convincing. The architects of the stupas were more concerned with identifying their constructions with traditional objects of veneration than they were with cosmic symbolism. They built, not for theologians and metaphysicians, but for ordinary people. The ritual of circumambulating the stupa seems to have been another adaptation from popular practice. The worshipper entered the enclosure by the

The Great Stupa seen from the south. The first ambulatory is at ground level. The second, approached by a double flight of steps, forms a terrace round the stupa, and it too is protected by a railing. In the left foreground stand some of the inner pillars of a chaitya *hall, the outer shell of which has disappeared.*

Ambulatory of the Great Stupa, and the south gate. The width of the ambulatory is 12 ft. 9 in. and the height of the railing 10 ft. 7 in. The origin of the railing from the old wooden form of bamboo rods passing through solid wooden uprights is clearly visible.

I.T.—2*

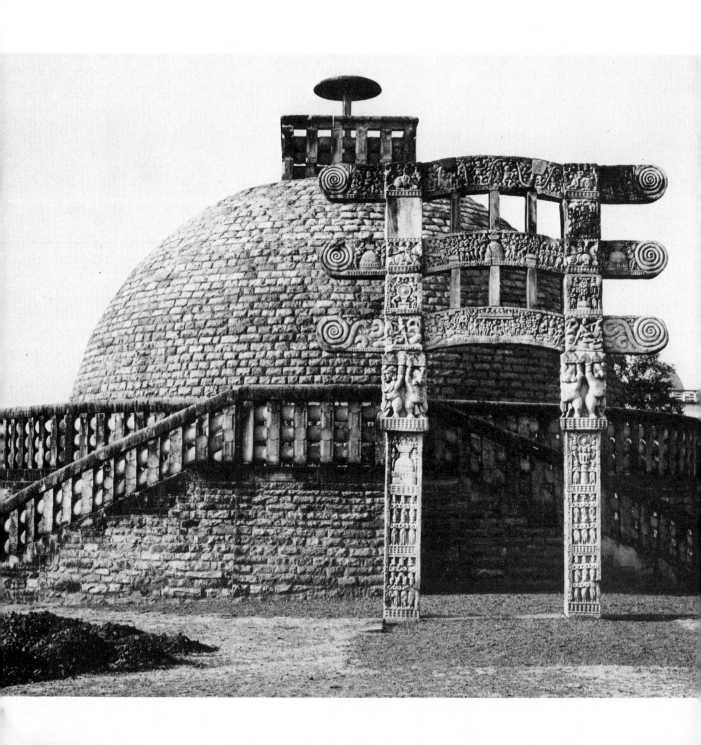

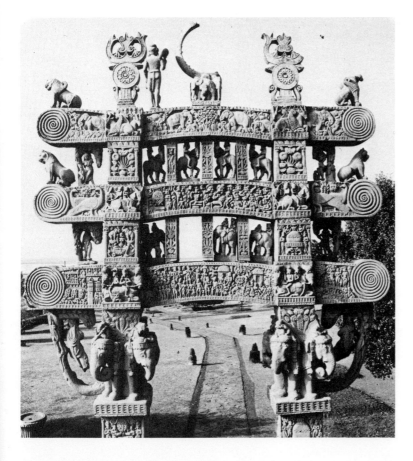

Opposite, Stupa No. 3. In this stupa were found the relics of two famous disciples of the Buddha, Sariputa and Mahamoggalana. The stupa is much smaller than the Great Stupa and has only one gateway. The ground railing was probably removed and used in the construction of other buildings.

Rear view of the architraves of the north gate of the Great Stupa. The centre panels depict stories from the jataka, the previous lives of the Buddha. At the top are emblems showing the wheel of the law, supported by elephants and flanked on either side by guardians with flywhisks (of whom only one remains) and the trident which symbolises the Buddha, the doctrine and the religious order.

eastern gateway and walked round the mound in a clockwise direction, imitating the movement of the sun across the sky—a common ritual in solar cults.

The Buddhist faith continued to expand, even after the death of Asoka ended the patronage of the ruler. The indifference of his successors, and even their persecutions, could not stop its spread. The monasteries amassed wealth and resources, and the influence of the Order of Monks increased. But this expansion had a price. The teachings of the Buddha triumphed over popular pre-Buddhist cults, but in the process they were conquered by the world of appearances.

In one sense, the process of change was democratic. Just as, in the European Renaissance, the face of Christ became humanised, so in

the second century BC the world of man – and this included all the gods and spirits of his world – came to surround the Buddha. The austere simplicity of the early burial mound no longer satisfied the needs of the worshippers. The first step in the transformation coincided with a great revival of the arts under the Sunga rulers, and initially the effect was to make the stupa a more dignified architectural construction.

The perishable materials of wood and brick were replaced by stone. About 150 BC, the existing Asokan stupa at Sanchi was enlarged to nearly twice its previous size, to cover an area of 120 feet in diameter and to rise to a total height of 54 feet – the size it is today. A terrace was added about 16 feet from the ground, producing a second ambulatory reached from the lower one by a double staircase on the south side. The mound itself was finished off with a facing of dry masonry, and a square railing was erected on top of the mound enclosing a pedestal from which rose a triple umbrella.

The ground-level wooden railing was replaced by a copy in stone which reproduced, literally, the carpentry style used in the earlier construction. The reason for this was not slavish tradition but undeveloped technique. The craftsmen were probably carpenters working for the first time in stone, a material they did not understand and considered only as a more intractable material than wood. As a result, they used joints suitable for wood when other means would have been better. At Sanchi, the craftsman was not only creating a new art in which to express his Buddhist faith but discovering that different materials demand different techniques.

Under the Sungas, figurative sculpture appeared on Buddhist stupas. The earliest examples are not from Sanchi but from Bharhut, about a hundred miles southwest of present-day Allahabad, and fragments are now in the museum at Calcutta. They appear to be enlarged versions of wood, or possibly ivory, carving. Sculptures on Stupa II at Sanchi are, however, from this period. They are a little clumsy in technique.

The real glory of the sculpture at Sanchi was created after the overthrow of the Sungas by the Satavahanas about the middle of the first century BC. The Satavahana empire was a great commercial power; rich merchants became patrons of monasteries. The stupas at Sanchi were completed under Satavahana rule with the addition of four gates to the Great Stupa and one to Stupa III. Their carvings are among the glories of Indian art.

30　　These gates (*toranas*) had more than one purpose. In the first place,

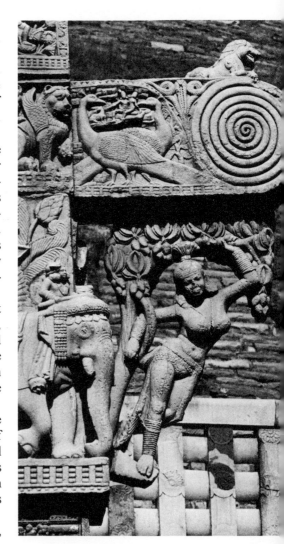

A detail of the front of the east gate. The two peacocks were emblems of the Maurya dynasty and may refer to the emperor Asoka. The bracket figure of a woman – a trifle heavy in the modelling, but in a most sophisticated pose – is a yakshi *or* vriksaka, *i.e. tree-woman and old fertility deity.*

they were monuments to piety, for each was given by a donor or group of donors who probably chose the subjects for the sculptors to carve. The gateways were also there to instruct, for the subjects of the reliefs were the lives of the Buddha and the long road he had travelled before achieving Enlightenment. In these stories in stone, the Buddha is shown in human form when his earlier incarnations are the subject; in those telling of his historical life, however, he is always represented by such symbols as footprints, or an empty throne. The form of the gateway also had a more profound purpose. This was to prepare the worshipper for the act of worship. The gates produce an effect of massiveness–they are over 30 feet high–and the cross beams give an impression of great strength. The human being who passes beneath them is dwarfed and reminded of his insignificance.

The reliefs and supporting sculpture of the gateways were, however, designed to assure the worshipper that, with the Buddha, a new world was born. The background of the episodes described in the reliefs is the ordinary life of the worshipper's world. The buildings are buildings he knows–his own hut, his own village, his ruler's capital. The animals are the animals of his fields, the trees those of his forest, and the flowers those of his garden. There is nothing spiritual or withdrawn about the sculpture at Sanchi. On the contrary, it celebrates the world of the senses. And above all, it shows a world without fear. The terrible magic of a universe full of demons which was the world of early man is now no more, for the Buddha has conquered the forces of evil. The sculptors convey a kind of solemn joy, not unlike that which Fra Angelico brought to Italian painting, in their landscapes of ordinary life and those who live it, the men and women, animals and plants. Even the spirits of the old, unredeemed world have been put in their place, all of them subservient to the Buddha. Gods and demons have become his doorkeepers and–for men who still need the old gods–intermediaries between the worshipper and the Blessed One.

But there is something more subtle in the art of the sculptors than just the use and absorption of old cults. The figures of the *yakshis* at Sanchi are more than survivals from early nature cults. In their frankly erotic poses they represent the world of illusion which the worshipper leaves behind as he enters the sacred enclosure. They also illustrate the use of sensual metaphor for spiritual purposes which is one of the unique features of Indian religious art.

Even before the construction of the great gateways, a number of

The architrave supports of the west gate. Here, instead of the usual elephant or lion supporters are representations of male yakshas, *pre-Buddhist divinities particularly associated with the earth and such treasures as precious stones and metals. Here, they too become subordinate to the Buddha and symbolise the absorption into Buddhism of popular cults.*

buildings had been erected in the vicinity of the stupas. These were temples for the carrying out of rituals, and monasteries for the priests. The first temples (or *chaitya* halls) were probably beehive-shaped, resembling the circular village hut of the times. Hitherto, worship had been in the open air but, as the stupa (*chaitya*) itself became an object of worship, smaller reproductions of it were made and placed under cover. The shape of the temple changed over the years and, though none of the early types have survived because they were made of wood, their general design lives on in the rock-cut temples of Ellura and elsewhere.

Some time around the second century AD, the Satavahanas were driven from the area of Sanchi by invaders from the north, and these invaders were themselves later replaced by others, known as the 'Western Satraps,' about AD 130. They ruled until soon after AD 388. They left little at Sanchi except a few sculptures of slight importance, but these indicate the change that had come over Buddhism in the first few centuries AD. The Buddha was no longer represented by symbols but as a divine personage.

It was not until the coming of the Guptas and their occupation of Sanchi at the end of the fourth century that, artistically speaking, Sanchi revived again, though it had never been without its worshippers, its monks, and its devout donors. The revival, however, was

The lower architrave of the south gate, rear view. This panel shows the so-called War of the Relics, and contains the essence of the whole event. On the right are the attackers; in the centre, the town of Kusinagara which they besiege; and on the left, the peace and the division of the relics. The city reflects contemporary secular architecture as well as the armies, battle order and weapons of the time.

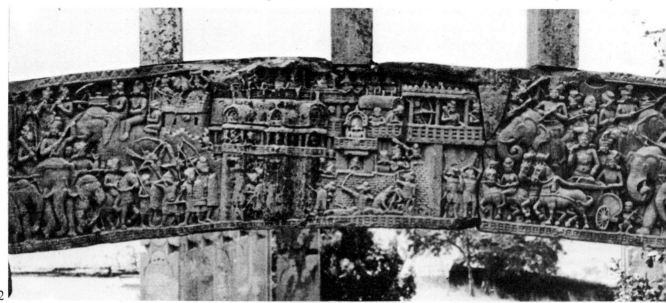

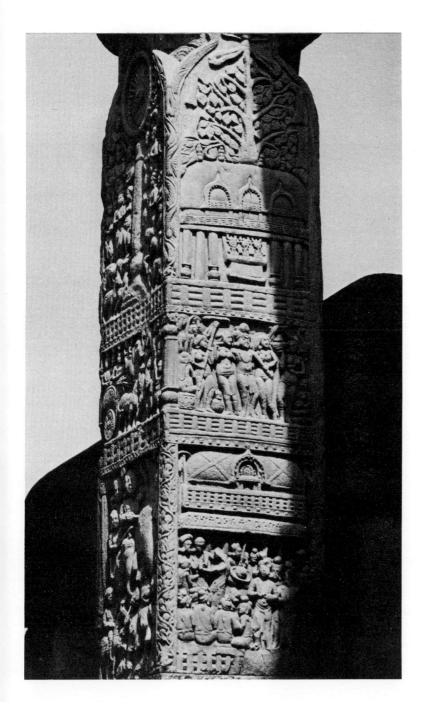

The left pillar of the south gate. Among the carvings, and visible on the left-hand face in this photograph, is the Wheel of the Law, mounted on a column. At the top of the right-hand face is the temple at Bodhgaya, built by Asoka around the tree under which the Buddha received Enlightenment. Asoka is shown immediately below with two of his queens and other women.

scarcely the beginning of new art, as it was in the Hindu temples erected in Gupta times. Temple 17 at Sanchi is, in its construction, a departure from everything that surrounds it. Stone is used as stone; the forms are not simply translations from wood. But the aesthetic ideas are derived from the past. The new spirit entering Indian art in the time of the Guptas gave a last bright flicker to traditional Buddhist forms. Elsewhere – at Ellura and Ajanta, for example – the art of the Guptas broke away from the past; at Sanchi its grip could not be loosened.

Buildings, of which remains survive, continued to be erected at Sanchi even after the decline of the Gupta power and its final collapse about AD 550. During this period, Hun invaders occupied northern India, and one of them, Toramana, is remembered as a fierce persecutor of Buddhism. At Sanchi, the sculptural remains are mainly detached objects, plaques and statues of the Buddha which were probably brought from elsewhere. A new power, that of Harsha (AD 606–647), established once again a political climate friendly to Buddhism. It is probable that a great deal of wall painting in the Ajanta style was carried out at Sanchi in the monasteries and chapels, but none has survived.

From the death of Harsha onwards, with the division of northern India under many rulers who owed no allegiance to any central authority, Sanchi displays only the losing battle fought by the Buddhist faith against a resurgent and dynamic Hinduism. The surviving pieces of detached sculpture and carving are curiously lifeless, without either spirituality or sensuality. The structures of this period are grandiose and pretentious, more suitable for display than devotion.

From the thirteenth century onwards, Sanchi seems to have been deserted. The Muslim conquerors of northern India, though they sacked towns and Hindu temples, left Sanchi alone. The real destruction was to come from time and the ignorance of early archaeologists. When Sanchi was discovered in 1818 by a British officer, a great deal of the site was in a good state of preservation. But very soon amateur archaeologists and treasure seekers succeeded in half demolishing the monuments. In 1822, the Great Stupa was cut, rather like a piece of cake, from top to bottom on one side. Work resulted in the collapse of the western gateway and part of the surrounding balustrade. The person responsible for these activities also partially destroyed Stupas II and III, at that time in an almost perfect state of preservation. Then, in 1868, another series of

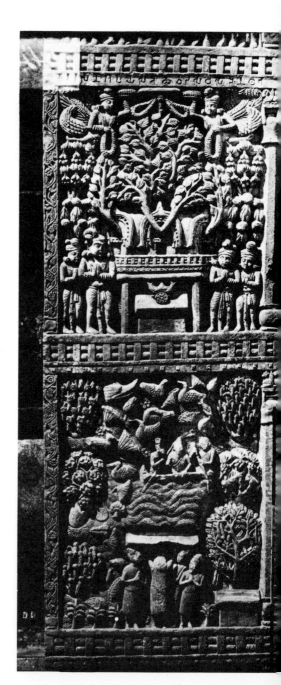

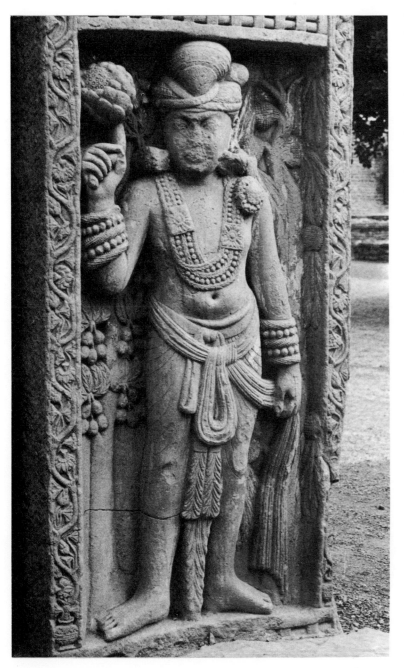

Above, lion supporters on the south gate. These are derived from the Asokan pillar (page 36). The Indian sculptor had little or no acquaintance with real lions, which, unlike the elephant supporters on other gates, are not represented naturalistically.

Opposite, two lower panels from the left pillar of the east gate. The upper shows the bodhi tree under which the Buddha received Enlightenment, and the lower, the miracle of walking on the water.

A guardian, from the pillars of the eastern gate, who represents another of the deities of the pre-Buddhist world harnessed to the service of the Buddha. These gatekeepers, who face each other across the entrance, are probably intended to be the lokapalas, the rulers of the four quarters of the world. Their dress is that of the upper classes of the time.

35

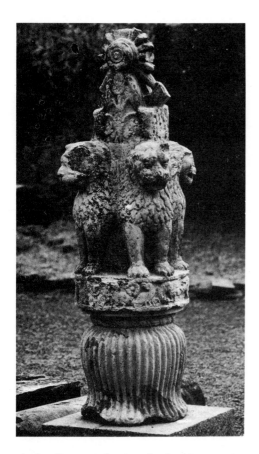

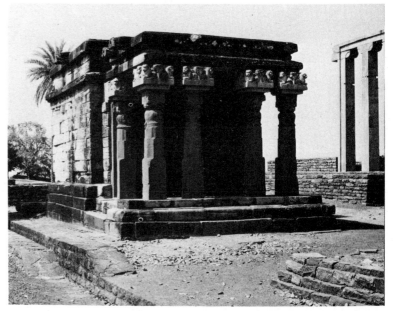

Asokan lion capital, originally placed on top of a high column. The bell-shaped base, drums and heraldic lions are of Persian origin. The wheel on top was a symbol both of the Wheel of the Law and of the universal emperor. This capital is an inferior copy of a much earlier one at Sarnath, the site of the Buddha's Enlightenment.

Above right, Temple 17, constructed in the fifth century AD. The design of the temple, with a porch before the sanctuary, is one of the earliest examples of the form of all later Indian temples, Buddhist and Hindu. The pillars are clumsy adaptations of the Asokan lion column.

excavations by a man who, in spite of everything, still deserves the title of 'Father of Indian Archaeology,' Alexander Cunningham, carried on the work of destruction. Cunningham extracted from Stupa III two relic caskets. These were discovered in the centre of the stupa on a level with the top of the terrace, in a chamber covered by a stone slab. In the cavity were stone boxes, one inscribed '*Sariputasa*' (i.e. 'of Sariputa') and the other '*Mahamoggalanasa*' ('of Mahamoggalana'). Sariputa and Mahamoggalana were disciples of the Buddha. Each box was eighteen inches square and had a lid six inches thick. Inside the boxes were caskets containing fragments of bone, jewels and beads.

It was not until 1881 that the government of British India did anything about preserving the monuments at Sanchi. Even so, no professional effort was made at conservation and reconstruction until 1912.

Sanchi has ceased to be a place of worship for Buddhists, but it still attracts pilgrims as well as sightseers. In 1952, the continuity of Sanchi as one of the sacred places of Buddhism was reaffirmed by the reinterment of the relics of Sariputa and Mahamoggalana – which had wandered around the world since their excavation by Cunningham – in a building specially erected to contain them.

Ajanta

The earliest buildings which the Buddhists constructed around their stupas were made of wood and thatch. In technique, they were copies or adaptations of secular buildings. Of course, because of the perishable nature of the materials, none of these early temples and monasteries has survived, but we can see what they looked like from the sculptural replicas which–from about the second century BC–were carved out of the living rock in various parts of India. These are sometimes rather misleadingly called ' cave temples,' as if they were merely an adaptation of natural forms. But in reality they are man-made caverns cut in imitation of free-standing buildings. As such, they are works of sculpture rather than of architecture.

Some art historians have traced the idea of these rock-cut sanctuaries to such prototypes as the tombs of the Achaemenid emperors of Persia at Naqsh-i-Rustam, where the façade represents an elevation of the palace at Persepolis just as the entrances to the early Buddhist rock-cut temples reproduce actual buildings. Certainly, the Mauryan rulers in India were greatly influenced by Persian ideas and the first rock-cut temples were constructed when these were still virile and fashionable.

But there were other reasons why the Buddhists chose to carve their temples and monasteries out of rock. According to a long-standing tradition in India, natural caves were ideal places for hermits and sages. Buddhism, anxious always to adapt existing religious practice to its own purposes, encouraged the use of caves as a retreat for holy men. As Buddhism developed a monastic organisation, small natural caves suitable for one or two ascetics became inadequate. Hence the construction of monumental artificial caves. There was, perhaps, another reason. In the growing anarchy and violence which followed the death of the Mauryan emperor, Asoka, these artificial caves provided physical sanctuary and a sense of permanency in a time of flux and uncertainty.

All the early examples of rock-cut sanctuaries can be found within a radius of two hundred miles of Bombay. The inside of the caves is usually plain, with highly polished walls and a simple, carved entrance. The method of construction–or, rather, of sculpture–was to start at the top, cutting out and finishing the roof before working downwards. This method dispensed with scaffolding. 37

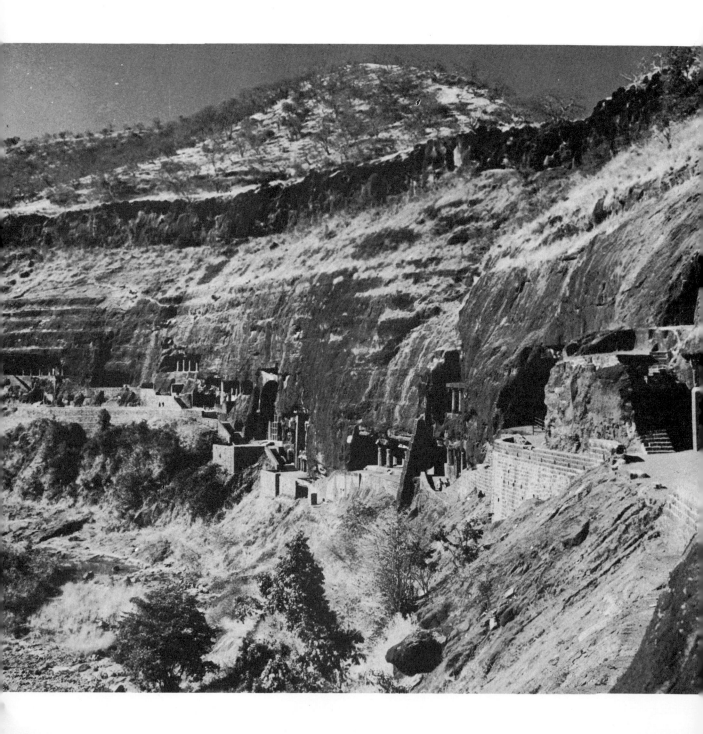

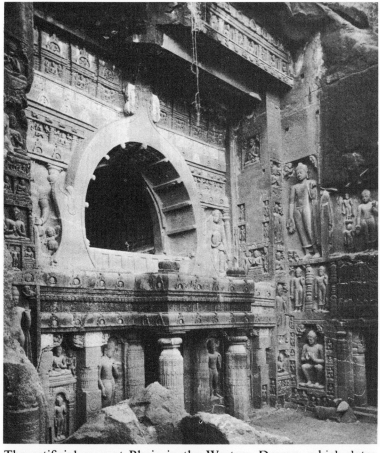

The artificial cave at Bhaja in the Western Deccan, which dates
from the beginning of the second century BC, is typical of the
earliest style. It consists of a nave, with rows of plain octagonal
columns ending in a semicircular apse in which there is a stupa cut
out of the rock. Ribs of wood were originally fitted to the vaulted
ceiling, and the entrance was of carved wood. From such simple
beginnings, the rock-cut temples and their associated monasteries
developed in size and splendour. The columns of the nave became
heavy with carving, and the façades of the entrances gained elabor-
ately carved stone verandas with a large central gable window to
let in the light.

This development, which is both aesthetic and religious (for
Buddhism itself changed under a variety of pressures), can best be

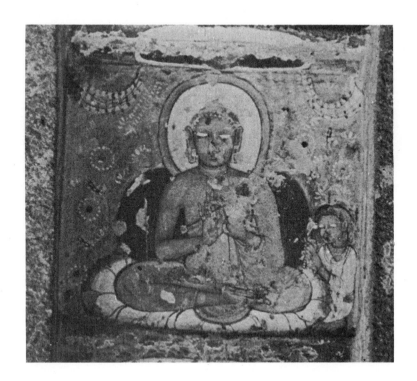

A portrait of the Buddha from the ceiling of Cave 10. This cave is the earliest at Ajanta and dates from the first or second century BC. The wall paintings, however, belong to the period between the first century and Gupta times. This is one of the early paintings.

Right, the temptation of the Buddha by the forces of Mara. Copy of a wall painting in Cave 1. The cave and painting date from the early part of the seventh century AD, and the painting shows an attempt by the Evil One to prevent the Buddha from practising the austerities which were to lead him to Enlightenment.

seen at Ajanta in the northern part of the Deccan, not very far east of Sanchi. Here, 29 caves, dating from the first century BC to the eighth and ninth centuries AD, were excavated on the horseshoe bend of a river. The area is wild and empty, and it seems likely that the site was chosen for its comparative isolation. Not only was there peace and freedom from the outside world, but also protection. Ajanta was a place of refuge as well as worship. The caves demonstrate the wealth of the Buddhist order as well as a decline in the purity of the religion. They also indicate that the faith was becoming increasingly remote from ordinary people and more an expression of the aristocracy of wealth and power.

The early caves at Ajanta are still models of free-standing buildings, but in the later ones it is obvious that, as the sculptors became used to working with rock, they allowed their skill to follow their imagination. It is very unlikely, for example, that Cave 19, either in the *chaitya* hall or the entrance façade, duplicated any actual free-standing building.

The caves at Ajanta were excavated during the ruling periods of

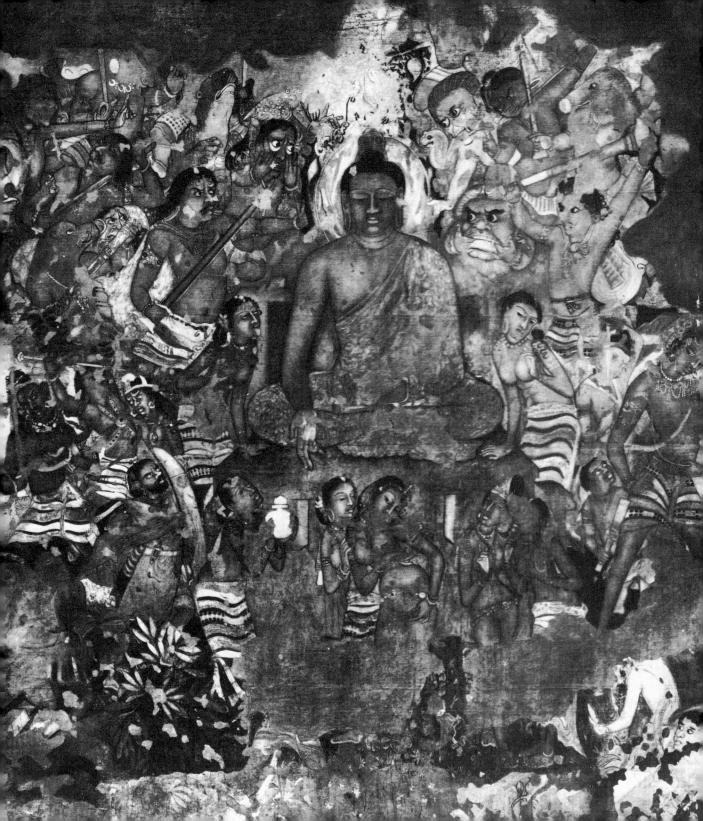

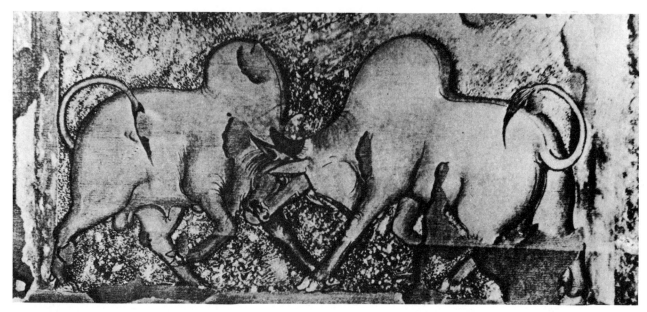

four Indian dynasties, the Satavahanas, the Vakatakas, the Guptas and the Chalukyas. Though the whole complex at Ajanta is of immense interest, its overwhelming importance in the history of art in India lies in the survival there of frescoes, the majority from the Gupta and Chalukya periods, but some others from earlier times.

Indian literature contains many references to the existence of wall paintings, both secular and religious. The earliest surviving examples are in Cave 10 at Ajanta, though all are in rather bad condition. These murals, which date from the first century BC, depict episodes from the *jataka*, the birth stories of the Buddha.

Like the carvings at Sanchi, the stories are told in continuous narrative form and no frames separate the episodes. The principal painting in Cave 10 tells the story of the Buddha's sacrifice of his tusks during his incarnation as an elephant. Most of the space is taken up with representations of elephants in their forest home, resting, feeding, bathing, anticipating the arrival of the hunters. The animals are shown in a completely naturalistic style, surrounded by floral and leaf forms which give the illusion of thick jungle. These show that there was already a well-established convention for the representation of nature as a background to the main narrative. There is no perspective, and distance and depth are conveyed by placing background figures above those in the foreground. Rocks

Two bulls fighting. Above a stylised band of flowers, this painting from a pillar in Cave 1 gives a naturalistic representation of two hump-backed bulls in close combat. A typical example of the realism with which the artist represented natural objects.

Right, wall painting from Cave 1. This is usually known as the Bodhisattva Padmapani but may well be intended to represent the Buddha before he renounced his princely life. He is dressed as a prince and holds a lotus flower in his hand.

42

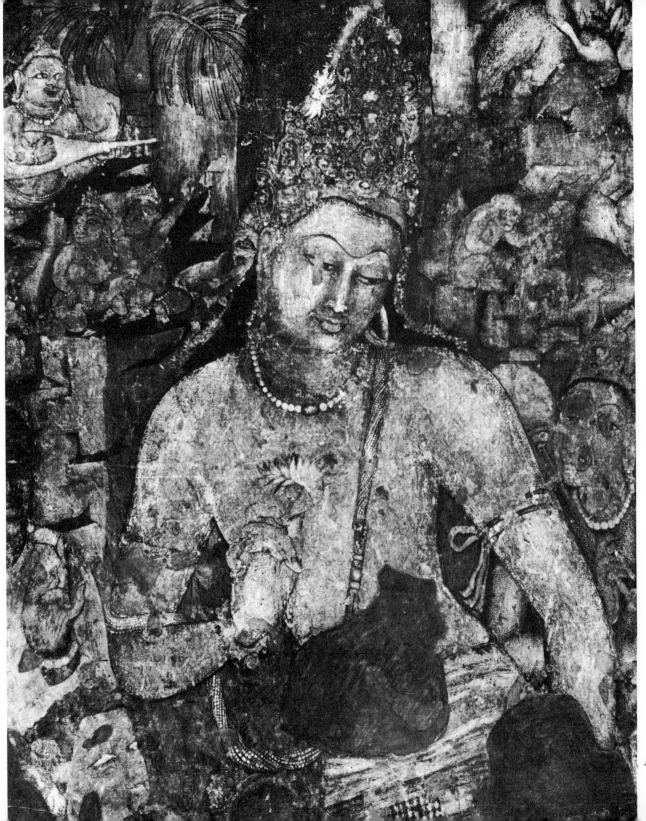

43

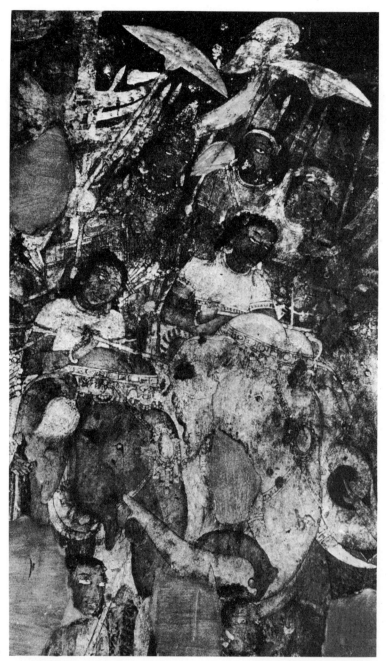

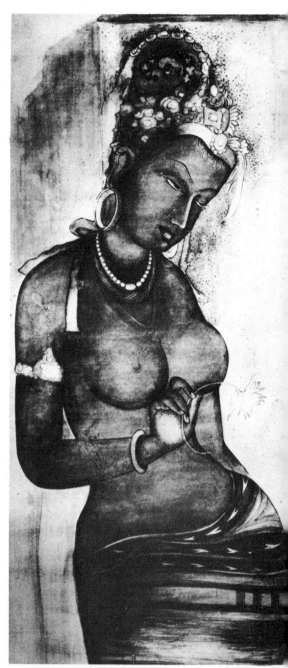

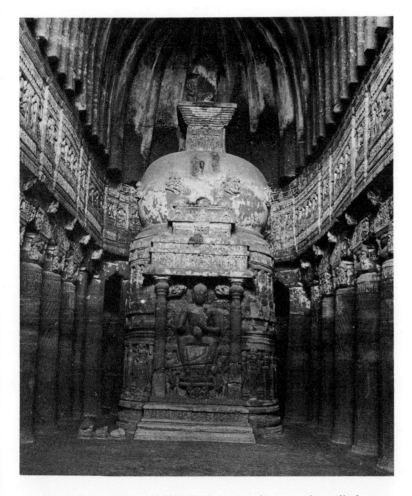

are shown as cubes, and hills and mountains as cubes piled upon cubes. Indeed, landscape in Indian art never developed beyond the acceptance of a few conventions to indicate trees, foliage or mountains. In a system of belief in which every natural object and phenomenon could be represented in the form of some demon or divine spirit, no purpose was served in representing them as they appeared to the eye. To the Indian painter, and to those who were intended to learn from his work, a tree was the spirit of the tree, and a lake the spirit of the lake. Only when the narrative required it would a natural setting be provided, and even then in the sketchiest fashion; a single tree represents an endless forest.

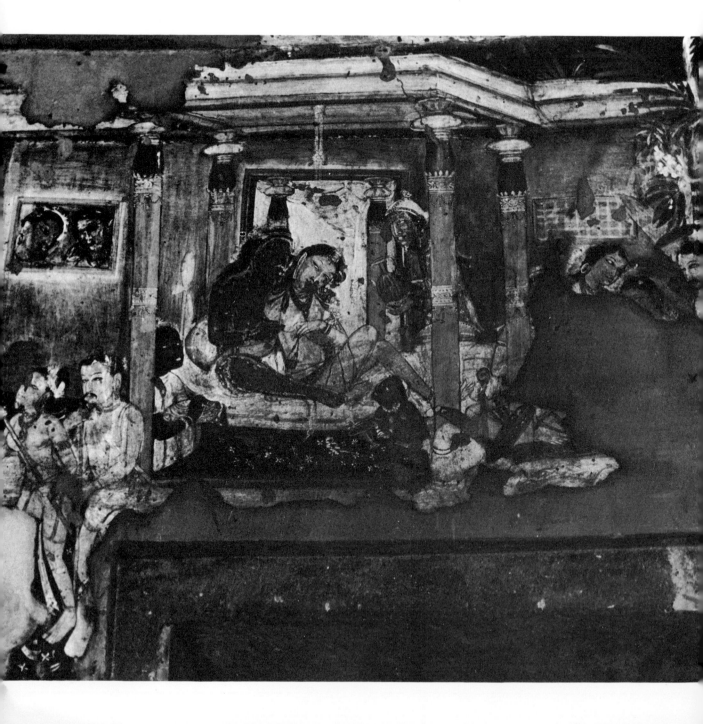

Later frescoes are somewhat difficult to date, but it is fairly generally agreed that Gupta and post-Gupta wall paintings can be found in Caves 1, 2, 16, 17 and 19, though their precise dates cannot be definitely established. They show clearly, however, how Buddhism had changed over the centuries and how Hindu concepts had entered the faith, beginning a trend which was to result in the triumph of Hinduism and the reabsorption of Buddhism into the religion its founder had rebelled against.

An example of this can be seen in the female figure next to the Bodhisattva Padmapani in Cave 1. She is not just another of the many female attendants who surround the prince, but the *shakti*, the personification of the female energy of the Bodhisattva. This was a Hindu concept, unknown to early Buddhism.

The personified gods also played no part in early Buddhism. In the earliest *chaitya* halls at Ajanta, there is no figurative representation of the Buddha and the votive stupa is plain and unadorned. But elsewhere, the Buddha has human form and is surrounded by lesser saviours. Even the stupa is no longer a simple burial mound. The figure of the Buddha seems to emerge from it as a real presence to whom prayer can be directed.

A similar change can be observed in the *viharas*, the quarters set aside for the monks. They, too, have lost the lonely austerity of early times. Cave 17, which dates from the sixth century AD, has a low ceiling and an interior court surrounded by cells for the monks. The ceiling has paintings of Buddha images surrounded by fabulous animals and lotus flowers. The columns are ornately carved and all the surfaces were once coloured, which must have given a very rich, almost jewel-like effect. It is all a long way from the simplicity of the founder and of the early monks of the order. Nevertheless, the superb frescoes of Ajanta would hardly have been painted but for the changes in the Buddhist faith.

The method used by the artists of Ajanta differed from that used in European fresco-painting. Strictly speaking, the wall-paintings at Ajanta are not fresco at all. In the technique used at Ajanta, the rough stone of the wall was covered with a layer of clay or cow-dung, mixed with chopped straw, rice husk or animal hair. This mixture was finished off with a coating of fine white clay or gypsum. The artist applied his colour to this layer which was kept slightly damp. Usually the design was outlined in red ochre, then given a thin monochrome coat through which some of the red showed. The various colours were then applied and the outlines were strength-

Wall painting of the Visvantara jataka *from the veranda of Cave 17. To the left, Prince Visvantara is shown distributing alms. Around him are musicians. On the right, the prince is seated with his wife, Madri, on his lap and is offering her a drink.*

47

ened with brown and black. So that the painters might be able to see what they were doing in the dark interior of the cave, large metal mirrors were set up outside to reflect the rays of the sun. Under these somewhat trying circumstances, the artists of the Gupta period produced an immensely virile picture of their times.

The paintings show processions of kings and queens, soldiers, brahmins and monks, shopkeepers and their customers. The characters in the stories reproduced appear in the normal surroundings of palace or simple house, in garden or forest, on a hillside or even on the sea. They travel on foot or horseback and in vehicles of the type common at the time. Sometimes they are carried in palanquins. Foreigners, such as Chinese, are shown in their characteristic native dress. Details of clothes and jewellery, hair styles and cosmetics, all confirm a picture of the everyday life of the leisured and the wealthy. So, too, at Ajanta we have a picture of the physical environment. All the flora and fauna of western India are reproduced. Horses and elephants, wolves, monkeys, dragons, bulls and lions crowd the walls. Pomegranate, mango and fig trees adorn the gardens.

The frescoes give a vivid impression of the architecture of the period, doubly valuable because—as they were mainly constructed of wood—no buildings survive. Domestic scenes are given in great detail, displaying the furnishings. At Ajanta, there is no turning away from the material world for that exclusively of the spirit. On the contrary, the Buddhism of Gupta times celebrates in no uncertain terms that blending of the spiritual and the material, the heavenly and the temporal, which had emerged at Sanchi and other sites centuries before.

The sculpture of the Ajanta caves cannot be divorced from the constructions themselves because the caves are, in effect, massive sculptures in which the worshippers prayed and the monks lived. The early caves were, of course, plain, but those constructed from the fifth century onwards became more and more ornate. The walls are covered with carvings of the Buddha, with loving couples, and standing or flying figures. The Buddha images are inclined to be rather monotonous in their repetition, though some are of great elegance and feeling, showing the essential characteristic of Gupta style, the combination of gentleness with an overwhelming sense of strength.

The various representations of celestial beings in flight, and the overall feeling of activity which the sculptor was able to convey by

scattering the figures around the walls and columns without formal

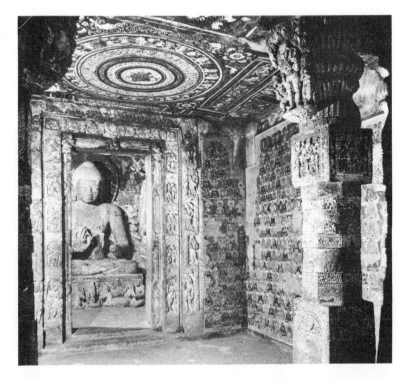

Opposite, flying couple from the ceiling of the front corridor of Cave 16, late fifth century AD. These figures appear on one of the brackets supporting the roof and represent a pair of heavenly personages. The male, wearing a rich crown and other jewellery, is a gandharva, a heavenly musician, and the female is his consort, an apsaras.

Below opposite, naga king and queen from the façade of Cave 19, which is covered with sculpture. The panel of the naga king and queen appears on the left wall. Above the king's head is a hood of seven serpent heads; behind, a female figure holds a chauri or flywhisk.

Entrance to the inner shrine of Cave 2, late sixth or early seventh century. The Buddha figure in the background is approached past a wall painting of hundreds of Buddhas, and there are three more Buddha figures in the shrine, which is covered with carvings and paintings and has a highly decorative painted ceiling.

design, foreshadow the general direction in which Indian sculpture was moving.

Outside the caves, the sculpture which decorates the entrance façades is somewhat different in feeling. The reliefs, some of which are among the finest examples of the period, are rigidly enclosed by a box-like frame. They have the same feeling of controlled vitality and elegance as the wall-paintings.

Ajanta is the last great site of Buddhist art in India. Buddhism was to survive in its country of origin in pockets; only in eastern India, particularly Bengal, did it survive in strength. But the influence of the Gupta style on Buddhist art in other countries was to be immense. The treatment and conventions of the Gupta style set the standard for Buddhists throughout southeast Asia. They were also transmitted by way of central Asia to China and Japan.

The source of this emigrant art was forgotten as it became naturalised. So too was Ajanta. For perhaps a thousand years the site was abandoned. Early in the nineteenth century the caves were dramatically rediscovered by some British officers of the East India

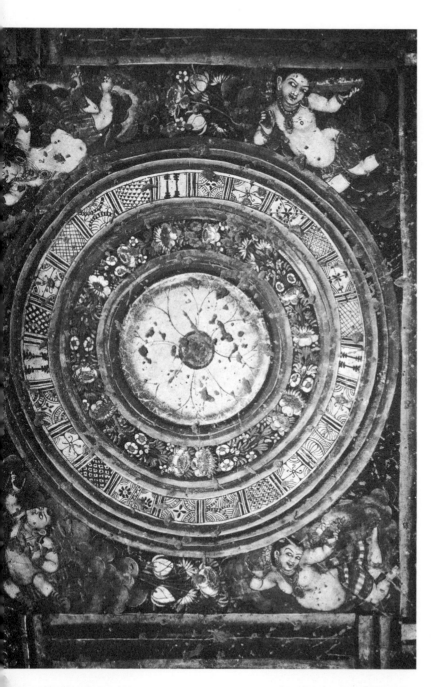

A section of the ceiling of the inner shrine of Cave 2. Unlike that in the previous illustration, where the ceiling corners are decorated with geese and flowers, this section contains sprightly and rather lush apsarases.

Right, the Buddha. The hands are held in a position known as the dharmachakra mudra, a gesture symbolising teaching.

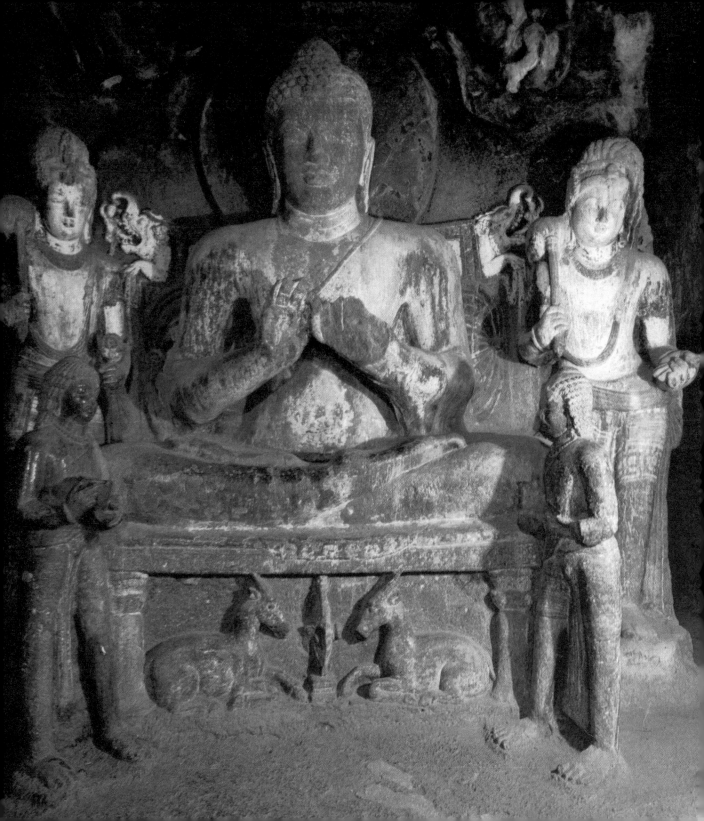

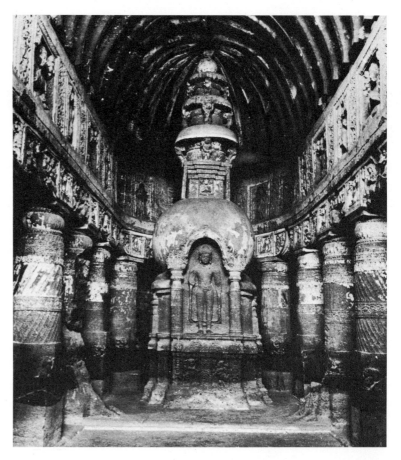

Chaitya *hall of Cave 19. After the extremely elegant façade of this cave (page 39), the main hall, in spite of its handsome carving, seems unsatisfactory. The pillars appear to crowd the space, and the dome of the stupa is so small that it looks no more than a canopy over the standing Buddha. The stupa itself is, however, very decorative.*

Company's army, though no systematic attempt to describe them was made until 1843. It seems that the wall paintings were then in relatively good condition, but the caves were at that time in the dominions of the semi-independent Nizam of Hyderabad and the state administration was not interested in preserving them. Heads cut out of the paintings were to be found on sale in Calcutta. Early in the present century attempts were made to protect the paintings and, unfortunately, to clean and restore them. The result is that today the paintings are probably in a much worse condition than they were a century ago. Less destructive methods of conservation have now been in use for some time and, despite the changes which the original colours have undergone, Ajanta, in all its aspects, remains among the greatest of the monuments of Buddhism.

Mamallapuram

The rulers of the Satavahana dynasty, who were responsible for the completion of the Buddhist stupas at Sanchi and the creation of the great carved gateways there, also inspired a somewhat different Buddhist art in the south. This dates roughly from the time at which the rulers were expelled from northern India. A number of stupas were constructed in the fifth century around the Kistna river, of which the most important was at Amaravati, where the style was influenced least by foreign ideas.

The style of Amaravati is preserved in a great many sculptural reliefs now in the British Museum, London, and the Government Museum, Madras. The stupa itself is in ruins and the area is shortly to be inundated with water as part of a great irrigation project. However, what remains of the sculpture of this and other stupas clearly reveals the debt owed to it by south Indian sculpture of the early medieval period. The essential difference between the art of Sanchi and that of the later Amaravati is to be found in the latter's almost frenzied sense of movement and dramatic character. In some of the reliefs, scarcely a straight line can be seen. Curves and rounded shapes give an immediate impression of rhythmic activity, and it is this–plus the dramatic content–which seems to lead directly to the Pallava style of Mamallapuram, a style which was to influence the art of Cambodia and Java as well as that of central and northern India.

The Pallavas ruled from about the end of the sixth century to the middle of the ninth, in an area which at one time included south Andhra (the region between and north of the estuaries of the rivers Godavari and Kistna) and most of the eastern Deccan. The main area of Pallava power was, however, centred on the country around present-day Madras and Thanjavur (Tanjore). The later Pallava kings constructed a large number of free-standing buildings, some of which still survive, but it is the remarkable series of rock-cut temples at Mamallapuram on the coast about 30 miles south of Madras which are of such importance in the history of Indian art. There, carved from outcrops of rock on the seashore are models of free-standing buildings which display the debt of Hindu temples to earlier Buddhist architecture and sculpture.

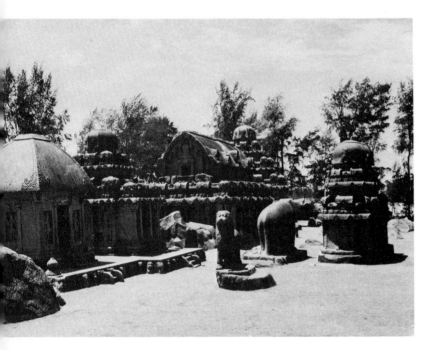

Though now deserted, Mamallapuram was a substantial city, created as a port for overseas trade by the Pallava ruler, Narasimhavarman I – called 'Mamalla,' the 'great fighter' – who reigned from *c.* 630 to 668. Today, a beach of white sand remains facing the deep blue of the Bay of Bengal, and separated from the mainland by salt water inlets; it is covered with carved and excavated rock. Nothing of the secular architecture of this once thriving seaport and important pilgrim centre has survived, because much of it was constructed of perishable materials. The foundations of the citadel can, however, still be traced. Inside were the palaces and administrative buildings, the wooden framework of which was filled in with brick and plaster. The city was well supplied with water. An extensive and sophisticated system drew water from the Palar river and distributed it through canals. The water was not only used for the obvious purposes of drinking and bathing. The remains of cisterns and conduits can be seen in some of the temples, and it seems reasonable to assume that water was used for ritual purposes. In fact, a popular belief in water worship has been suggested and the great sculptural relief of the Descent of the Ganges is said to be representative of it.

54

Above, the Arjuna ratha. *Work was abandoned before the lower storey was completed, and there is a crack running through the building. The figure on the right is of the god Indra, mounted on his elephant. The two female sculptures are probably two of the queens of the builder, King Narasimhavarman.*

Left, the so-called Pandava rathas, *beginning (on the left) with the* Draupadi, *then the* Arjuna, Bhima, *and* Dharmaraja; *on the right, next to the carved animals, is the* Sahadeva. *The Draupadi* ratha, *named after the wife of the heroes of the* Mahabharata, *is extremely simple in design probably because it is the only one dedicated to a female, the goddess Durga.*

Right, the Bhima ratha, *showing in the unfinished lower storey the technique used by the masons. The barrel roof is of the so-called 'elephant back' type and the roof terminates at either end in a* chaitya *hall shape, showing the debt to early free-standing Buddhist buildings.*

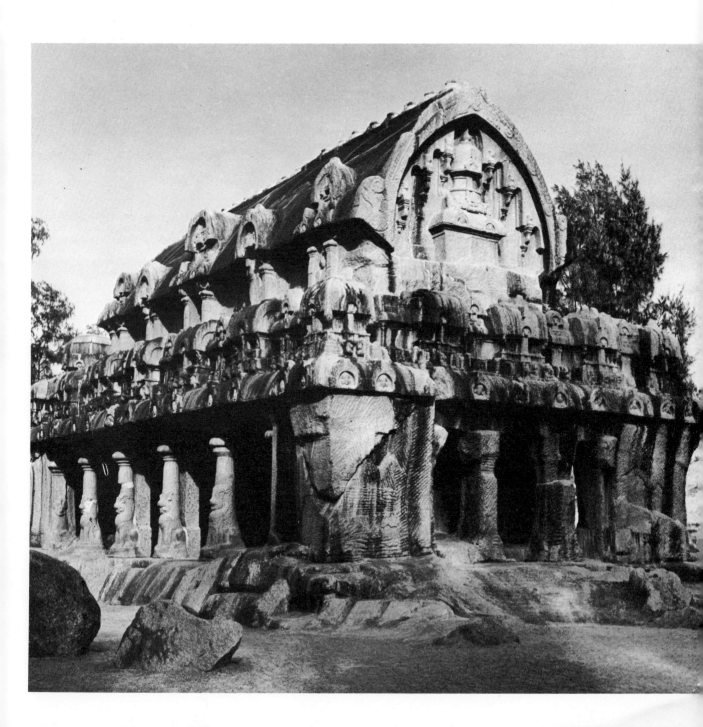

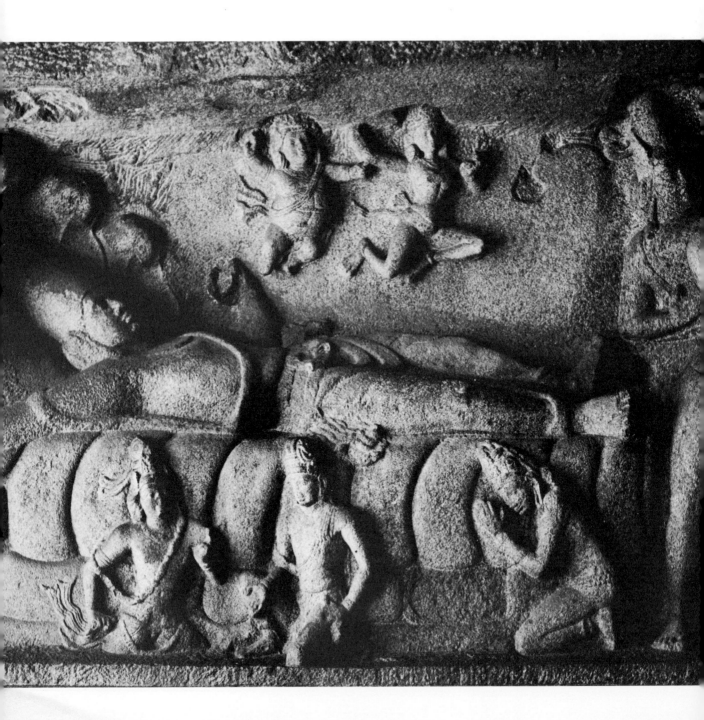

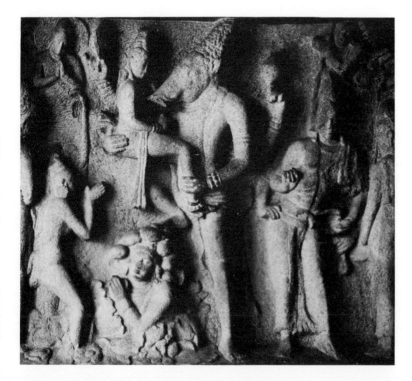

Opposite, the god Visnu reclining on the serpent Ananta, a wall relief in the Mahishasura cave temple. His consort, Laksmi, kneels with hands together at his feet. It seems highly probable that the relief was once finished off with carved plaster and painted in a variety of colours.

The Adi Varaha cave. Another manifestation of Visnu, this time as the Cosmic Boar (Adi Varaha). The god rescues the earth goddess from the king of the serpents. The goddess is almost human in size and – as in all reliefs at Mamallapuram – there is no attempt to overawe the worshipper.

The rock-cut architecture at Mamallapuram consists of ten excavated halls (*mandapas*) and eight monoliths (*rathas*). Of the latter, the most important are the so-called Pandava *rathas*. These were named after the heroes of the great Indian literary epic of the *Mahabharata* and their joint wife, Draupadi, some years after the *rathas* were constructed – the result, apparently, of a misunderstanding over the name of the town, which was interpreted as meaning 'city of heroes,' i.e. of the *Mahabharata*.

The first of these *rathas* is a simple shrine dedicated to the goddess Durga. It has a pilaster at each corner and the stone roof is carved in a semblance of thatch. It has been suggested that the shape of the shrine is based on that of an aboriginal hut. Alternatively, the prototype may have been a portable shrine, examples of which can still be found in south Indian villages. Whatever the origin, it is certainly meant to represent a common type of shrine. The base is, in fact, supported by figures of animals who give the impression that they are actually carrying a weighty burden.

Next to the Durga shrine (which is called Draupadi, after the wife

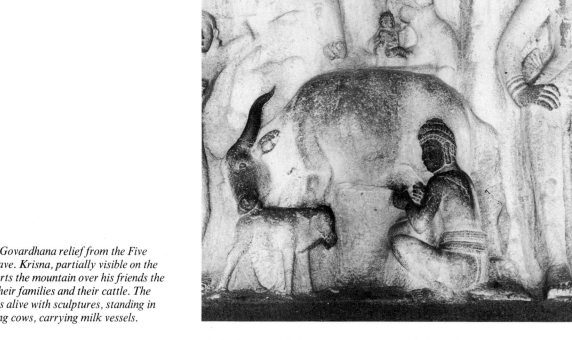

The Krisna Govardhana relief from the Five Pandavas cave. Krisna, partially visible on the right, supports the mountain over his friends the cowherds, their families and their cattle. The whole wall is alive with sculptures, standing in rows, milking cows, carrying milk vessels.

of the Pandavas) is a much more sophisticated version of the small shrine. This, the Arjuna *ratha*, is still a simple square structure but is covered with sculpture and has an elaborate tower, a kind of stepped pyramid, which can also be seen in an even more elaborate form on the Dharmaraja *ratha*. The peculiar shape of the tower has been the subject of ingenious explanations by art historians, one of which is that it represents a city wall with thatched lookout posts. A more likely origin lies in the shape of the monks' cells in early Buddhist monasteries. As the number of monks increased, more cells had to be provided, and this was done by adding a storey over a roofed courtyard. In time, this would produce something resembling a squat tower. The Dharmaraja *ratha*, which is a temple and not a hostel for monks, has naturally modified the purely functional design to a decorative one.

The Buddhist origin of the remaining *rathas* is particularly apparent in the Bhima *ratha*. This, with its rectangular shape and

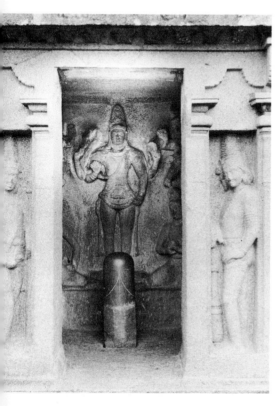

The Trimurti mandapa, *or cave. The sanctuary is dedicated to the gods Brahma, Visnu and Siva, but Siva appears as the principal deity and the others merely as manifestations of him. The god is shown carved from the rock of the rear wall and also in the form of the lingam. Offerings of water, milk and oil poured over it have given it a high polish.*

barrel roof, is quite obviously a survival of the Buddhist *chaitya* hall on which the rock-cut sanctuaries were based and which must have had a long life as a type of free-standing building. A development of this style can be seen in the later Baital Deul temple at Bhubaneswar in Orissa.

The *mandapas*, or cave excavations, of which there are ten at Mamallapuram, are not very large. None of them exceeds 25 feet deep and 20 feet high. The architectural features are simple and were designed to act as a frame for the sculpture so that the *mandapas* are really showcases for the sculptured panels and figures. The worshipper could leave the glare of the sun to look at the figures of the gods or representations of mythological scenes in the still well-lighted, but shady, *mandapa*. Though the architectural features are kept simple, they are exquisitely carved. Nevertheless, the emphasis was on the sculpture, and the façade of the temple was not allowed to distract the worshipper from it.

The temples of Mamallapuram are principally dedicated to the worship of the gods Siva and Visnu, who were particularly popular in south India when the temples were built. A wall relief from the Mahishasura *mandapa* shows Visnu reclining on the serpent Ananta. The whole is a symbol of water, with which the serpent in India is always associated, and Ananta floats on the cosmic ocean. The symbolism was all perfectly clear to even the simplest worshipper.

The serpent was only one of the many facets of the god's personality, and each had its symbolic form. In the Adi Varaha shrine, Visnu is shown as a boar. This scene, too, is connected with water, for in it the god, finding the young Earth menaced by the power of the king of the serpents, plunges into the cosmic sea and brings up in his arms the Earth Mother. The choice of the boar form is also significant, for it is a warm-blooded animal belonging, like that other warm-blooded animal, man, to the earth. It is also, however, familiar with water as it lives in swampy areas. The boar thus represents two of the characteristics of Visnu.

Another of Visnu's many facets is illustrated in a long relief which shows the god in the form of Krisna. This relief is crowded with cowherds, their families and their cattle, all sheltering from a thunderstorm under an umbrella which is actually a mountain held over their heads by the boy Krisna. The mountain is called 'Govardhana,' which means 'welfare of cows.' The story is a simple one. The boy Krisna has been sent to stay with cowherds in order 59

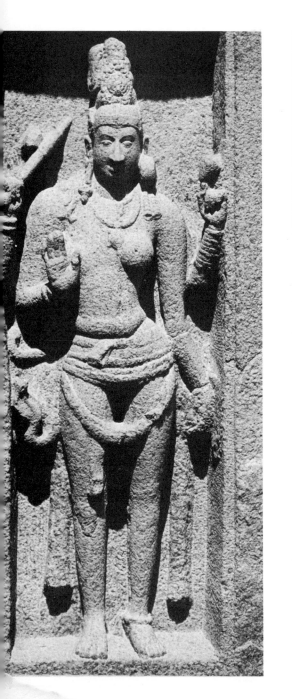

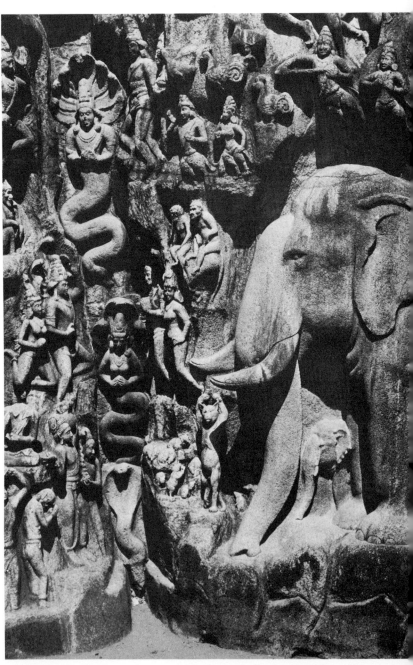

Far left, relief from one of the niches of the Arjuna ratha *showing the god Siva as half man, half woman (Siva Ardhanari). Usually, the two aspects of the god's nature – the male passive and the female active – are shown separately, but here they appear together to make it clear that they are indivisible.*

Left, detail from the Descent of the Ganges relief; the central cleft, showing the naga *(snake) king and queen ascending. The sculptor also included a cat, symbol of hypocrisy, pretending to be an ascetic and surrounded by credulous mice. It was a reminder that not all ascetics were genuine.*

Below, the Descent of the Ganges. This relief is sometimes, incorrectly, called Arjuna's Penance. Water from a concealed cistern originally flowed down the vertical cleft towards which all the figures appear to be moving. The sage Bhagiratha, who persuaded Siva to grant the boon of the river, appears left of the cleft, meditating before a ratha.

to protect him from a demon. While living among the people of the soil, Krisna persuades them not to make their customary sacrifice to the god Indra, suggesting instead that they worship the things which give them their livelihood – the woods and the hills, the fields and the cows. Indra, lord of the thunderbolt, is the old king of the gods and the thunderstorm is his wrath. But Krisna has challenged and is triumphant. Indra himself seeks reconciliation with the young saviour who has flouted him.

In effect, the story is a legend enshrining the birth of a new god, just as in Christianity Jesus superseded Jehovah. The parallel may be taken further, for Christianity developed as a religion of proletarian appeal, an anti-aristocratic religious revolt. So, too, did the worship of Krisna. Visnu and Siva acquired class connotations, and each came to summarise all the old cults and claimed to be the supreme god. At Mamallapuram, they coexisted in one sacred area, the division between them not yet a cause of conflict. Indeed, Mamallapuram is in one sense an attempt to avert such conflict. In later times, however, Siva worship became identified with the

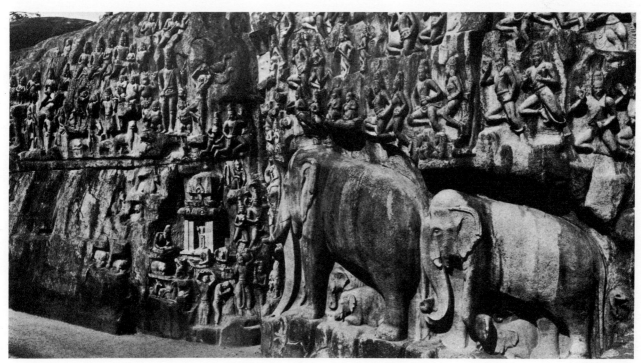

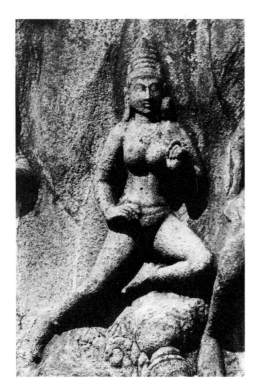

A flying goddess, detail from the Descent of the Ganges relief. All the figures in the relief are lively and elegant. They are exaggeratedly slim and their clothes are so diaphanous as to be barely visible. On their heads, they wear high crowns.

aristocratic and landowning classes, while Visnu, in his personification as Krisna, became the god of the workers, the peasants and the producers.

At Mamallapuram, the two great gods have their separate places. The *rathas* are dedicated to the worship of Siva, most of the *mandapas* to Visnu—but not all. In one, the Trimurti *mandapa*, dedicated to the orthodox trinity of gods who divide between them the rhythms of the universe—Brahma the creator, Visnu the preserver, Siva the destroyer—Siva appears as the principal deity and the others merely as aspects of his nature. As the illustration shows, the supreme god is represented not only as a figure but as his symbol, the lingam or phallus, the most simple and recognisable image of the generating process. The human form of the god stands out brightly from the back wall of the shrine, a mask representing one of his many faces. The lingam, rigid and silent, crystallises the god's fundamental essence. On either side of the entrance are two guardians, elegant, graceful young men who are hardly guardians at all but worshippers who have been caught up in the delight of the gods. This almost trance-like wonder is one of the principal characteristics of the Pallava style.

The greatest sculptural achievement at Mamallapuram, however, is not found in the *mandapas* or in the decoration of the *rathas*. It can be seen in the carving on two enormous boulders and is usually called the Descent of the Ganges. This great relief is in the open air, in the full light of the sun. There is no mystery but a tremendous sense of activity as scores of figures move towards the central cleft, down which water flows from a cistern at the top.

As always in the interpretation of Indian art, art historians disagree over the details of the story told in this magnificent relief. The most acceptable version is that it represents the successful attempt of the pious king Bhagiratha to persuade Siva that the life-giving waters of the river Ganges should be permitted to descend to earth, after the south Indian saint, Agastya, had swallowed the entire sea and left the earth and those living on it without water. Agastya had simply intended to help some ascetics harassed by demons who, when chased, escaped into the sea. This good deed with evil results had to be corrected and Bhagiratha, by incredible austerities, first persuaded Brahma to agree to allow the Ganges to come down to earth. But if the river of heaven were to fall directly on the earth, the tremendous weight of water might shatter it. Only Siva could break its fall and, after further austerities, Bhagiratha induced him

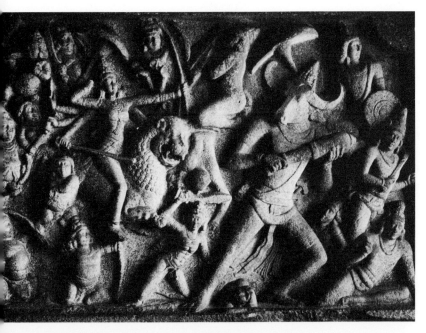

The goddess Durga killing the buffalo demon. Wall relief from the Mahishasura cave. This relief occupies the wall opposite that showing Visnu on the serpent (page 56). The scene, though it tells a story of almost brutal drama, is as gentle and restrained as all Pallava sculpture. Yet there is no loss of vigour, and the figures of the goddess seated on a lion and the surrounding gods sweep irresistibly forward.

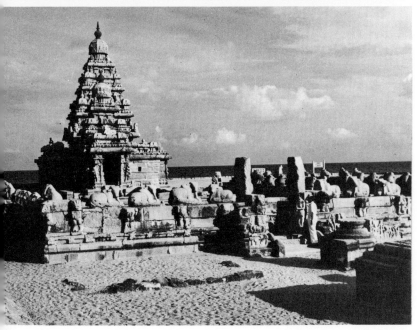

The Shore Temple. Unlike the rathas, *this is a structural building. Around the containing wall are statues of reclining bulls. The main temple is dedicated to Siva and the bull represents Nandi, the god's mount. The smaller structure in front is not a porch but a separate temple dedicated to Visnu.*

63

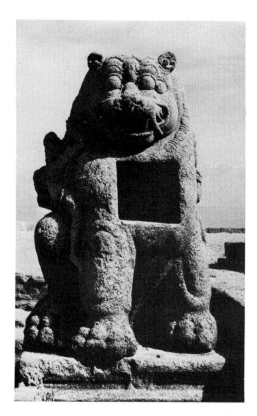

Figure of a lion by the side of the Shore Temple. Riding on both sides is the goddess Durga, and on the hind legs, attacking the lion, is the buffalo demon, Mahishasura. This is an echo of the subject of the wall relief illustrated on the previous page. The square hole in the lion's chest was intended to contain a lamp.

Opposite, the towers of the Shore Temple.

to co-operate and let the river fall on his head. The matted hair of the god broke the rush of water, and the river descended gently to the Himalayas and thence to the Indian plains. The myth both directs the attention of the believer to the divine nature of water and to the fact that the great gods can only be influenced by the psychic energy that comes from the long endurance of self-inflicted suffering.

The representation of the myth at Mamallapuram is a continuous narrative. The episodes converge from left and right on the central cleft in which the river flows to earth. There, a giant serpent king floats up the torrent, his face set in rapt devotion as is that of the serpent queen who follows him. There are other deities of the water, and on either side crowd all the living things of the world who have come to watch the saving of their world. Bhagiratha is shown twice. At the bottom of the central panel of the carving, he sits before a typical Pallava shrine; here he is meditating in order to gain the assistance of Brahma. The second time, the sage is shown in an upright yoga position and next to him is Siva. These two episodes, though shown close together, take place at different times and in different places. Here can be seen the Indian concept of the continuity of events rather than their division by time and space.

The sculptural treatment is calm; there are no mysteries or horrors, no dramatics or violent effects, only serenity and repose. Even the animals seem quiet and lost in bliss.

With the death of Narasimhavarman around 680, work on the *rathas* and other sculptural undertakings stopped. His successor, Rajasimha, built only structural buildings. One of these, called the Shore Temple, stands on the beach not far from the Descent of the Ganges relief. The terraced spires are an obvious development of the Dharmaraja *ratha*. The treatment, however, shows an attempt to break away from the prototype and think in terms of architecture rather than of carving. There is, consequently, a new sense of lightness. The temple, which probably dates from the early eighth century, is surrounded by sculptures, of Nandi the bull, mount of Siva, in rows on the tops of walls, as well as many others. Perhaps the most significant is a rampant lion pilaster which suddenly appears in Pallava art. From the Shore Temple it became one of the most prominent characteristics of the later Pallava style.

The Pallava kings continued to construct temples at other sites which were to have considerable influence on later south Indian art. But at none does the sculpture reach the heights of that at Mamallapuram.

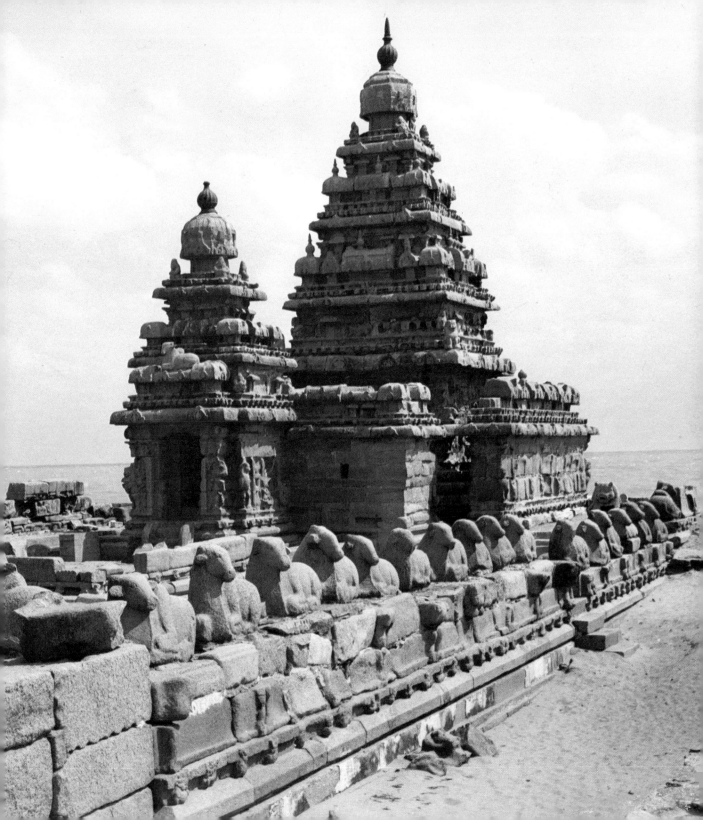

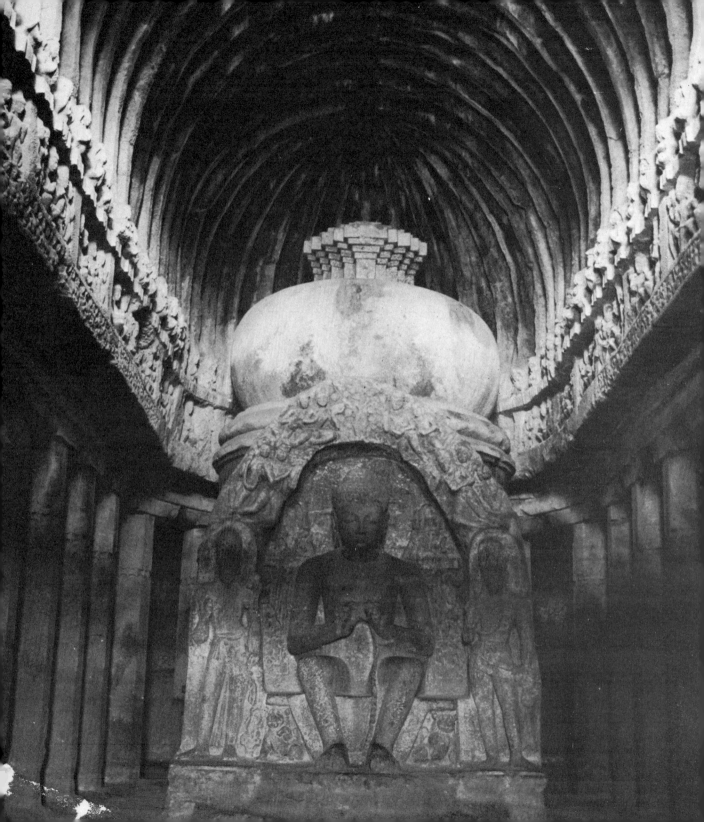

Ellura

Though by the seventh century AD the building of free-standing temples in stone was well established in some parts of India, the interest in rock-cut sanctuaries continued until at least as late as the tenth century. At Ellura, not far from Ajanta, there are 34 caves – some Buddhist, some Jaina, and some Hindu – which are examples of the last phase of this form of construction.

The Buddhist caves are twelve in number and date from perhaps the late fifth to the eighth centuries. Though contemporary with the later caves at Ajanta, they show a certain decline in some of the architectural features. This can best be seen in the façade of Cave 10. This cave – known as the Visvakarman, after the god of the arts – is the latest of the *chaitya* caves in western India. A distinctive feature of the façades of Buddhist rock-cut sanctuaries is the 'sun window.' The conventional window is shaped like an extremely large horseshoe. It was more than just a device for letting in light. Over the centuries it had become a special component of the architecture appropriate to the worship of the Buddha. At Ellura an attempt was made to break away from the convention. The horseshoe window is small and has another window below it divided into three sections which look clumsy and certainly take away from the entrance a great deal of the monumental impressiveness which characterises the more traditional style.

Of the Buddhist caves, that known as the Tin Thal or 'three-storeyed' (Cave 12) is perhaps the most magnificent. It was carved in three stages. The first is entered by a short flight of steps through a plain façade which is nevertheless impressive. This austerity, which leaves the visitor unprepared for the wealth of sculpture that decorates the interior, is maintained in the entrance, where of the eight square columns supporting the roof only two have carvings, and these of a delicate, formal, floral design known as 'vase and foliage.' The body of the cave is decorated with sculptured wall panels, and from the south end a staircase leads to the first floor.

On the landing is a room containing figures of the Buddha and the Bodhisattva Avolikitesvara Padmapani surrounded by attendants. The stair goes on up to the second floor but does not, at this point, continue to the top storey. To reach the top, it is necessary to cross a large hall – over 100 feet long – divided into three aisles by

Window arch from the façade of Cave 10. This cave – called the Visvakarman, after the god of the arts – dates from c. 700–750 and is one of the most magnificent of the rock-cut sanctuaries of Buddhism, as well as the latest to be constructed. Tantrik influence is probably shown by the amorous couple in the centre medallion.

Opposite, the chaitya *hall of Cave 10, Ellura. The cave is carved in imitation of wooden structures and this is particularly obvious in the ribs of the ceiling. The huge figure of the Buddha is carved in a separate piece of rock which stands before the three-tiered stupa.*

67

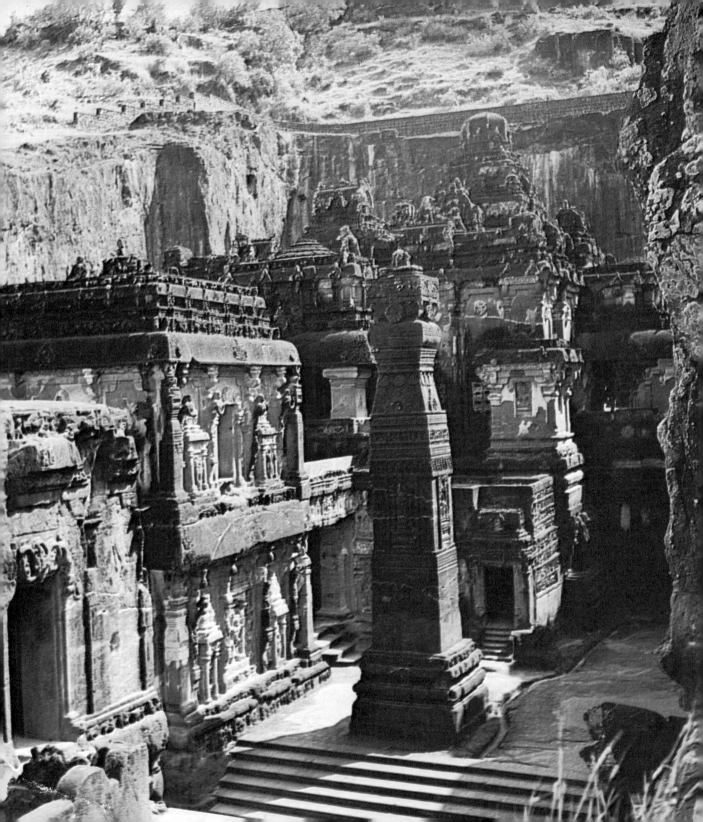

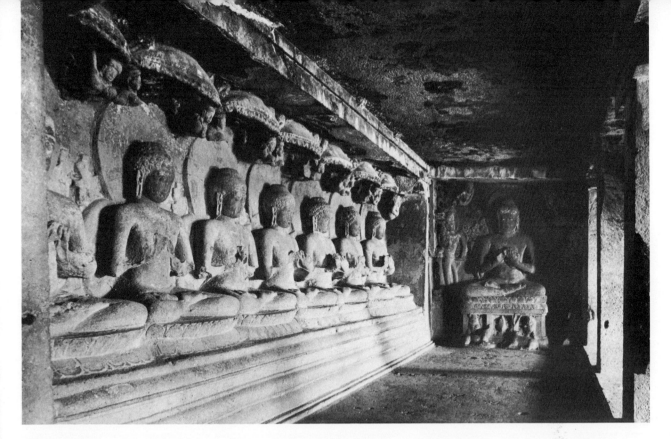

rows of pillars. The top floor, which was being sculpted by the Buddhists when the Hindus were engaged in building the nearby Kailasanatha temple, is one of the most impressive parts of Ellura. The hall is supported by 42 pillars, all square and plain. In the recesses at the end of the aisles formed by the pillars are figures of the Buddha on stately thrones, attended by Bodhisattvas and other celestial beings. The figures of the Buddhist saviours are repeated in various parts of the cave in such a way that their silent presence seems to invest the entire area.

While the last Buddhist caves were being excavated at Ellura, the Hindus began to make rock-cut temples for their own use. Until this time, though rulers might be Hindu—as, for example, were the Guptas—they were usually tolerant of all faiths. But during the reign of the Rashtrakutas (AD 753–973) a more aggressive attitude seems to have emerged. Cave 15, known as the Das Avatara (the 'ten avatars' or incarnations of Visnu), seems originally to have been a Buddhist *vihara* and the first storey was enlarged by destroying the monks' cells. Cave 15 contains one of the most interesting examples of what can be called a transitional style, emerging out of that of the Guptas and anticipating that of the full flowering of medieval Hinduism. The sculpture illustrated here of Visnu as a

Cave 12, known as the Tin Thal, or Three-Storeyed. The cave dates from the same time as Cave 10. On the east wall of the third floor sit seven Buddhas in teaching posture, their heads shaded by umbrellas symbolic of their power. In the far niche sits the historic Buddha teaching in the Deer Park, site of the First Sermon.

Opposite, view of the Kailasanatha temple with the shrine of Nandi on the right.

69

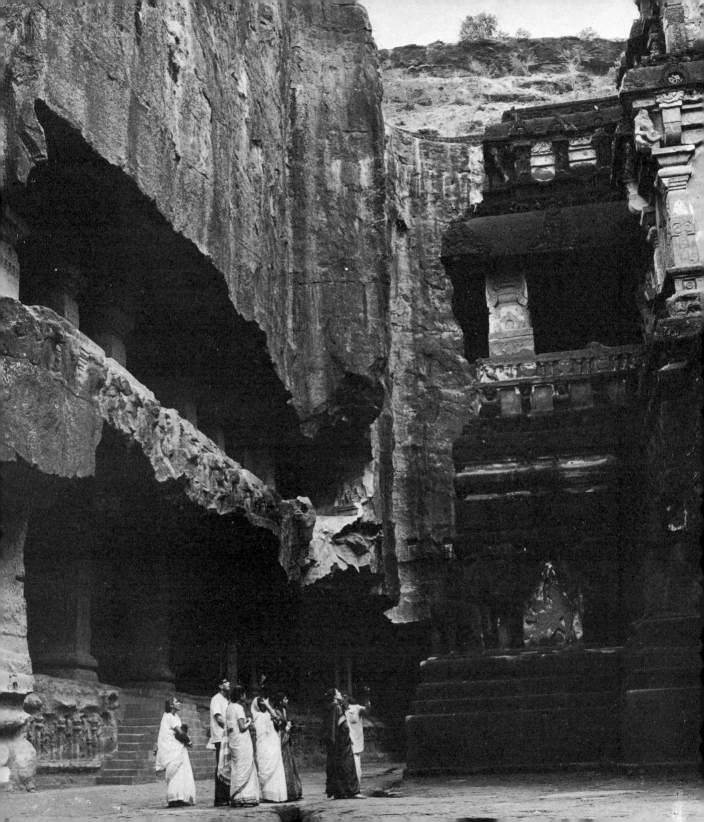

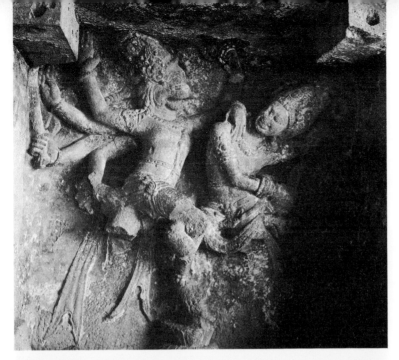

Wall relief from Cave 15, c. 700–750. This cave is Hindu and is known as the Dasavatara, or Ten Incarnations. The relief shows Visnu as Narasimha, the man-lion, attacking the tyrant king Hiranyakashyapu.

Flying figure from Cave 16, the Kailasanatha. The sculpture shows the same elegant vitality as that in Cave 15 (above) though it is somewhat later in date.

Opposite, Kailasanatha temple (Cave 16). The closeness of the main temple to the surrounding rock, in which caves are cut, can be plainly seen. So, too, can the animals (elephants and lions) which appear to be supporting the weight of the temple upon their backs.

71

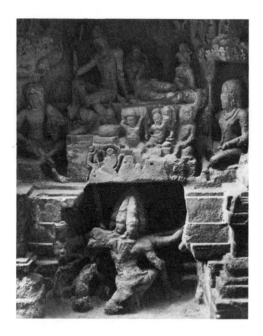

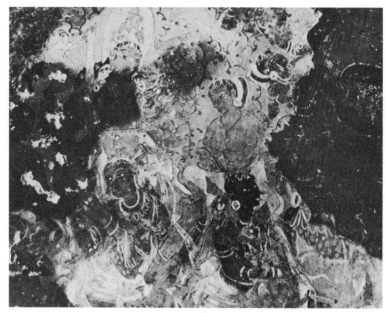

Above, the demon Ravana shaking Mount Kailasa, Kailasanatha temple. This immensely theatrical subject, in which the demon imprisoned under the sacred mountain shakes it, is dealt with in a most undramatic way, yet the calmness of the treatment only underlines its message – that good cannot be upset by evil.

Above right, painting from the porch of the Kailasanatha temple. The underside of the porch roof still bears remnants of mural painting, dating probably from the ninth or possibly tenth century. This one shows the god Visnu and his consort, Laksmi.

Opposite, northwest corner of the Kailasanatha area, the so-called Lankesvara cave. The large figure on the left is a door guardian. In the niches inside the porch are statues of the goddesses of the sacred rivers.

man-lion attacking the tyrant king Hiranyakasyapu is still, like the sculpture at Ajanta, contained within a frame – but only just. The whole sculpture appears to be about to burst out of the formal restrictions. Both the figure of Visnu and of the king are turned outwards towards the observer. An over-riding sense of drama or, more properly, of dance-drama prevails. During the Gupta period, there was a highly developed style of dancing, known as Bharat Natyam, which has been preserved in south India to this day. The language of the dance was transferred to sculpture. It is significant that the earliest Indian manual of aesthetics, the *Visnudharmottaram*, which probably dates from Gupta times, states that only with a knowledge of the dance is it possible to display emotions. The paintings at Ajanta contain a wide variety of gestures and poses which give the impression of a dance. So, too, does some of the sculpture at Ellura. In the relief in Cave 15, the god and the king are engaged in dancing a *pas de deux*. The same dance effect can be seen in the flying *devata* from the Kailasanatha temple.

The Kailasanatha (probably erected between 760 and 800) is not a cave, but the very opposite, a mound of stone hewn out of the solid rock. Into the mountainside two great trenches were dug and joined, so that a monolithic block of stone – over 200 feet by 150

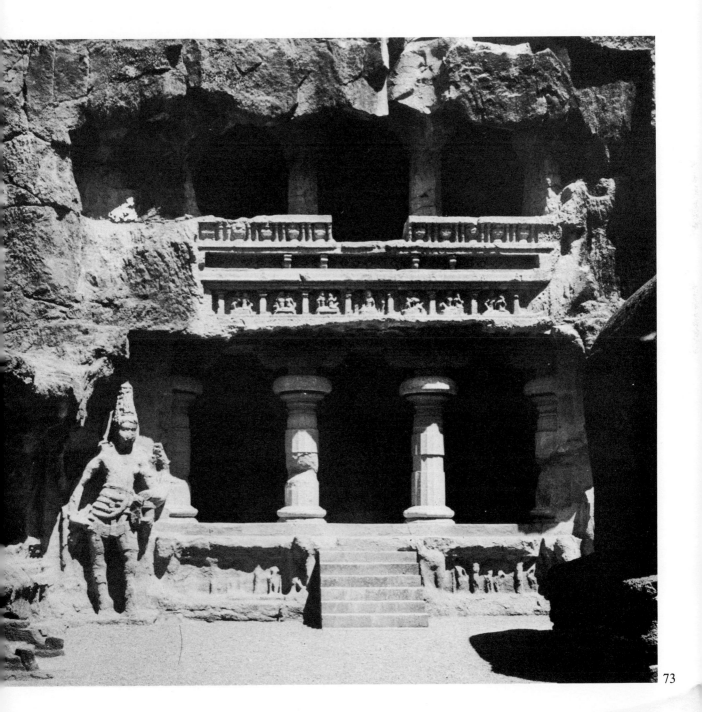

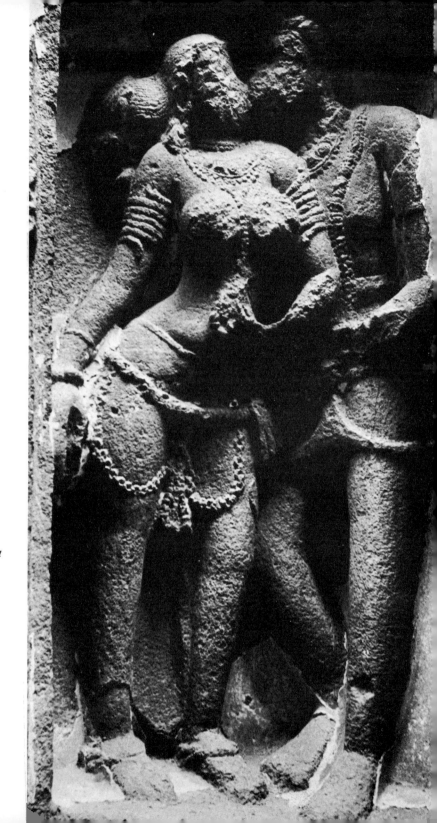

Sculptured man and woman from the Kailasanatha. Around the temple there is a great deal of erotic sculpture illustrating the various types of embrace listed in the manuals of sex.

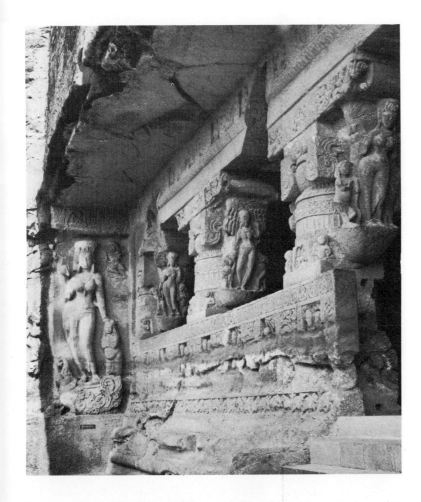

Veranda façade of Cave 21 (Ramesvara), eighth century. The figure on the left represents the goddess of the sacred river Ganges. The sculptor has given the goddess a most graceful pose, but the dwarf, on whose head she rests her left hand, seems barely able to take her weight.

feet in outline, and 100 feet high – was left at the bottom of a deep pit. From this block, the temple was carved. The operation was carried out from the top downwards, making scaffolding unnecessary. Though the model for the Kailasanatha was undoubtedly a free-standing building such as the Dharmaraja *ratha* at Mamallapuram, the technique of carving downwards led to some unavoidable deviations. The Kailasanatha remains, like the caves, an example of sculpture rather than of architecture. As such, it is probably the most impressive single work of art in India. Photographs cannot do justice to the whole composition. Rock masses form not only the main temple but also two immense free-standing columns and a

life-sized carving of an elephant. Bridges connect the temple itself with halls and shrines cut into the walls of the pit.

The temple is dedicated to the Hindu god, Siva, and is intended as a replica of the god's home in the Himalayas, Mount Kailasa, the Olympus of the Hindus. The god himself is represented in the innermost sanctuary by a giant lingam. The whole composition is a statement of resurgent Hinduism and, in effect, this glorious temple is the symbol of victory over Buddhism.

The fact that the Kailasanatha stands in a pit, the sides of which throw shadows, posed certain problems for the designer. One of these he solved by placing the temple on a very tall base. Standing high on this base is the temple proper, its various shrines cut out of the solid rock. But the bright sunlight and the dark shadows produce a very special effect, increasing the feeling of movement in the sculptured friezes and intensifying the sense of mystery.

The temple is approached through a screen and the shrine to the mount of Siva, the bull Nandi. This shrine, about 50 feet high, is connected with the main temple by a bridge. The screen, which is a gatehouse with accommodation for the keepers, is joined by a bridge to the Nandi shrine.

Perhaps the most spectacular feature of the Kailasanatha is the carved base of the main shrine. This consists of lions and elephants, life-size or larger, very deeply cut into the stone. At first sight, and in most photographs, they appear to be quite statically holding up the massive structure above them. But in parts of the frieze lions and elephants are engaged in fighting so viciously that it appears they might, in their anger, bring down the whole structure.

Inside the temple itself, there is a sculptured representation of an attempt to bring down the sacred mountain and, with it, the god Siva himself. This, probably the most famous and certainly the most frequently reproduced of the Kailasanatha sculptures, tells the story of the great demon Ravana. A constant enemy of the gods, Ravana has been imprisoned in the underworld and is held there by the weight of Mount Kailasa. In the relief, he is shown trying to break free by lifting the sacred mountain with the strength of his 20 arms. He succeeds in shaking the mountain, and Parvati–consort of Siva–grasps the god's arm in sudden fear. But Siva is totally un-moved and, with the pressure of his toe, crushes the demon. The god is shown as absolutely secure in his power over evil. No assault, even the superhuman one of Ravana, can succeed. The purpose of 76 the relief is undoubtedly to state the proposition that Good will

Sculpture from Cave 33. The cave is part of the Jaina group and dates from the eleventh century. There is some controversy as to the subject of this relief, but it seems most likely that it represents the goddess Siddhaiki.

always triumph over Evil in the most dramatic way. The whole of the action takes place in a box some eight or nine feet deep, and displays once again the close connection between the dance and sculpture in medieval India. There is something of the quality of the Descent of the Ganges relief at Mamallapuram in the treatment of the figures and, despite undoubted Gupta influences in the stylistic treatment, the whole relief displays the supreme flowering of the south Indian imagination.

When the Muslim invaders reached Ellura during their conquest of the Deccan in the sixteenth century, they referred to the Kailasanatha as the 'Rang Mahal,' which means painted palace. It would seem, therefore, that at that time the temple was painted. The whole

Interior of Cave 32, with the goddess Siddhaiki. Another Jaina cave, sometimes known as the Indra Sabha because of the mistaken identification of the Jaina god Matanga with the Hindu god Indra; both are normally shown mounted upon an elephant. The highly complicated carving of the pillars suggests the delicacy of ivory carving.

of the structure was probably covered with a bright white gesso, so increasing the resemblance of the spires to the snow-capped peaks of the real Mount Kailasa in the Himalayas. Traces of several layers of thin plaster still remain on some of the sculptures, which were probably polychromed. Some art historians have also suggested that the details of the figures were finished off with a kind of stucco.

In the ceiling of the temple portico are a number of paintings which may date from the ninth or tenth century, and there are others in the main hall. These paintings are very different from the ones at Ajanta. Though the composition and colouring resemble the earlier style, the features of the gods are no longer round and elegant, but sharp, with beaked noses and bulging eyes. Here can be seen the beginnings of a style which came to fruition many years later in the Jaina miniature paintings of Gujarat.

Of the shrines surrounding the great mound of the Kailasanatha, one of the most beautiful is that of the Three Rivers. The shrine is carved out of the rock wall and contains, in three niches, sculptures of the goddesses of the three sacred rivers of Hinduism, Ganges, Jumna and Sarasvati. The background in each of the niches is carved with lotuses, water flowers, vines and creepers. The carving is deep, and the swirling of the foliage gives the impression of movement, as if the goddesses were emerging from the rivers which they symbolise. The figures themselves are cut so deeply that they are almost detached from the background–another example of the highly sophisticated use of light and shade which is characteristic of the finest work at Ellura.

A short description and a few illustrations cannot do justice to the tremendous wealth of sculpture contained in the Kailasanatha. Even today, enough of the glory remains to justify the claim made in a surviving copper-plate inscription of the reign of Krishna I:

Krishnaraja caused to be constructed a temple of wonderful form on the mountain of Elapura [Ellura]. When the gods moving in their aerial cars saw it they were struck with wonder and constantly thought of it, saying to themselves: 'This temple of Siva must have created itself, for such beauty is not to be found in a work of art.' Even the architect who constructed it was struck with wonder. His heart failed him when he considered building another like it, for 'how is it possible that I built this except by magic?'

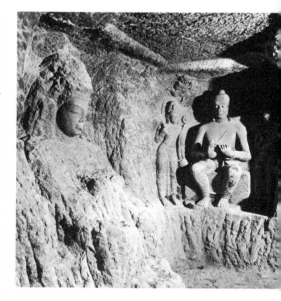

The technique of carving. An unfinished corner of the north gallery of Cave 2 shows how the stone was first crudely roughed out. After this, the sculptor would mark and then finish the face. It is probable that one workman was responsible for faces while others completed the rest of the figure.

Right, the sanctuary of the Jaina Tirthankara Mahavira, Cave 32. On either side of the door are guardians, on the left Matanga and on the right Siddhaiki. The somewhat stiff and massive images are characteristic of Jaina sculpture.

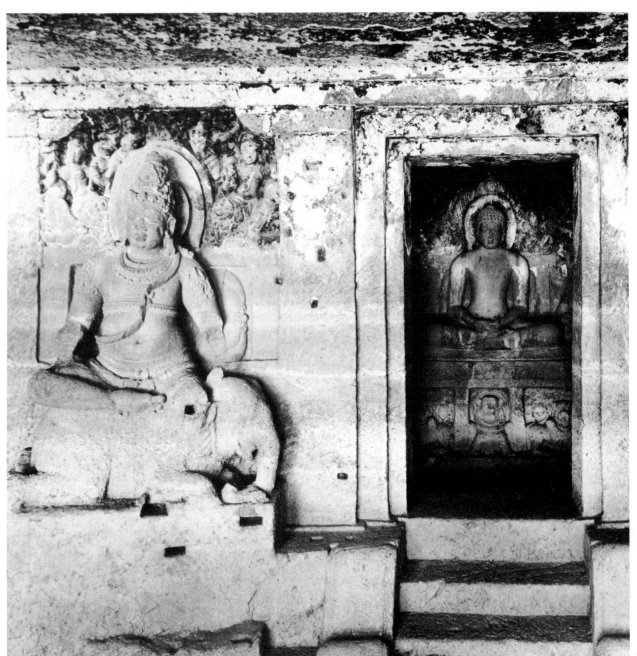

79

The late Buddhist and Hindu caves at Ellura, and of course the Kailasanatha, convey a tremendous sense of the divine in the figures of the gods. They are aloof and spiritual. The sculptors' treatment is not 'realistic,' and for all the solidity of the stone in which they are carved the figures give the impression that they are merely appearances, insubstantial visual projections of the gods' presence. This technique, which began in Gupta times with figures of the Buddha, at Ellura becomes the dominant characteristic of the Hindu conception of the form of the gods. It is all the more surprising that the sculpture of the Jaina caves at Ellura, dating from the ninth to as late as the eleventh century, shows no trace of this development. The figure sculpture is heavy and lacks vitality.

The group of Jaina caves is set a little apart from the others. There are five, but only three have any real interest. One of these (Cave 30) is a copy, on a smaller scale, of the Kailasanatha. In reducing the size to about a quarter, the Jaina version has become dumpy. The smaller area is crowded with sculpture, which is out of scale with its surroundings. Cave 32, known as the Indra Sabha, is much more interesting, though here too the figures are inclined to be ponderous. This cave does, however, give proof that the normal method of excavation was to work downwards from the ceiling, since the top storey of the cave is completed while the bottom one is only roughed out.

All the Jaina caves at Ellura show considerable craftsmanship and effort. The intricate decoration of the columns and walls has all the meticulous detail of fine ivory carving, a style which was to become the dominant characteristic of later Jaina temples. But there is a lack of overall design, so that individual works, sometimes of very high quality, do not fit harmoniously together. Particularly after the Hindu caves, there is something lacking in the Jaina ones. The decorations are elegant and the craftsmanship of a high order, but essentially lifeless and cold. Even the naturalism of the figures of the Jaina saviours (impressive as they are, standing naked and upright) is rigid and unfeeling.

With the Jaina excavations at Ellura, rock sculpture in India was virtually at an end. Developments in building technique meant that man could erect his sacred mountain in the open air instead of tunnelling into the living rock. The art of the sculptor came out into the sunlight, and though it gained in beauty it lost the mystery of dark corridors and dim-lit sanctuaries which, for nearly a thousand years, had prepared worshippers for the fearful majesty of the gods.

Detail from the tower of the Rajrani temple (page 94).

Bhubaneswar

Just as Mamallapuram is characteristic of the medieval south Indian or Dravidian style, so Bhubaneswar is of the north Indian or Nagara style. Bhubaneswar is in the state of Orissa in eastern India. It is a city of temples dedicated to Siva, and its name means 'Lord of the World.' According to tradition, the site once contained about seven hundred temples. Most of these have disappeared, if, in fact, so many ever did exist. The surviving temples date from about the middle of the seventh century to the middle of the twelfth. There is little agreement among scholars about the rulers, or even the dynasties, responsible for the construction of the principal temples, but most were probably erected by rulers of the Kesari dynasty, which ceased to rule in the middle of the eleventh century, and by those of the Ganga dynasty which succeeded it.

A considerable body of writings, known as *sastras*, survives from this period. These were in effect builders' manuals containing the most precise instructions for every detail of construction, but they also dealt with such important matters as the choice of site, the special types of buildings suitable for the worship of particular gods, and the correct form of magical rituals to be observed when laying out the plan. The choice of site was sometimes governed by the pre-existence of other shrines and a tradition of pilgrimage to them. When such an obvious site qualification was not available, one was invented.

According to legend, the site at Bhubaneswar was originally a great forest of mango trees, an object of worship in very early times. The god Siva, discouraged by the presence of so many unbelievers, made up his mind to leave Benares (now called Varanasi). A sage advised Siva to move to a mango forest, already sacred to the god Visnu. Siva, approaching Visnu, received his permission to settle there on condition that he never returned to Benares. When Siva explained that he could not cut himself off from Benares, full as it was of temples and sanctuaries, Visnu pointed out that everything that distinguished Benares was also to be found at the new site. So Siva, in the form of the lingam, stayed at Bhubaneswar. The lingam can be seen at the Lingaraja temple. Most legends betray at least a modicum of truth, and the tale of the origins of Bhubaneswar probably indicates that the worship of the god Visnu was estab- 81

I.T.—4

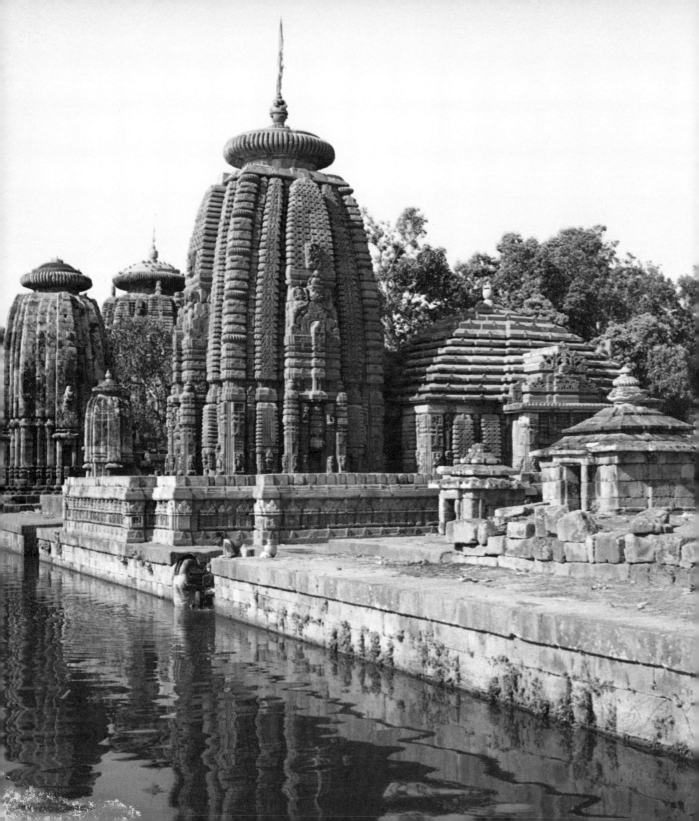

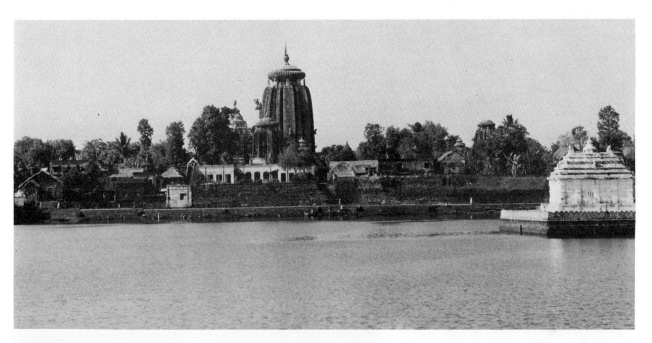

Above, the Sacred Pool, with the Lingaraja temple in the background. The pool measures over 1,200 feet by 650 feet. In the centre, seen to the right of this illustration, is a small island on which there is a sanctuary dedicated to Siva. Once a year, an image of the god is immersed in the water.

Opposite, the Mukteswar temple beside the Sacred Pool.

The Parasurameswar temple, c. 750. This temple is roughly contemporary with the great Kailasanatha temple at Ellura. The relief of Siva and Parvati on Mount Kailasa, with the demon Ravana immured below, tells the same story as the relief at Ellura (page 72).

Two reliefs from the Parasurameswar temple. In the upper panel are dancers, and in the lower, musicians playing the flute, cymbals and drums. The panels are actually grilles situated at one side of the west doorway. Like the rest of the sculpture, they are particularly fine.

Opposite, the Baital Deul temple. This building has much in common with the Bhima ratha *at Mamallapuram (page 55) and is derived from free-standing Buddhist architecture. In the centre of the face is an adaptation of the* chaitya *arch with the window area in the middle here filled by a piece of sculpture.*

lished on the site and that the 'invitation' to Siva was an attempt to harmonise the rival cults of the two gods. The accusation that Benares was thronged with unbelievers may well have been designed to enhance the importance of the new centre of pilgrimage in opposition to the old.

The earliest example of the north Indian architectural style at Bhubaneswar is the Parasurameswar temple, dated *c.* AD 750. The temple is small, the entire length being only 48 feet and the height of the tower 44 feet. The porch is angular and four-sided, rather like a primitive cell. The walls are pierced with low latticed windows, and decorated with reliefs of dancers. The two parts of the building appear oddly unrelated. The squat, heavily horizontal porch does not join the tower satisfactorily. It has been suggested that the porch and the tower were erected at different times, and this may be true, though there is no way of telling which of them was built first. The tower over the sanctuary still retains the feeling of a horizontal rather than a vertical building, with its flat slab-like layer effect. But the stone, which ranges in colour from orange through red to purple, is covered with small carvings, and the general effect is not that of architecture but of sculpture, which reduces the heaviness of the structure.

The other temple of the early phase is the Baital Deul, which is probably a little later than the Parasurameswar. Here, a very different architectural tradition is immediately obvious. Except for a miniature structure of vaguely similar style in front of the Mukteswar temple, there is nothing else like it at Bhubaneswar. Stylistically, the Baital Deul resembles the form of the Bhima *ratha* at Mamallapuram, and its prototype is undoubtedly the Buddhist *chaitya* hall. Whether the architect's inspiration came from south India cannot be proved, but it seems more likely that the design is a product of purely local Buddhist traditions. Again, like the Parasurameswar, the Baital Deul is a comparatively small structure. The ground plan is only 18 feet by 25 feet, and the tower is about 35 feet high. The porch is also of unusual design; it is rectangular in shape but has a small shrine embedded in it at each corner. These are miniature versions of the tower of the Parasurameswar temple.

The general characteristics of Orissan architecture, which are only vaguely discernible in the Parasurameswar temple, can be seen at their most attractive in the Mukteswar temple, which dates from about AD 950. Most art historians agree that this is the finest of all temples in the northern style. The uninhibited eye would

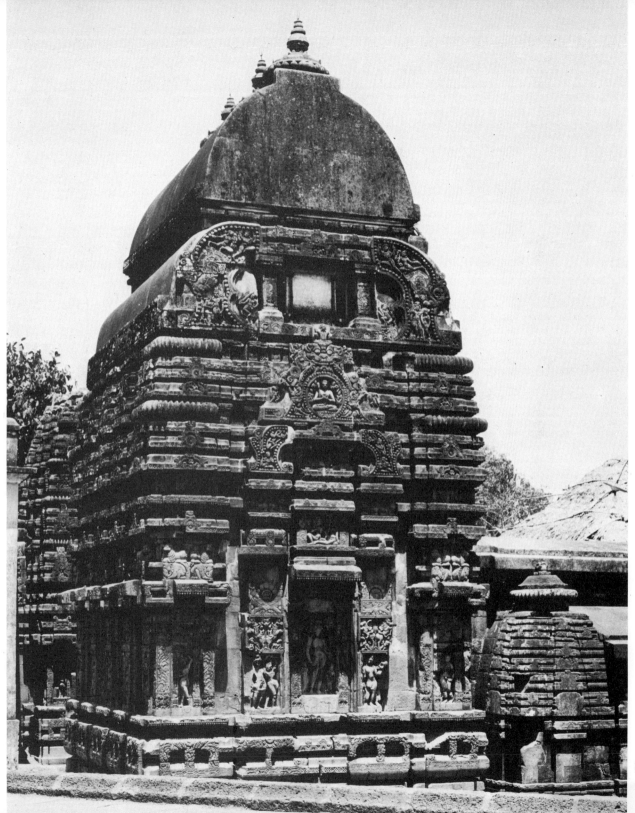

85

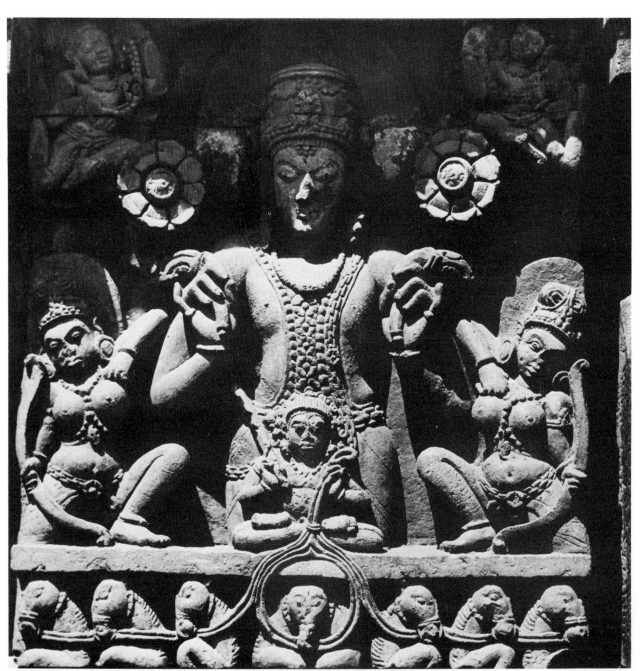

Opposite, the sun god, Surya, from the Baital
Deul temple. The god, holding a lotus in each
hand, sits in his chariot drawn by seven horses.
His charioteer, the god of dawn, sits in front,
and behind Surya's head is the disc of the sun.

An apsaras from the façade of the Baital Deul
temple. One of a series, she holds in her right hand
a lotus flower. Others hold a mirror as they
apply cosmetics, or listen to a parrot telling a
love story.

*Siva as lord of the dance (Siva Nataraja).
Mukteswar temple. When the god performs the
cosmic dance, it is believed that the universe
consists of the light flashing from his limbs.
Surrounding the sculpture are* chaitya *arch motifs.*

*Opposite, window of pierced stone from the
Mukteswar temple. This building is about two
hundred years later than the Parasurameswar
and Baital Deul temples and displays
considerable sophistication, both in construction
and in its sculpture. The window frame is alive
with monkeys, naturalistically portrayed.*

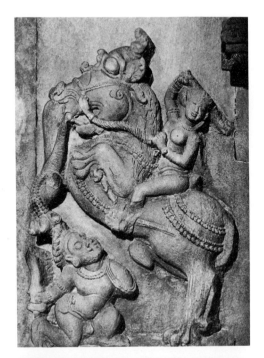

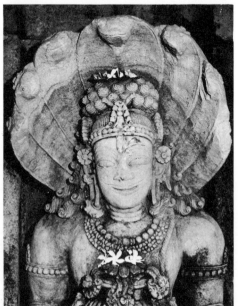

probably confirm this. The Mukteswar temple is small, about 45 feet by 25 feet, with a tower 35 feet high. It is, however, complete with its own sacred pool or tank and entrance gate. The temple area is enclosed by a railing. Perhaps the most striking feature is the tower. No longer squat and crude, it permits no doubt that it *is* a tower. The layer-like appearance of that of the Parasurameswar is here broken by strong vertical ribbons. The Mukteswar shows the characteristics of the fully developed northern style. One art historian of the nineteenth century described this temple as the 'gem of Orissan architecture,' and it is a precise rather than a literary description. The incrustation of sculpture is like stone jewellery of great delicacy. A constantly recurring decorative motif is that of the old *chaitya* arch, which appears in many variations. The porch has ceased to be a rather heavy rectangular building with a flat roof sometimes lit by skylights, and now has a stepped, pyramidal roof. The Mukteswar temple also has the distinction of being the only temple at Bhubaneswar in which the interior of the porch is decorated with carvings. Apart from the sacred figures depicted on the exterior, there are many secular scenes. A principal theme is that of the pilgrimage. Couples are shown walking alone, and one scene, repeated in a number of panels, shows a large group of people carrying their baggage on bamboo poles. The lattice windows of the porch are surrounded with humorous scenes of monkeys playing pranks or grooming each other.

The gateway (*torana*) is of a most unusual design, its columns surmounted by a semicircular arch. It is clearly the work of some individual genius, for it avoids any feeling of heaviness despite the massiveness of its members. The gateway is elaborately carved.

The largest temple at Bhubaneswar is the Lingaraja, constructed about AD 1000. The great tower, known as the Sri Mandir, dominates not only the immediate temple complex but also the town of Bhubaneswar itself. The temple stands in an enclosure measuring 520 feet by 465 feet, surrounded by a high, substantial wall, which was obviously designed for defence; it has an inner platform from which men could patrol the wall while observing the surrounding approaches. This probably indicates a period of instability in the state towards the end of the Kesari dynasty and the time of its replacement by that of the Gangas. Tradition has it that the builder of the tower was King Yayati Kesari, but there is no historical proof that he ever existed. The Lingaraja, as it survives, consists of four structures of different dates – the tower, the pillared hall or porch,

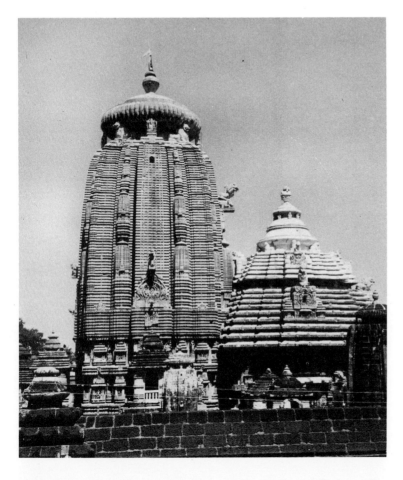

Opposite, Mukteswar temple. A group on the
west façade. The sculpture depicts a battle
between a female figure, mounted upon a monster
which has the body of a lion and the trunk of an
elephant, and a dwarf armed with a sword and
shield.

Below opposite, a naga king from the Mukteswar
temple. Behind the head is the characteristic
hood made up of seven serpents. One important
function of nagas is to act as door guardians of
Hindu shrines, and they are usually shown in
attitudes of pious devotion fitted to this role.

Left, the tower and porch of the Lingaraja
temple, with its surrounding shrines and the outer
wall of the courtyard. This temple, the largest in
the temple complex, is still in use and is only
accessible to high-caste Hindus.

the Dancing Hall (or Nat Mandir) and the Hall of Offerings. The
buildings are all on the same axis. The original design seems to
have been for only two buildings in the usual manner, i.e. the tower
and the porch. These two were probably constructed at about the
same time. The Dancing Hall and the Hall of Offerings are between
one hundred and two hundred years later.

The Lingaraja houses the chief cult image of the temple city
dedicated to Siva, the lingam or phallus, which is the symbol of the
god. The image is a great unworked block of granite set in a socket
of chlorite which represents the yoni.

In the Lingaraja enclosure there are many free-standing buildings.
These, many of them replicas of the tower of the main temple, are

91

shrines erected by pious donors. This grouping of subsidiary buildings around a main structure is one more closely associated with Buddhism and Jainism than with Hinduism. At Bhubaneswar, it suggests that the area was a place of longstanding religious significance, possibly one of those sacred Buddhist or Jaina towns whose precise location has still not been confirmed. In the Lingaraja enclosure the little towers of the shrines seem to strain towards the tower of the temple, which itself gives the appearance of the greatest strength, holding up at its summit a mushroom-like stone of tremendous size. The tower looks much taller than it actually is because the vertical lines are strongly emphasised by ribs, two of which, on each side, carry reduced replicas of the tower itself.

The sculpture on the tower of the Lingaraja is subordinate to the architecture, as if the architect had decided that the mass itself was almost enough. On the upper parts, there is little except the characteristic Orissan symbol of the lion crushing an elephant, and the great gryphons who support the disc at the summit. The lower reaches, however, are thickly covered with sculpture of considerable quality, though some critics have professed to see in it the decadence of the Orissan style. As usual, it includes statues of the gods and goddesses, groups of musicians playing their instruments, flying nymphs, and male and female snake-spirits (*nagas* and *naginis*). There are also a number of *maithuna* figures. In shattering contrast with the exterior, the interior of the tower and the adjoining buildings is completely unadorned. The tower is hollow and has an interior staircase carved out of the seven-foot-thick walls. The Lingaraja is still an important object of Hindu pilgrimage and is not accessible to non-Hindus.

A number of examples of the later period of Orissan temple architecture can be found at Bhubaneswar. The Rajrani temple belongs to a later period and may well have been the last of its type to be constructed. There is some controversy over its dating, but it seems unlikely that it was built before the beginning of the twelfth century. The temple as a whole is unfinished, probably because of the cost, but fortunately the tower is complete, and the unfinished porch tells us something about the techniques of the Orissan stone carver.

The tower, which is about 55 feet in height, shows more sophistication than the earlier temples at Bhubaneswar. The distribution of the purely decorative elements is much more fluent and the whole effect is of considerable grace. It closely resembles, in fact, the style

Right, another view of the courtyard of the Lingaraja temple, showing the large number of free-standing buildings surrounding the main structure. Many of these shrines are of late date and were given by pious merchants and pilgrims.

The tower of the Rajrani temple. The small towers, each with their spire and cap, are replicas of the main tower to which they are attached like buttresses. They are, however, a technical device which gives the impression of constant upward thrust.

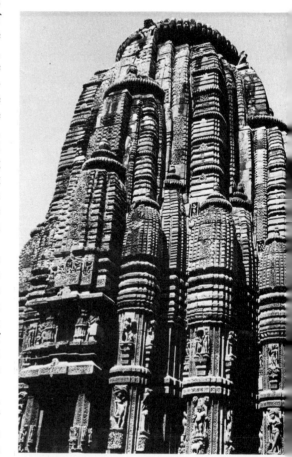

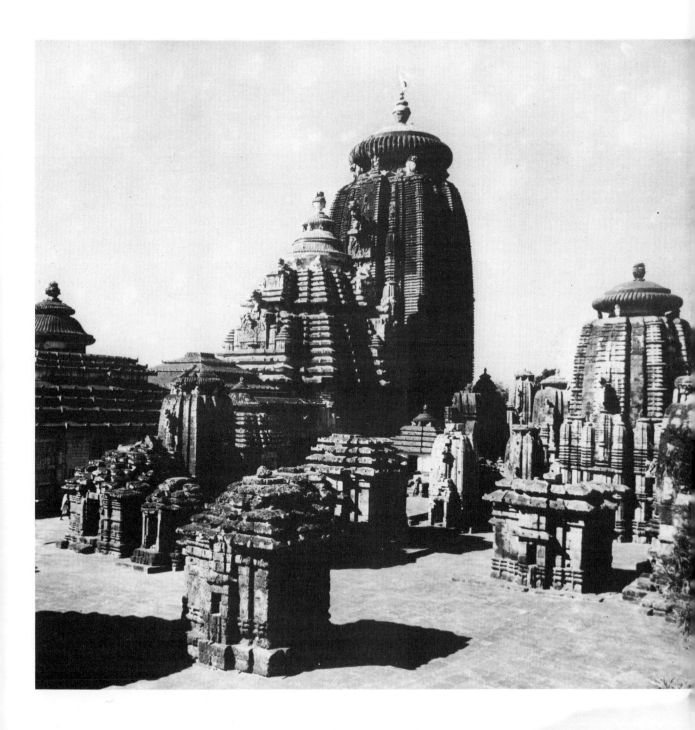

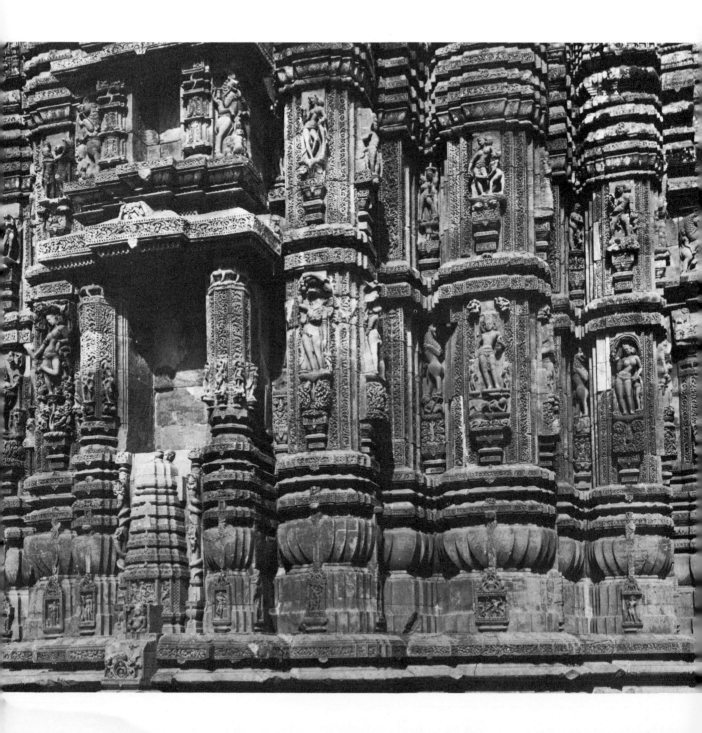

of the temples at Khujarao, a distinct departure from the style prevailing at Bhubaneswar. The treatment of the tower makes its ground plan, though in reality square, appear to be round. This is achieved by the elaborate recesses on both the interior and exterior of the tower.

The tower is covered with decoration and sculpture in the Orissan manner: medallions encased in scroll-work, creepers, leaves and flowers. An unusual motif shows the foliage and stylised flower designs emerging from the mouths of geese. The figure sculpture includes a great many representations of females, some surrounded by monkeys and peacocks, others with children. The Lady under a Tree is probably the finest medieval expression of a female fertility deity.

The porch, which remains unfinished, is partly decorated with *nagas* and *naginis*, but its main interest lies in the designs on the walls. Some of these are merely inscribed, while others are fully blocked out. The technique seems to have been for the builder to rough out projections from the stone, ready for the sculptor to work on. The marks of the chisel are still fresh and clear today. The temple appears never to have been used, as there is no sign of a cult image having been installed. It does seem likely, however, that the temple was dedicated to the god Visnu.

The name given to the temple has caused some speculation. According to a local story, the temple was originally constructed as a pleasure resort by an Orissan ruler (*raja*) and his wife (*rani*). This is not improbable in view of the very close affinity between sacred architecture and that of royal residences. Another suggestion about the origin of the name is that it actually refers to the type of stone used in the construction of the temple, which is known locally as *rajaraniya*.

Notwithstanding an increase in architectural and sculptural sophistication, which is shown at Bhubaneswar in successive temples, building methods remained extremely primitive even in the largest constructions. The later temples at Bhubaneswar were built on the principle of corbelled vaulting, which is seen first in the porch of the Mukteswar and, technically speaking, no fundamental change occurred from this time onwards. Orissan architects concerned themselves only with increasing the height of the tower and its associated buildings. At Bhubaneswar, they succeeded in their aim, and the Lingaraja still stands as proof of it. At Konarak, they were to fail.

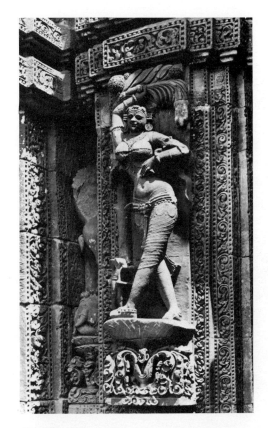

Detail from the southeast corner of the Rajrani temple, the so-called Lady beneath a Palm. This motif, of a traditional fertility deity, goes back to Sanchi (page 30) and even earlier. It demonstrates the persistence of tradition in Indian society and therefore in subjects for sculpture.

Left, a section of the southwest wall of the tower of the Rajrani temple. Most of the surfaces are covered with an almost lace-like pattern of vine and lotus scrolls. The niches contain gods and goddesses and monsters like those in the Mukteswar temple (page 90).

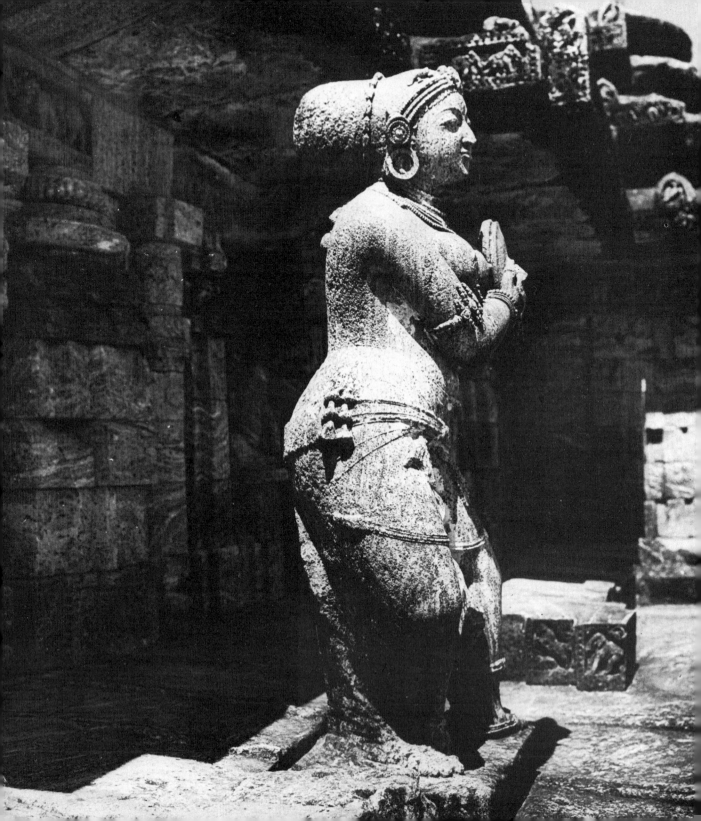

Konarak

The greatest and, in effect, the final achievement of the style of Orissa is the Surya Deul, or Temple of the Sun, at Konarak on the sea coast not far from the great temple-city at Puri. The temple is sometimes referred to as the Black Pagoda, a name given to it by mariners because, from the sea, it appeared as a dark mass in contrast to the white of the temple at Puri. It was a useful landmark for sailing ships making their way up the east coast of India towards the mouth of the river on which Calcutta stands.

Today, the ruins of this vast temple stand in an empty landscape of sand dunes. At least one art historian, appalled by the frank eroticism of some of the sculpture at Konarak, has suggested that the site was always remote and that it was chosen in order to conceal from the mass of the people the sinister orgiastic rites which he believed took place there. However, Konarak appears in actual fact to have been an important port, which was certainly known to the geographer Ptolemy in the second century AD and is mentioned by later sources as engaged in trading with Java and other parts of southeast Asia. The sand has covered much of the base of the temple when it was first seen by James Fergusson at the beginning of the nineteenth century. As all the parts of the temple visible today have been rendered so by comparatively recent excavation, it is by no means improbable that further excavation would reveal traces of the former port.

As with all legends relating to the siting of particular temples, explanations given for the choice of site are not particularly helpful. But at least there is little doubt about its dating. Konarak seems to have been constructed during the reign of the Ganga ruler, Narasimhadeva I (1238–64). It took twelve years to build and, according to surviving sources, absorbed the total state revenues for the same period. Though this may be an exaggeration, it was not uncommon at this period for rulers to use the larger part of their revenues on the construction and adornment of temples, intended not only to honour the gods but to emphasise their own glory. Narasimhadeva, at least, had some justification for erecting a monument to his own grandeur. At a time when Islamic invaders were penetrating into eastern India, he was able to resist them and even at one time to extend his territories.

A statue of a female musician from one of the spaces between the tiers of the porch tower on the Temple of the Sun. This, a cymbal player, is from the third floor. Some of the other, more than life-size, figures have fallen.

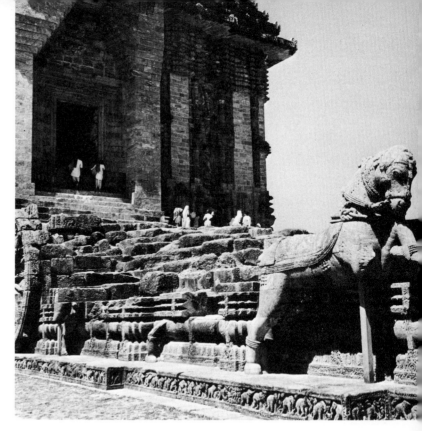

The steps leading to the porch of the Temple of the Sun. The temple is a representation of the chariot of the sun god, Surya, to whom it is dedicated. At the left of the photograph is part of one of the giant wheels, and in the foreground one of the seven horses.

Horse, detail of the above. The angle of the head and the open mouth give a remarkable sense both of strength and strain as the horse helps to pull against the vast weight of the temple chariot.

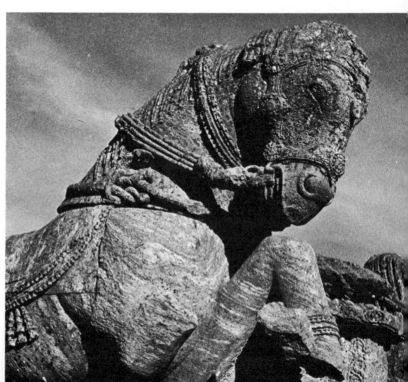

The temple was conceived on a colossal scale, which remains clear even today when much of it lies in ruins. The great tower, which was probably designed to reach a height of 225 feet (possibly more), is now merely a stump. Joined with it was the porch, the roof of which was over 100 feet high. At the base of the tower were three subsidiary shrines with outer staircases leading up to images of the sun god, Surya. In front of the porch was a detached building, the Dancing Hall or possibly the Hall of Offerings. Around the main structure stood a number of free-standing buildings, including a refectory (or possibly a kitchen) and additional shrines. There were also groups of free-standing statuary. The whole was surrounded by an enclosure, measuring 875 feet by 540 feet, the walls of which were pierced by gateways on three sides.

The architect conceived the temple to the sun god as a representation of the god's chariot. The sun is said, in the *Rig-veda*, to ride across the heavens in a car or chariot drawn by seven horses; at sunset the god unyokes them and night comes down. (This is a myth which is not unique to India.) Both the sanctuary tower and the porch were therefore placed on a high plinth on which were

One of the 24 wheels, nearly ten feet high, from the south side of the temple plinth. On each of the spokes there is a circular opening containing a man and woman in erotic pose. The plinth is also covered with erotic sculpture.

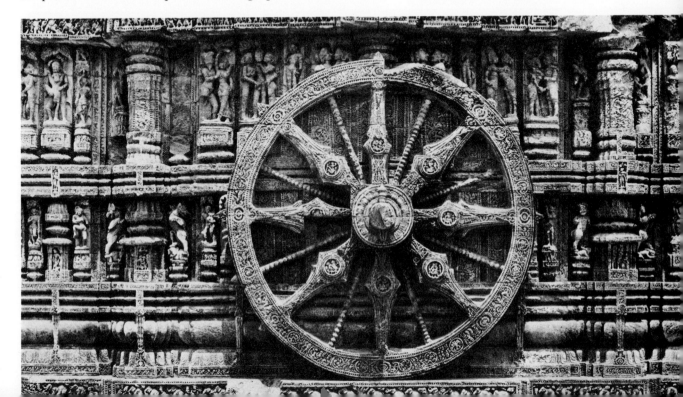

The porch of the Temple of the Sun, with the Natamandir (or Dancing Hall) in the foreground.

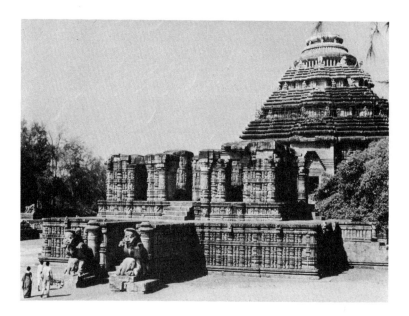

carved in relief 24 giant wheels, twelve to each of two parallel sides. In front of the porch, the sides of a wide flight of steps are supported by superb sculptures of horses. These, their harnesses covered with rich ornament, prance and strain as if the whole structure is about to take to the sky.

From the surviving remains of this vast temple, it seems likely that the tower was never completed. This was the result not, as in the case of the Rajrani temple at Bhubaneswar, of shortage of money but of the limitations of contemporary constructional techniques. It is probable that the foundations began to sink before the upper reaches of the tower were completed. Among the great quantities of fallen masonry are huge stones, dressed and carved, which in their present condition show none of the damage to be expected if they had fallen from a great height. There are also quantities of girders, over 40 feet long, made of handwrought iron of such purity that they are still free from rust even though the site is only a mile from the sea. These girders were used to support the roof stones of the larger buildings. Their purpose could once be seen inside the porch, and iron girders were also used to support the architecture of the main doorway. Unfortunately, during the last century attempts were made to remove the architrave to the museum in Calcutta. To reduce the weight, the stone was cut in two. Even so, the sections

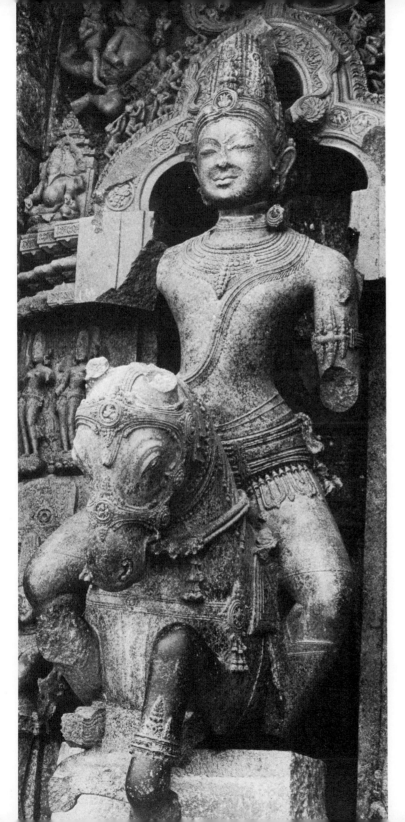

The sun god, Surya, from the first floor facing north. The god is shown riding, not in his usual chariot, but upon a horse decorated with magnificent harness. Behind the god's head, and framing it, is a chaitya *arch motif.*

were only carried a short distance as they apparently turned out to be too heavy; if true, this is an ironic comment on the march of progress, as the original builders brought the stone from a distance of over 80 miles. Today, it is not possible to enter the porch as the interior has been filled with sand in order to prevent further collapse and the entrance sealed with stone slabs. As with the other examples of the Orissan style, however, the interior was extremely plain; the exterior, in contrast, was and remains literally covered with carving.

Even in its present condition, the porch is a superb work of art. Basically, it is very simple in design, a cube surmounted by a pyramid. The surfaces of the cube are recessed so that the building is not entirely square. The roof, too, has been elaborated. The square portion is in three stepped tiers, one more than is to be found elsewhere in Orissa. Between the tiers are wide spaces containing large statues. Some of these are of female musicians playing the flute, the drum, or the cymbals, presumably because certain of the gods – including Surya and Visnu – are supposed to enjoy an offering of music. The apex of the pyramid is made up of the characteristic flat-ribbed, circular finial. The interior of the porch consists of a

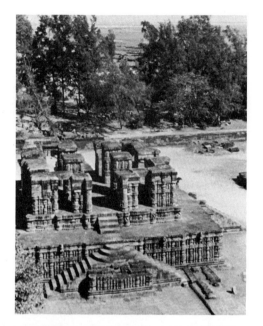

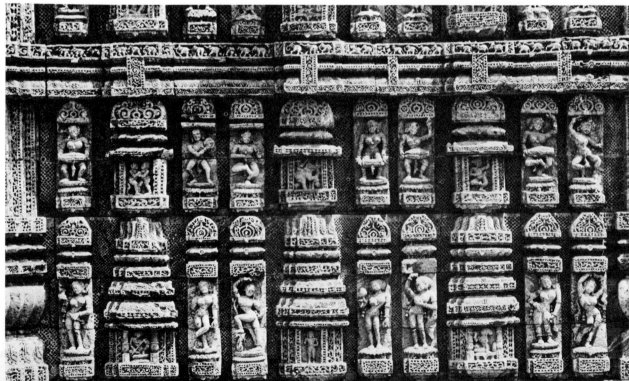

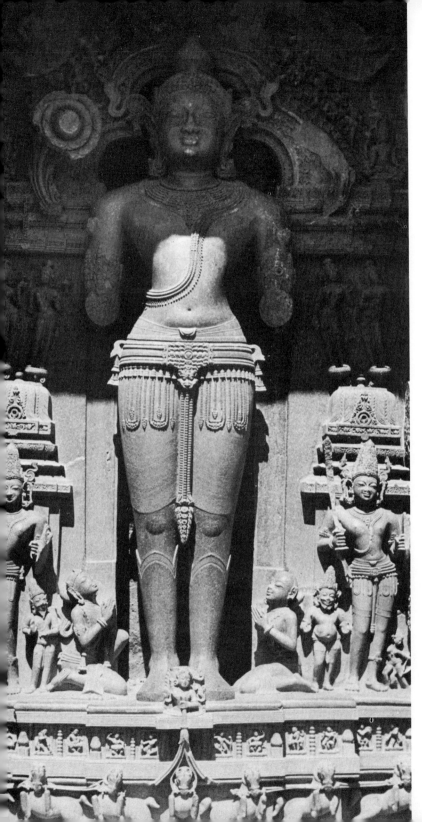

Opposite, the Natamandir, or Dancing Hall, seen from the top of the porch. The pillars of the hall, where the sacred dances which formed an important part of the ritual of worship were performed, were originally surmounted by a pyramidal roof. The hall was placed on a very high plinth which makes the terrace into a stage.

Left, the sun god in his chariot, from the south façade. The green chlorite from which the statue is carved gives the impression of bronze.

Below opposite, detail from the south face of the plinth of the Natamandir. As is appropriate to a Dancing Hall, the sculptures show dancers and musicians, all of whom are women. With the lattice-like carving of the background and the high relief of the frames round the sculptures, the impression is rather of a detached screen than of carved relief.

Detail from the statue of the sun god, north façade. The stone has been chased almost as if it were metal to show the delicate embroidery and the folds of the cloth.

single chamber about 60 feet square, with a roof supported by four huge pillars. At the far end, a vestibule leads into the sanctuary underneath the spire. This is a cell some 25 feet square. It is not known what cult image was in this cell.

The general form of the tower was probably that of the Rajrani temple at Bhubaneswar, though there is no actual record of what it looked like. Though the indications are that the tower was not in fact completed, legends assert that it was. The finial, it is said, was a lodestone and attracted coastal vessels, presumably by means of its effect on their compasses. Sailors are said to have climbed the tower and thrown down the lodestone. It is just possible that this is an embroidering of the fact that the tower collapsed because the weight at the top was insufficient—which is not, in engineering terms, improbable. But it remains more likely that the tower was not completed because of shifting foundations.

The collapse of the tower at Konarak brought one great benefit to modern scholarship by revealing the technique of the Orissan temple builder. At Konarak, most of the masonry used in the construction is of soft, whiteish stone, but most of the doorways and many of the principal sculptures are of hard green chlorite. The stones are not held together by mortar or even by iron staples but by the balancing of weight upon weight. It was this method which made the weight of the final disc-like finial of crucial importance. The shifting of foundations during the construction would naturally upset the balance of the whole building. The stones were hauled into position by means of ramps of earth. In all probability, the roof of the porch was constructed upon a mound of sand which was afterwards removed by way of the doors. Though the roof is constructed in the Orissan manner of corbelled vaulting, this was reinforced by lintels resting on the four great pillars. Even this, however, was regarded as insufficient to bear the immense weight of the roof and each lintel was itself reinforced by beams of wrought iron. This use of iron girders appears in no other part of India. They can be seen, *in situ*, in the Gundichabari—the Garden House of the god Jagannath—at Puri, which is open to non-Hindus.

The sculpture decorating the plinth and the walls of the porch is among the most remarkable in the whole of India. Some observers have seen a certain decadence of style even in the larger figures, but this may be less an objective critical conclusion than a response to some of the subject matter. The reliefs of the sun god himself, facing directly forward in the pose suitable for gods in a state of

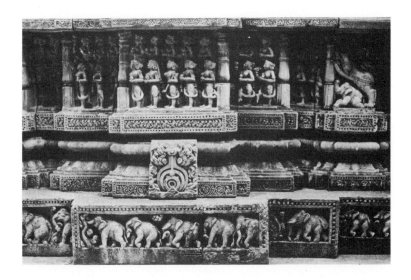

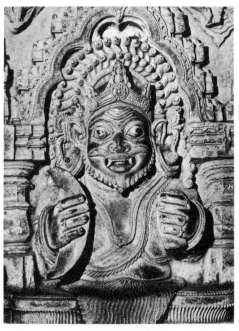

Rahu, the causer of eclipses. The demon has no body, and when he swallows the moon it reappears again after passing through the darkness of the demon's throat.

Above left, part of the plinth below a statue of the sun god. The panels contain lines of female devotees carrying offerings to the god. At the base is a continuous frieze, which goes round the temple, showing naturalistically observed elephants in a variety of poses.

spiritual equilibrium, seem to invite the prayers of the worshippers. The extreme delicacy of the carving of the ornamental accessories, of the skirt and the belt, show an impressive standard of craftsmanship. The treatment, too, of the large figures on the terraces of the pyramidal roof of the porch is of just the right heroic style to make them stand out from a great distance without interrupting the architecture.

Among the many subjects carved on the walls are female dancers (on the walls of the Dancing Hall) and large numbers of animals, both fantastic and real. A popular hybrid is the lion-elephant, which is possibly meant to represent the triumph of the sun (lion) over the rain (elephant). Also among the sculptures is a representation of Rahu, the demon of the eclipse; he would seem to have at least some right to appear on the temple of the sun god.

A constantly recurring motif is the Face of Glory (*Kirtimukha*), a mask of a leonine monster, which is a characteristic ornament of the northern style. According to one legend, the Face of Glory was created by the god Siva in the form of a devouring lion-demon in order to eliminate Rahu, who had been sent to Siva by the demon Jalandhara to demand the goddess Parvati as his consort. Rahu, in order to escape, took refuge in the god himself. The demon created by Siva demanded a substitute to devour, and was ordered by Siva to consume itself. This it did, leaving only the face. At this point, Siva declared: 'You will be known henceforward as the Face of

105

Erotic couple.

Opposite, the porch of the Temple of the Sun.

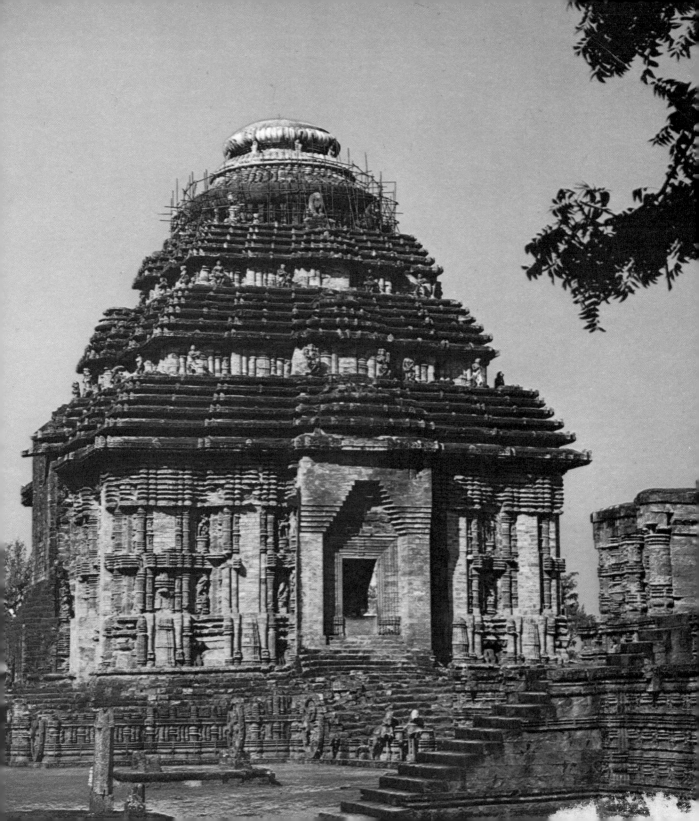

One of two elephants standing in the enclosure north of the temple. The significance of these two free-standing statues is not clear. In their trunks they carry a human figure holding a shield. The treatment of the animals is completely naturalistic.

Glory and you shall stand forever at my door. Whoever omits to worship you will never win my grace.' From being a particular emblem of Siva, the Face of Glory came to be used as a device to ward off evil, and it is as such that it appears at Konarak in the temple dedicated to Surya. A possible, but somewhat far-fetched alternative explanation for the lion mask is that it represents the man-lion incarnation of the god Visnu, who is closely related with Surya as he is a manifestation of solar energy. This incarnation is also a terrible one, for the god took this man-lion form in order to destroy a demon king who had challenged him. The incarnation therefore represents a threat to the impious. The name given to this incarnation is Narasimha, which was also the reign-name adopted by the builder of the temple at Konarak. It was perhaps a further attempt to glorify Narasimhadeva I by suggesting a significant relationship with Visnu.

Of all the magnificent carvings at Konarak–and hardly an inch of the exterior is uncovered–the most famous are the many erotic groups, consisting of two or more figures of males and females engaged in a remarkably wide range of sexual activities. Art historians anxious to explain these away have insisted, though with very little conviction, that the embraces typify 'the idea of *moksha* or union with the divine, the achievement of that primordial unity broken at the time Purusa [the Cosmic Man] divided himself to create the world.' Others have seen the figures as representative of some objectionable cult associated with the worship of the sun and including 'orgiastic rites.'

A large body of generally irrelevant literature supports the former suggestion. No convincing evidence whatsoever supports the latter. Another interpretation is that the sculptures, which display all (and more) of the *bandhas* or positions listed in that celebrated (though overrated) manual, the *Kamasutra*, are in fact advertisements for the delights available from the *devadasis* or temple prostitutes. The erotic sculpture at Konarak is placed squarely at eye level, and it appears to have been executed by less expert hands than the larger, and essentially religious, sculptures.

It is highly improbable that we shall ever know the precise reasons for this particular sculptural theme at Konarak. The most likely explanation is that both the religious and the carnal explanations are true, and that Konarak was, in effect, a *cinéma bleu* of the most sophisticated kind. It is certainly, today, one of the great monuments of Indian art.

Khujarao

There are two main 'type-sites' which epitomise the northern medieval style of Indian architecture. One of these is Bhubaneswar; but it is at the second, at Khujarao in the Chhatarpur district of Madhya Pradesh, that this architecture can be seen at its most refined and—if the function of religious architecture is to convey a feeling for the divine—at its most successful.

This extraordinary group of temples, of which some 20 of the original 85 are still standing, was constructed between AD 950 and 1050 by the Chandella Rajput rulers of Bundelkhand, who are particularly remembered for such socially useful building projects as reservoirs. The most important of the surviving temples were erected during the reigns of Dhanga (c. 954–1002) and Ganda (1002–19).

Unlike the temples of Orissa, those at Khujarao show no growth of style. They are examples of a fully developed expertise and craftsmanship, the coincidence of religious need, great patronage and artistic genius. They also represent a special kind of religious tolerance, the necessity for which perhaps arose because the Chandellas were new rulers, having been feudatories of the Pratihara rulers of Kanauj. Whatever the reason, at Khujarao there are temples dedicated not only to Siva and Visnu but also to the Jaina saints. Of even more interest is the essential similarity of their architecture. It has been suggested in explanation that the rulers may have intended to create a centre of religious learning, but there is no actual evidence of this. Ample precedent existed for a number of shrines, representing different beliefs, being congregated together, but they were not usually contemporary. There is nothing else quite like the complex at Khujarao.

The temples at Khujarao differ completely from those of Orissa in being elevated from the ground by an extremely high plinth of solid masonry. On top of this the temple structure stands. Whereas in Orissan architecture the porch and other buildings are conceived as separate structures, at Khujarao the whole is thought out as a single building taking, roughly, the groundplan of a cross with a long axis from east to west. The only entrance to the temple was at the extreme east end, i.e. the foot of the cross. In the simplest form, the temple was divided into three main compartments: the sanctuary, 109

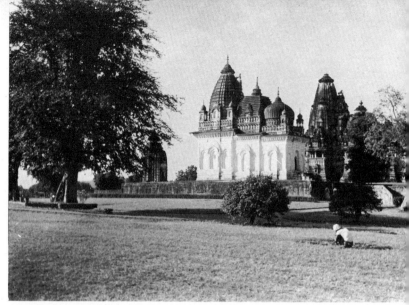

A view from the north of some of the temples in the Khujarao complex.

The temples stand upon a high plinth which is frequently decorated with sculpture. On the left, the characteristic balconies of the Khujarao style.

Opposite, a balcony. In contrast with the highly emphasised verticals of sculpture rising in tiers, the horizontals of the balconies create voids filled with shadow which seem to stress the steadily rising roof line.

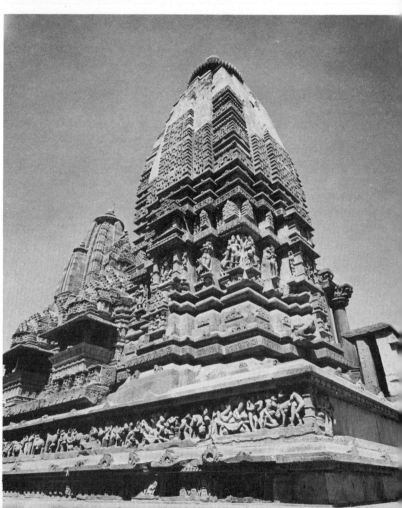

110

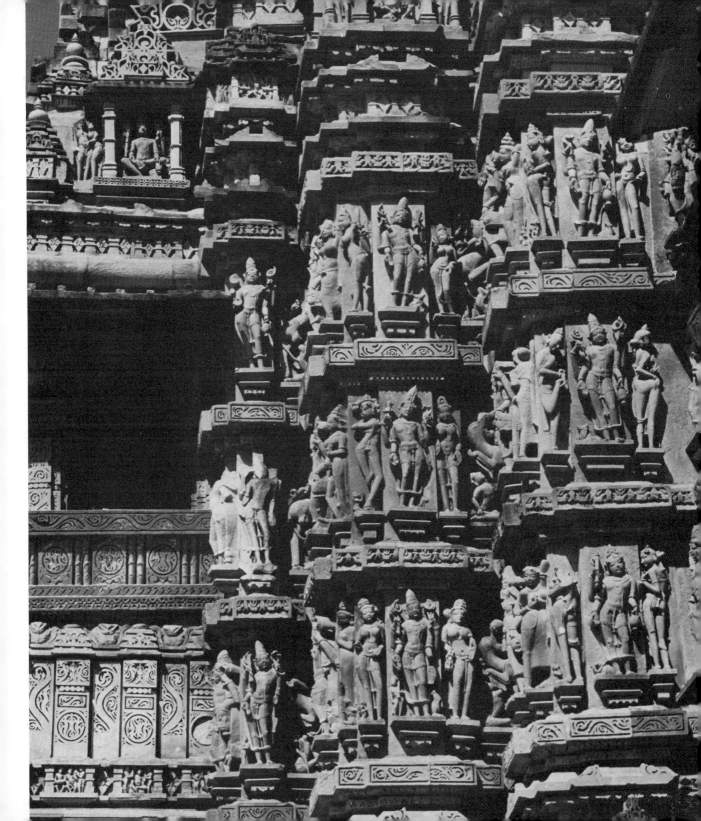

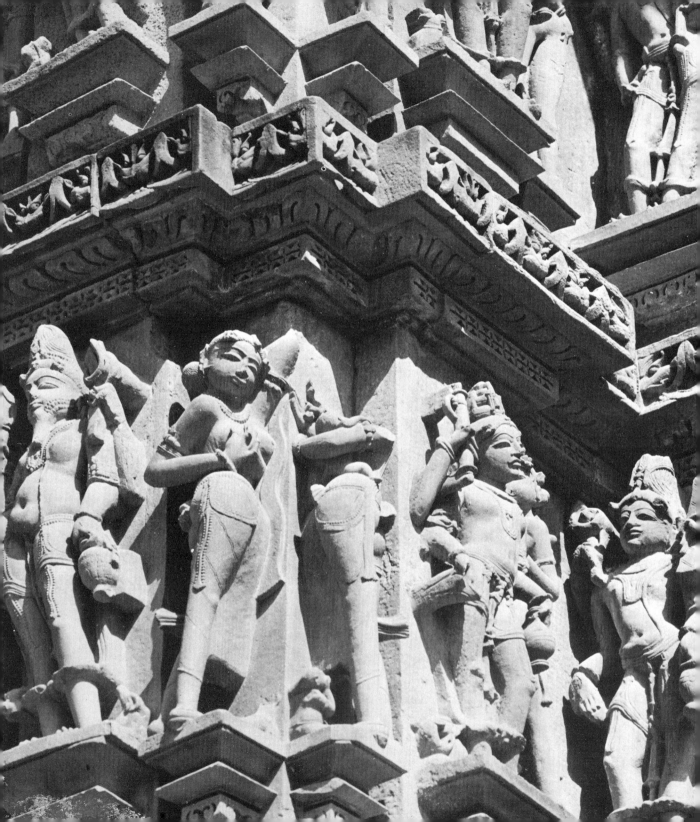

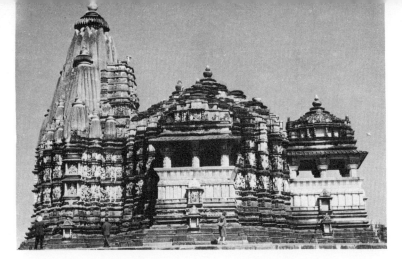

surmounted by the highest tower; an assembly hall, the equivalent of the porch in the Orissan style; and an entrance portico.

Using this plan, the builders produced what is, in effect, a series of mountain peaks culminating in that over the sanctuary. Set upon their high base, the buildings appear to soar upwards, for the designers created distinct vertical projections in order to carry the eye continually higher until it reaches the summit of the slender tower. The method makes the most effective use of light and shade. A horizontal series of window openings not only allows light and air into the interior but also throws intense shadows. The purely decorative carving is, too, an exercise in light and shade. The flat surface of the sandstone is cut deeply into tendrils and arabesques, producing a continuous contrast of bright and dark.

Between the window openings rise vertical columns which, above, become friezes running round the entire building. These friezes are peopled with statuary carved in high relief and rather less than life-size. They range in subject from divine personages, male and female, to human beings, and all are extremely graceful and dynamic. There are no horrors nor demons, and the general impression is of gaiety and happiness which reflected, no doubt, a luxurious court life. The principal effect is one of intense and pleasurable activity.

The sculpture at Khujarao is of very high technical quality. This is particularly apparent in the representation of the female figure. The celestial beauties who are the musicians and entertainers of the reconstructed heaven which the temple represents are shown in a wide range of provocative attitudes. They are tall and slim, and the elongated lines emphasise the voluptuousness of their buttocks and breasts. There is an air of lightness, appropriate for creatures who, according to legend, were made of mist and vapour. Though they are dynamic in form, their activity has a special languour, a sense of timelessness suited to the infinities of heaven.

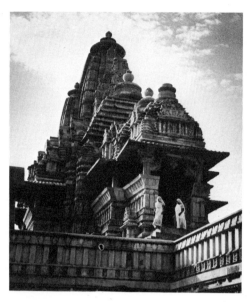

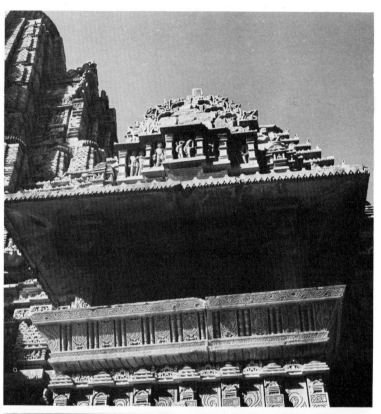

Lakshmana temple. The porch entrance stands at the top of a very steep flight of steps created by the height of the plinth. The temple is dedicated to Visnu.

Above right, balcony of the Kandariya Mahadev temple.

Right, lintel of the porch of the Lakshmana temple. Like the other openings in the interior of the temple, this lintel is festooned with a foliated strut. The sculptor has given to the stone the appearance of an ivory carving.

Kandariya Mahadev temple. A ceiling in the main hall. The swirling pattern of receding circles and arcs is like the effect of stones thrown into a pool. In the normal lighting of the temple, the ceilings are usually in total darkness.

The men who carved these statues had very little to learn from anybody, and the general structure of the temple displays the same sophistication. The tower over the sanctuary makes this particularly apparent. Unlike the Orissan type, which is pyramidal in form, that of Khujarao is domical. The curves increase the sense of upward thrust. So, too, do the turrets set into the tower at successive levels. The symbolism of the tower–a symbolism by no means restricted to the temples of Khujarao–is that it represents the world mountain, Meru, which like a pillar separates heaven and earth, or Mount Kailasa, the home of Siva. At Khujarao, the symbolism is at its most effective.

The interiors of the temples at Khujarao again emphasise the difference from Orissa. In the latter, the temple interiors are almost always lacking in decoration of any kind. This is certainly not so at Khujarao. There, the interior of the temple is approached by a very steep flight of steps leading to the portico. The doorway, like the doorways of other parts of the temple, has a cusped archway delicately carved, or a strut, foliate in form. From this doorway, a small passage leads into the portico proper. This is rectangular in shape, the sides open and the ceiling supported on pillars. Through the portico is the main hall, square in shape. On each side are transepts which lead to the balcony-like window openings, and

115

The tower of the Visvanath temple. An inscription records that this temple was built in AD 1000. Its form is that of the Kandariya Mahadev temple, but it is one sixth of the size.

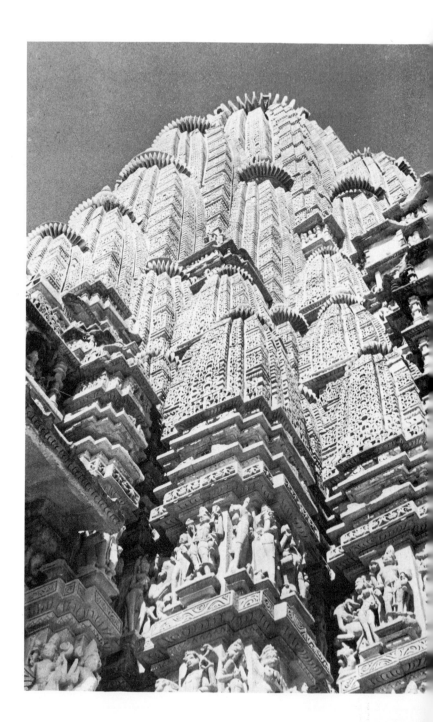

across the main hall is a vestibule, with the sanctuary beyond. This is entered through an ornate door which usually repeats the decorative motif of the temple entrance.

The average size of the main halls is only about 25 feet square, but at this point of the structure they carry a very considerable weight of roof which could not be supported by a single span of ceiling. The method used was therefore to place a pillar at each of the four corners of the hall, holding up heavy beams which in turn support the ceiling. The capitals of these pillars, the beams and the ceilings are all carved. The capitals are decorated with dwarfs and gryphons. Between these rather ugly beings are female figures of great beauty. The treatment of the ceilings is particularly fine, and very much a gesture of faith as the ceiling is usually invisible, certainly so without artificial light. The most common design is one of intersecting circles which produce shell-shaped recesses from which hang single pendants. Each stone of these ceilings was carved separately and jointed together on the ground. They were then dismantled, and the ceiling was fitted by lowering the stones into place from above.

The main group of temples at Khujarao consists of about a dozen, arranged in two lines. These contain buildings dedicated both to Siva and Visnu, some of them standing next to one another. In each line there is one large temple with slightly smaller ones alongside. The largest is the Kandariya Mahadev, dedicated to Siva. This temple is 109 feet long, 60 feet wide, and its tower is nearly 118 feet high. The plan here is of a cross with two arms, as, in addition to the transepts leading off the main hall, there are similar ones leading off the passageway which surrounds the sanctuary. The lower reaches of the building slope inwards and are surmounted by a kind of dado supporting a massive balustrade which, in turn, slopes outwards like the back of a chair. Above this appear the window openings. These are divided by pillars topped by a wide eave; from this rises a gable which blends into the turrets of the roof, maintaining the constant vertical thrust of the building. There are two other temples planned on the same principle, though on a smaller scale; one of these is the Siva temple of Visvanath, and the other is dedicated to Visnu. The remaining temples are smaller still and have only one pair of transepts.

In the Jaina temples, of which six are in a reasonable state of preservation, the principal divergence from the general style is shown by the elimination of window openings from the design.

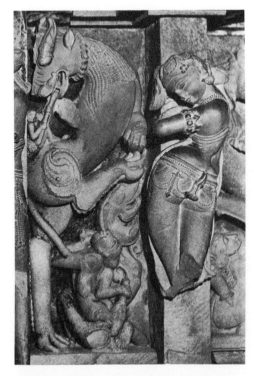

Sculpture from the wall of the ambulatory of the innermost sanctuary of the Visvanath temple. The female figure of a heavenly nymph is calm, almost sultry, in contrast with the activity in the niche beside her. The sculptor, by placing the belly of the figure flat against the wall and twisting the waist, produces the effect of quiet voluptuousness which is characteristic in the representation of heavenly beings at Khujarao.

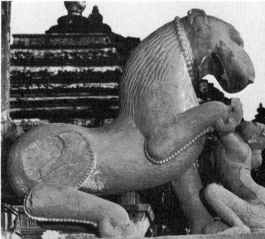

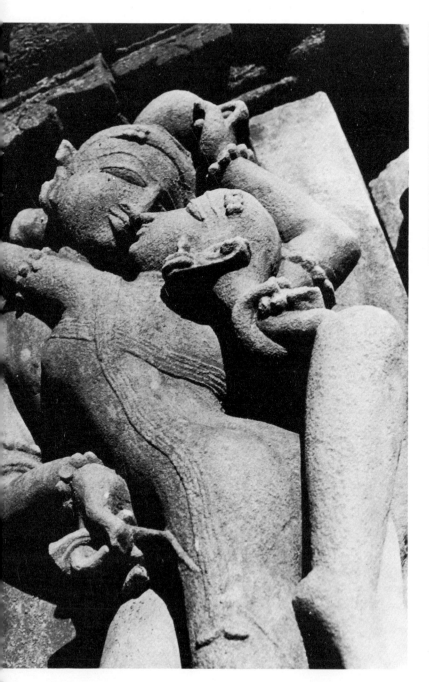

Above, woman and lion. This group is in a small pavilion between the Kandariya Mahadev temple and the Deva Jagadambi. It is a rare example of sculpture in the round and dates, as do the temples, from about AD 1000. The exact significance of the group, though often guessed at, is not known.

Left, an erotic couple from the façade of the Deva Jagadambi temple.

Right, in spite of the intense eroticism of much of the sculpture at Khujarao, the overwhelming effect is not so much of sexuality as of bliss. This detail of the head and shoulders of a couple from the Kandariya Mahadev temple shows something of the dreamlike quality which underlies, not the poses, but the expression of the figures.

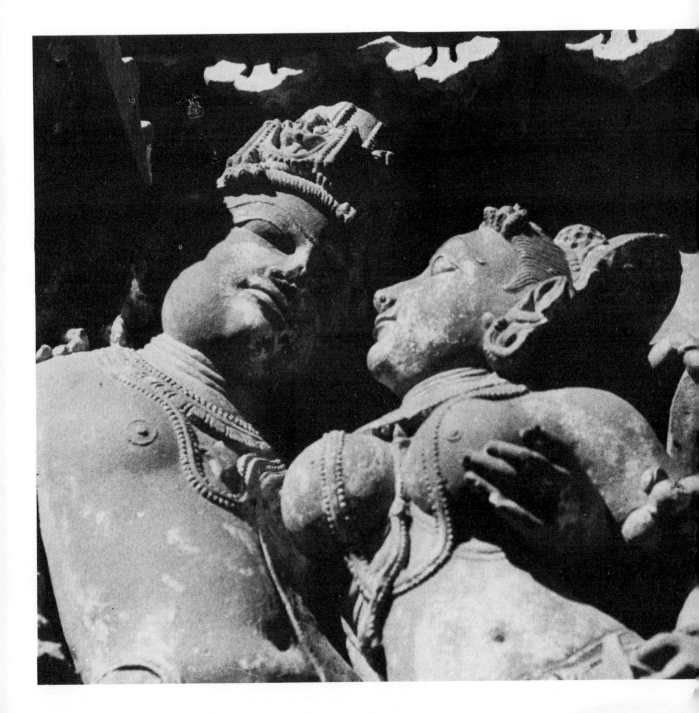

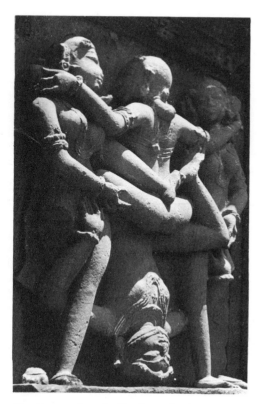

Erotic group from the Kandariya Mahadev temple.

Opposite, the Kandariya Mahadev temple.

This tends to produce a rather dull exterior. The Jaina sculptors tried to lighten it by elaborating the horizontal friezes of statuary which, in these temples, continue around the wall surfaces without interruption except for projections carved into pillared niches containing figures of particular sanctity. Apart from the adaptations necessary for the carrying out of Jaina rituals, the interiors are architecturally the same as those dedicated to the Hindu deities.

One of the Jaina temples, now a ruin, was apparently of a different type from the rest. All that is left today is a cluster of twelve pillars over 14 feet high, standing on a moulded plinth and supporting a flat roof. The slender columns are exquisitely carved, and the complete temple must have been the work of a particularly talented group of builders and sculptors.

Like Konarak, the temples of Khujarao have a reputation for containing sculpture which expresses, in the words of one famous contemporary tourist guide to India, 'the side of life which Westerners tend to discuss in whispers or not at all.' It should be added that many Indians seem to share this prudish attitude – at least in the presence of foreigners and in works of art history intended primarily for them. Undoubtedly, the sculptures at Khujarao showing two or more persons in sexual embrace are remarkably explicit, if anatomically somewhat unlikely, but their obscenity exists only in the eye of the beholder. In medieval India, sexual desires were permitted uninhibited expression for sound social reasons. The 'spiritual' explanations so frequently to be found in books on Indian art are largely irrelevant, though the protest which these erotic sculptures reflect was certainly given a religious vocabulary. There is no doubt that orthodox religious leaders did attempt to give sanction to some of the manifestations of sexuality, and the sculpture at Khujarao may represent such reconciliation between orthodox belief and popular cults. Undoubtedly rulers would, as a matter of policy, seek to reconcile with the state any deviant and heterodox sects likely to become the focus of political opposition.

Whether the Chandella rulers were themselves devotees of any cult is not known. It has been suggested that they were introduced to a Tantrik-Saiva cult by their vassals, the Haihayas or Kalachuris of Chedi, who used it to corrupt the dynasty so that they might take its place. This seems highly improbable and is based on the very shaky assumption that an 'unhealthy' interest in sexual behaviour is a symptom of cultural decline. The Chandellas were, in fact, defeated by Islamic invaders of superior military expertise.

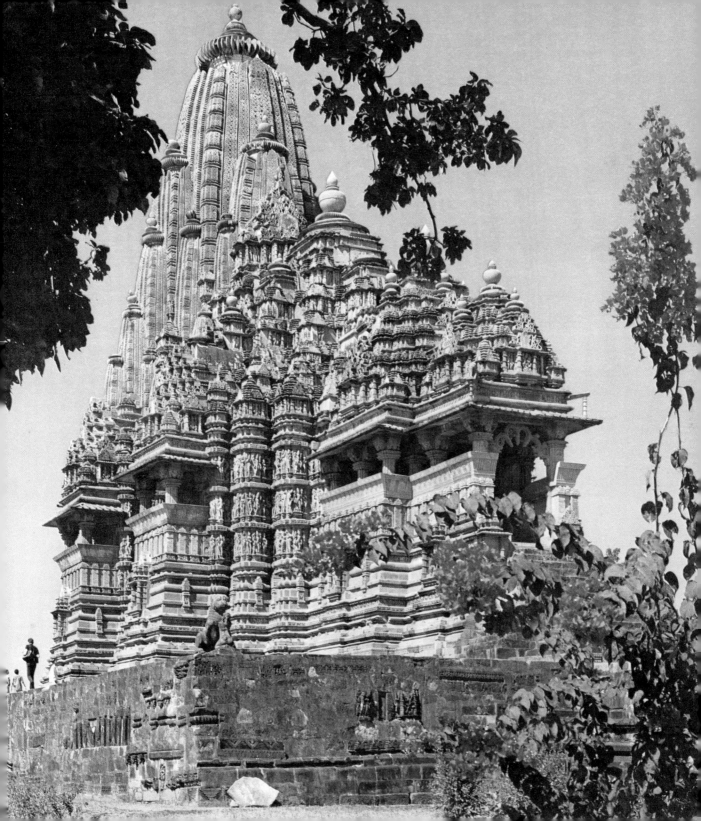

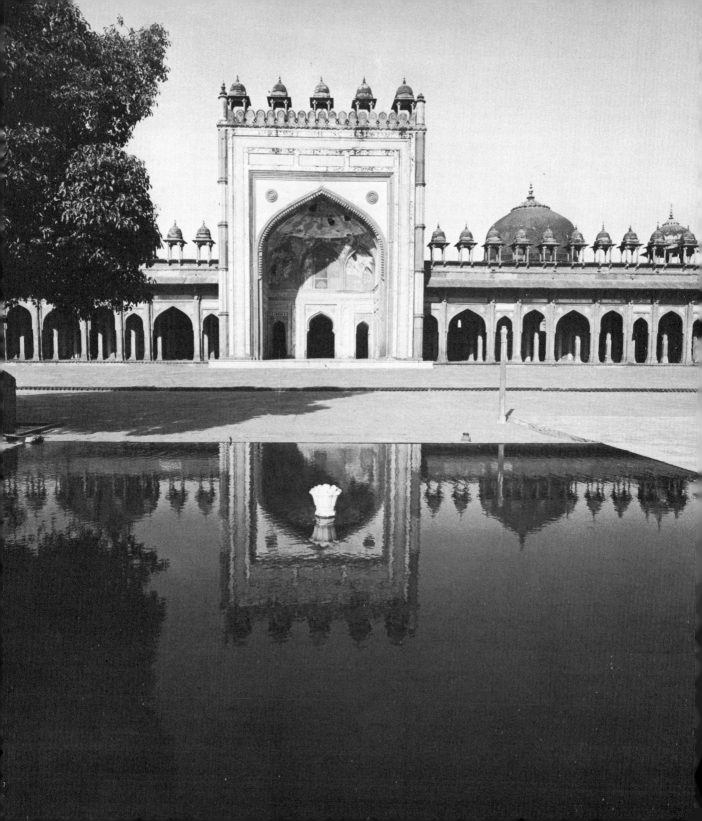

Jama Masjid, Fatehpur Sikri

The city of Fatehpur Sikri, of which the Jama Masjid and surrounding buildings form the most impressive part, stands deserted 24 miles west of Agra. The city was begun in 1571 by the Mughal emperor, Akbar (reigned 1556–1605), on the site of the village of Sikri where his son and successor, Jahangir, was born in 1569. Before this event, Abkar–whose first three children had died in infancy, leaving him without an heir–had been assured at Sikri by a Muslim holy man named Salim Chisti that an heir would be born if the emperor's Rajput wife moved from Agra to Sikri. Jahangir, in his memoirs, wrote of Akbar's decision to commemorate the auspicious outcome: 'My revered father, regarding the village of Sikri, my birthplace, as fortunate to himself, made it his capital and in the course of 14 or 15 years the hills and deserts, which abounded in beasts of prey, became converted into a magnificent city, comprising numerous gardens, elegant edifices and pavilions, and other places of great attraction and beauty. After the conquest of Gujarat [by Akbar] the village was named Fatehpur, City of Victory.' In 1585 Akbar abandoned Fatehpur Sikri and, except for one brief visit, never returned. The city has remained empty ever since.

Within the very short space of nine years, one of the most spectacular architectural complexes in the whole of India was constructed astride a rocky ridge which rises above the surrounding plain. The city is surrounded on three sides by a wall approximately two miles long by one mile wide, but it does not seem likely that Fatehpur Sikri was ever intended to be fortified strongly enough to withstand a major siege. In an emergency, the inhabitants could retire on Agra which was strategically placed on the river Jumna and could easily be defended. The purpose of Fatehpur Sikri was to be a ceremonial capital, in effect a vast palace. There are no streets, only an arrangement of broad terraces and courtyards.

The largest and most imposing structure in the complex is the great mosque, on which the other buildings are aligned. Generally speaking, all the buildings, both religious and secular, follow the same style, though with interesting regional variants in their treatment and decoration. This was a result of the size of the undertaking and the speed with which it was built. Such a vast plan could not be

View across the Jama Masjid enclosure, showing the main entrance to the sanctuary. The height of the doorway hides the main dome over the central chamber. The dome to the right, which is duplicated on the left, covers another chapel.

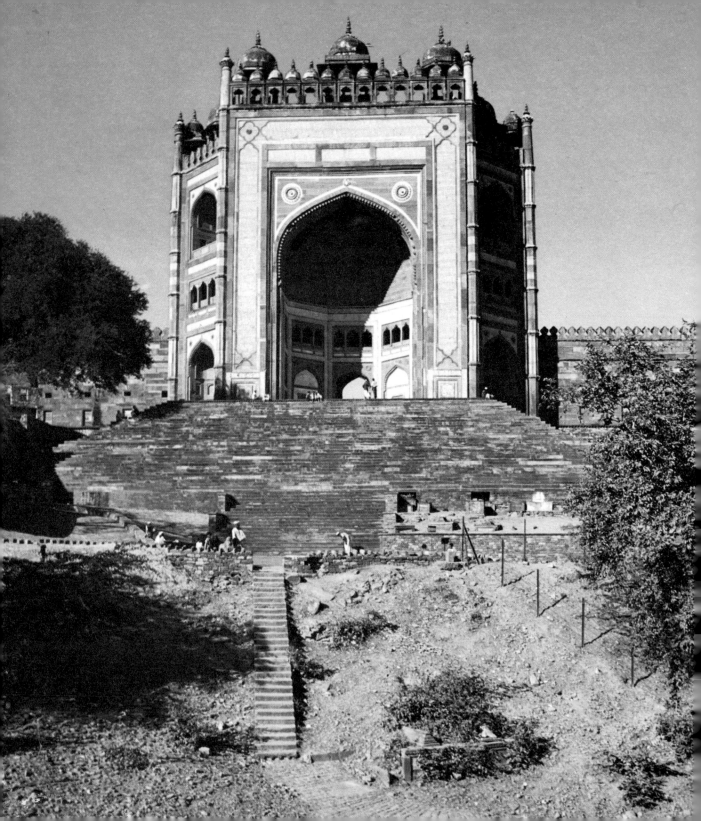

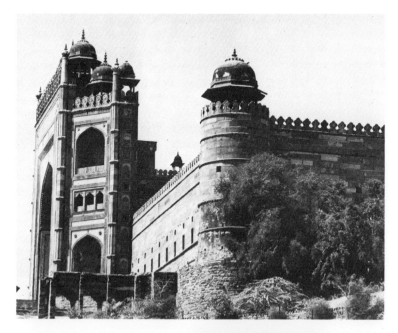

The outer wall of the Jama Masjid enclosure.
The wall, constructed of red sandstone and
battlemented, has a turret surmounted by a dome
at the corner. To the left is the Buland Dwarza.
The wall is not the city wall but that of a separate,
defensible area within it.

Opposite, the Buland Dwarza or Gate of Victory.

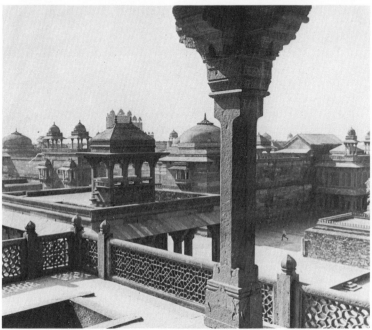

View of the inner walls of the Jama Masjid
enclosure with the Buland Dwarza in the far
background. This view is taken from the palace
area and shows, in the middle distance, the palace
of Jodh Bai, the emperor Akbar's favourite
queen.

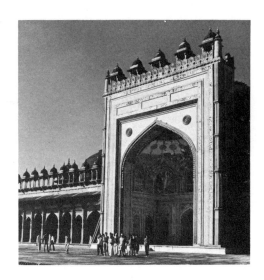

The main entrance. The arched recess, with its semi-dome, is decorated with floral motifs.

Right, view through the cloisters on the south side. On the right is the mausoleum of Islam Khan and on the left, partly hidden by the pillar, is the tomb of Sheikh Salim Chisti. Behind the tomb rise the kiosks of the northern gate, which was used only by the women of the emperor's harem.

carried out by the guilds of local craftsmen alone, and many workers were brought from other parts of the emperor's extensive dominions. It is possible to identify the architectural idioms of the different regions, or at least of the more distinctive ones such as the Punjab and Gujarat. However, unity of style was imposed by the emperor's own taste and, presumably, the overall control of some kind of superintending architect.

The group of religious structures dominated by the Jama Masjid consists of the great mosque itself, its southern gateway or Buland Dwarza, the tomb of Salim Chisti, and the mausoleum of Islam Khan, which is on the northern side. Originally, the design consisted only of the mosque, covering a rectangular plan measuring 542 feet

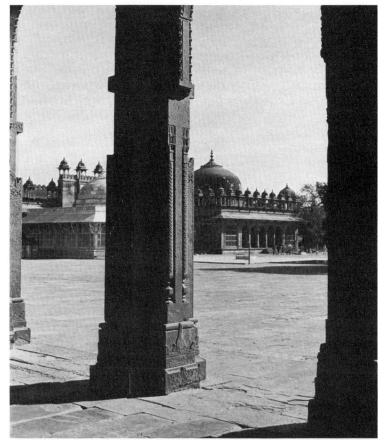

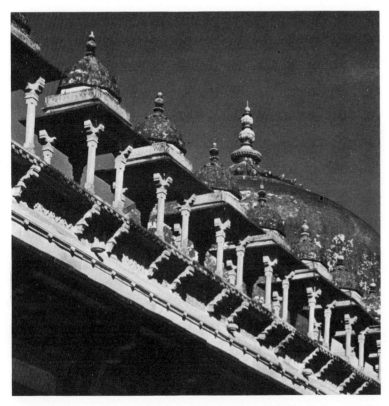

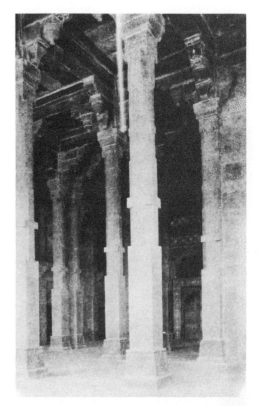

The southern interior aisle of the mosque, looking towards the main sanctuary. The pillars, which are extremely plain, are topped with capitals that use Hindu motifs. The brackets are also distinctively Hindu in style.

Above left, detail of the roof of the mosque. To the right is the dome over the main chapel. The kiosks stand out from the pediment and are supported on brackets. The free use of such kiosks to break up the skyline is characteristic of Mughal architecture in the period of Akbar.

by 438 feet, with an interior courtyard of unusually large size. According to an inscription, the mosque was erected in 1571, which probably means that building began in that year and not that it was finished at that time. The inscription reads: 'This the masjid is the duplicate of the holy place,' which suggests that it was supposed to be a replica of that at Mecca. The design of the mosque is conventional in that the courtyard has a pillared cloister on three of its sides, with the western end occupied by the sanctuary. The courtyard was originally entered by three gateways set into the north, south and east walls. All these were subsequently altered except one, that in the east wall known as the King's Gate which was used by Akbar when he entered the mosque for daily prayers.

The cloisters of the mosque are divided into numerous cells separated from each other by walls with open verandas in front. The cloisters are lofty, being over 28 feet in height, and are surmounted by a flat roof. The cells were probably used by religious

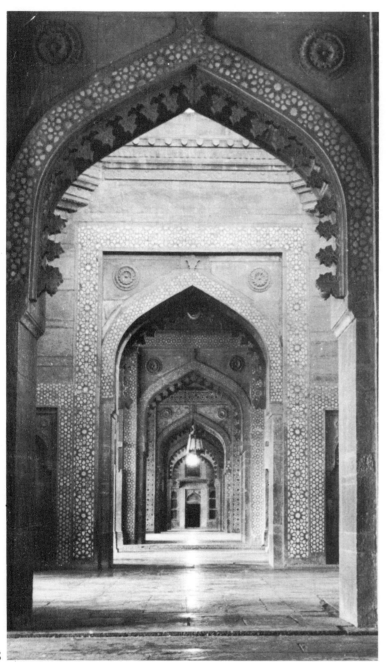

View through the aisle linking the three chapels. The lamp hangs in the main sanctuary. The decoration is in red sandstone inlaid with marble, and the abstract motifs are painted.

Right, interior of the main sanctuary, showing one of the mihrabs. These arched recesses are used to direct the worshippers' prayers, as there are no images in Muslim temples. The principal mihrab faces west, towards Mecca.

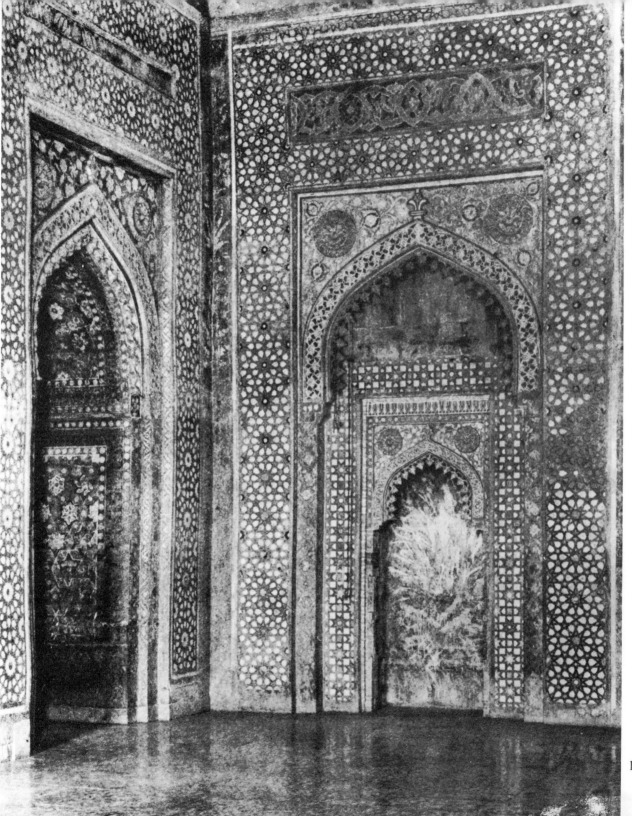

A drawing which shows the decoration above the
principal mihrab in the main sanctuary. The
detail is from the carved spandrel, the triangular
area between the curve of the arch and the
square enclosing it. The background to the
carving was originally a dark blue and the
carving itself highly gilded.

teachers and their pupils. The roof of the cloisters is embellished, and the skyline, which would otherwise be rather dull, is made interesting by the addition of kiosks placed over the arches. The kiosks consist of four slender columns supporting a dome. The coping that supports the domes projects and is, in turn, supported by a series of brackets.

The mosque proper stretches along the west end of the courtyard for 288 feet and is 65 feet in depth. The structure is divided into three main portions, a square central area with a large dome above and a long pillared hall on each side. At the end of each hall is a set of five small rooms above which are staircases set into the outside bastions of the walls. These staircases lead to the *zenana* galleries from which women could watch the services taking place below without themselves being seen.

The entrance to the sanctuary is through a large arched portico. The height of the portico almost conceals the great dome behind it. In fact, the portico is really a pylon and, as such, a substitute for the minaret, which is not found on any of the mosques erected at Fatehpur Sikri. This was probably the influence of the style of Jaunpur, to the north of Benares, which for a short period in the fifteenth century was the scene of an outburst of cultural and artistic activity of a very high order. The portico, however, is by no means a copy of those at Jaunpur, which are basically rather plain. As befits the capital city of the greatest ruler in India, the gateway is magnificently decorated, with marble inlays set in the red sandstone of which, like every other building in Fatehpur Sikri, the mosque is constructed.

Three doorways in the portico open into what is in effect a nave, which has on its western wall the principal *mihrab*. This is a niche or arched recess towards which worshippers turn to pray. The nave is roughly 40 feet square, and the dome above is supported on a base with 16 sides, panelled and decorated with flowers. The whole of the chamber is covered with the most elaborate floral designs which, even though the colours have faded considerably, still retain something of the richness they must have displayed when they were newly created. The range and quality of the carved, painted and inlaid ornamentation is unequalled in any other contemporary building. Some of the finest of this work was, not unnaturally, lavished on the decoration of the principal *mihrab*. This extends from the marble floor of the chamber to the first support of the dome and is surrounded by a broad rectangular sunken architrave,

Buland Dwarza. A detail of the main, or 'horseshoe' entrance. The raised decoration running up the sides consists of quotations from the Koran, *in Arabic script. According to an inscription at the base they were cut by one Hussain Chishti.*

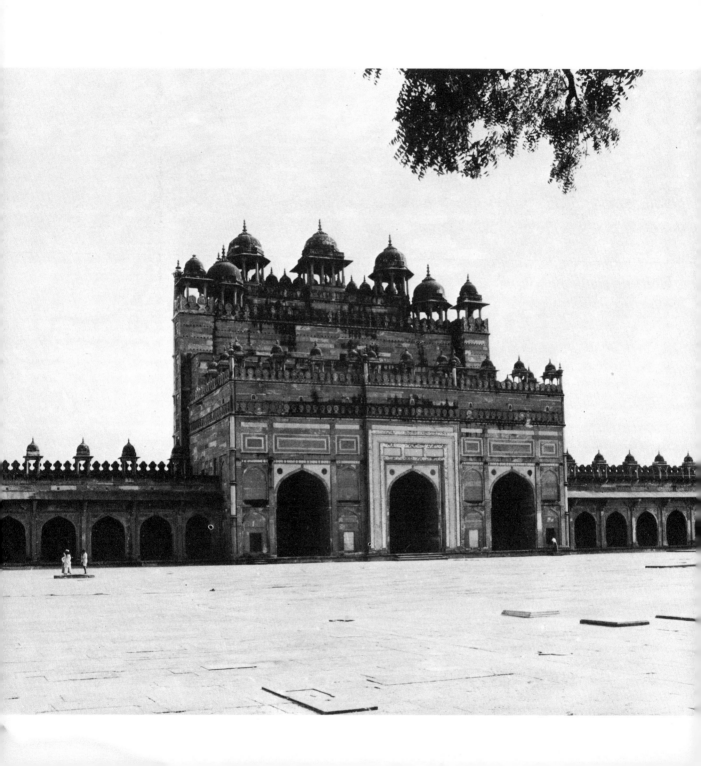

Opposite, Buland Dwarza from the mosque enclosure. The tremendous height and dramatic treatment of the outer face of the gateway becomes, on the interior face, plain and somewhat perfunctory. The treatment of the domes and the staircase method of reducing the height give a cluttered effect while still overpowering the scale of the cloisters.

Base of one of the jambs on the main face of the Buland Dwarza, showing the beginning of the inscribed Arabic lettering and the manner in which the carved sandstone was inlaid with white marble.

painted a deep blue and carved with verses from the Koran in raised characters covered with gold. The rest of the decoration was made up of flower patterns in white, red and blue on a chocolate ground, and delicate carving.

In spite of the magnificence of the mural decoration, the main effect of the interior of the mosque is purely architectural. There is a constant variety of vista created by the contrast between the open spaces of the main sanctuary and the side chapels with their domed roofs, and the pillared aisles which link them together.

The delicate balance of the mosque, its courtyard and the three gateways, in which all the subsidiary structures were designed to lead naturally to the main sanctuary, was destroyed some years after its construction by the insertion of a new gateway into the south side. The gateway itself is a superb structure, but its masterfulness of design diverts the eye and its great size dwarfs not only the mosque but every other building in the city.

The decision to destroy the original southern gate and to replace it with another was made by Akbar in 1602. An inscription on the central archway of the gate reads (in part):

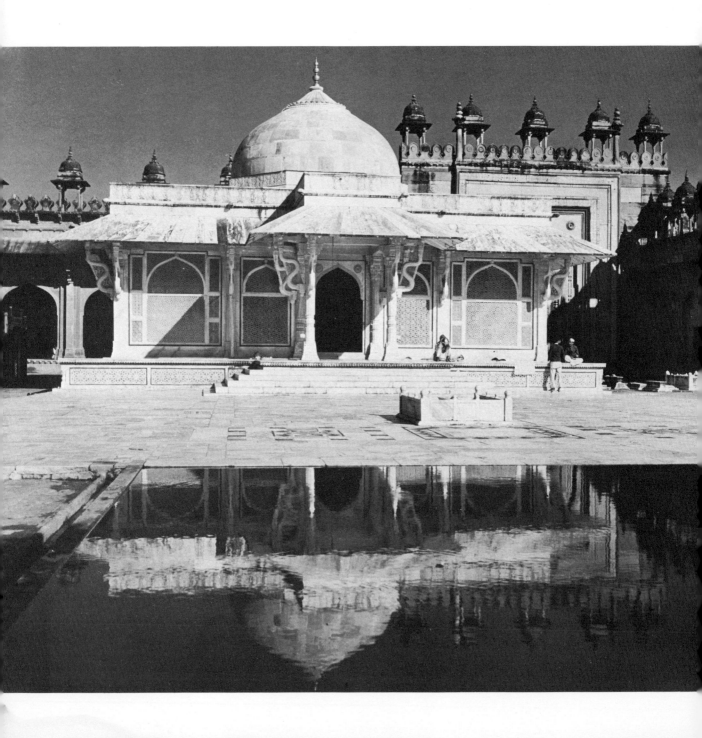

King of Kings, Shadow of God, Jalaluddin Muhammad Akbar, the emperor on returning from the conquest of the south in the 46th divine year [of his reign] reached Fatehpur.
Said Jesus, on whom be peace! The world is a bridge, pass over it but build no house upon it; he who hopes for an hour may hope for eternity; the world lasts but an hour, spend it in devotion; the rest is unseen.

The gate known as the Buland Dwarza, or Gate of Victory, is approached from the outside by a steep flight of steps 42 feet high. The structure itself is 134 feet high and 130 feet wide on the front elevation. The effect of great height and solidity is increased by the fact that the entrance face is not flat but is made up of a frontal plane with lesser ones at either end receding at an angle. The front plane is a rectangle 86 feet wide, and the greater part of its surface is taken up by the arched recess of the entrance porch. By a clever manipulation of the planes of the half-dome, the quite small apertures of the doors are not overwhelmed by the size of the recess. The façade of the gate is crowned by a perforated parapet behind which is a range of kiosks.

After the immensely impressive exterior, the Buland Dwarza opens into the courtyard with something of an anticlimax. With the exception of the lowest portion, the walls are undecorated and the upper storeys are masses of naked stone completely out of harmony with the interior walls of the courtyard, from which it stands out about 15 feet, and the cloisters on either side. There is something perfunctory about the finishing of the interior façade, as if the designers had assumed that the Buland Dwarza would not in fact be viewed from the courtyard side.

In direct and telling contrast with the unsatisfactory interior face of the Buland Dwarza is the elegant tomb of Salim Chisti, which is set in a quadrangle formed by the cloisters and the out-jutting tomb of Islam Khan. The tomb represents, with a clarity assisted by the white marble from which it is constructed, an entirely different set of aesthetic purposes from those of the Gate of Victory. In the latter, the architecture is a grandiose statement of imperial power, and it displays a certain aggression, suitable to a monument to conquest. The tomb of the simple saint who spent his life among the stone-carvers is a monument to their craft as well as to the piety of kings. Every year that piety is renewed, not by kings but by thousands of childless women, both Muslim and Hindu, who

The tomb of Sheikh Salim Chisti, with the women's gate in the background. The present tomb, which is in white marble, replaced an earlier one, probably of red sandstone. It is small and extremely elegant, and in the rather sombre surroundings appears more like a pleasure pavilion than a tomb.

135

Detail from the tomb of Salim Chisti. The veranda windows are inset with fretted marble. The serpentine brackets, their curves also filled with carved marble, are not structurally necessary to hold up the very wide eaves. Their design is Hindu in feeling and owes much to the techniques of the ivory carver.

come to pray at the saint's tomb in the hope that they too, like the wife of the emperor Akbar, will bear a son.

What makes the tomb doubly interesting is that it is not the building originally erected on the site. This was probably constructed in the ubiquitous red sandstone of the mosque and the rest of the city. Though it seems likely that the original design was retained, the present structure dates either from the end of the reign of Akbar's son, Jahangir, or from that of his successor, Shah Jahan, the builder of the Taj Mahal.

The plan of the tomb is extremely simple, consisting of a square with sides 24 feet in length. The mortuary chamber is 16 feet in diameter, and the whole is covered by a low dome. The tomb itself is covered by a wooden canopy entirely inlaid with mother-of-pearl worked into geometrical patterns and applied like the scales of a fish. Around the core of the tomb is a wide terrace supported on pillars. The spaces in between are filled by screens of perforated marble. On the southern side there is a projecting porch. The pillars of the terrace, with their honeycomb capitals, are extremely graceful and, jutting out from them, are brackets which appear to support the wide eaves of the roof, though in fact they do not. These are unique in their design. They are serpentine in shape, and between their curves are perforated foliations. They seem to be translated from ivory carving and are distinctly Hindu in feeling. Like the rest of Fatehpur Sikri, they demonstrate the immensely rewarding interaction between Persian and Hindu cultures which created the Mughal style.

The Golden Temple, Amritsar

Though the present structure of the Golden Temple, or Harimandir, the most sacred shrine of the Sikhs, dates from the middle of the eighteenth century, a temple was first constructed on the site by the fifth guru, Arjun, two hundred years earlier. It was Arjun's first task, after assuming the spiritual leadership of the Sikhs, to erect a temple on the land given to his predecessor by the Mughal emperor, Akbar, in 1577, on which a new town had begun to grow up. In conformity with the eclectic nature of the Sikh religion, which sought to combine both Hindu and Muslim beliefs, it was a Muslim divine, Mian Mir of Lahore, who laid the foundation stone of the Harimandir, the temple of God.

Instead of building the temple on a high plinth in the Hindu style, Arjun had it built in a depression so that worshippers had to go down steps in order to enter it. Also, it had four entrances, symbolic of the new faith which made no distinction between the four Hindu castes. The cost of construction was raised by a donation from every Sikh, consisting of one tenth of his income. When the temple was completed, the ceremonial pool was filled with water and named *Amrit-sar* or Pool of Nectar.

In 1595, Arjun began the compilation of a sacred anthology, the *Granth Sahib*, the Sacred Book of the Sikhs. Enemies of Arjun reported to the emperor Akbar that this anthology contained texts attacking Islam. On a journey north, passing near Amritsar, the emperor asked to see a copy of the book and, satisfied that the allegations were baseless, made an offering of gold coins. In 1604, the compilation was finished and the *Granth Sahib* was placed in the Harimandir where the practice of reading from it began.

Arjun's original foundation with, no doubt, additions and ornamentation seems to have survived the persecutions of later Mughal emperors who did not have Akbar's tolerance of other faiths than Islam. The trouble began with the decline of the Mughal empire in the eighteenth century and the frequent invasions by Afghans which followed the weakening of the Mughal central authority. In 1757 part of the Harimandir was destroyed as a reprisal for Sikh attacks on the Afghans, and the sacred pool was ritually polluted by being filled with the entrails of cows. The temple was rebuilt, only to suffer the same fate in February 1762, a month 137

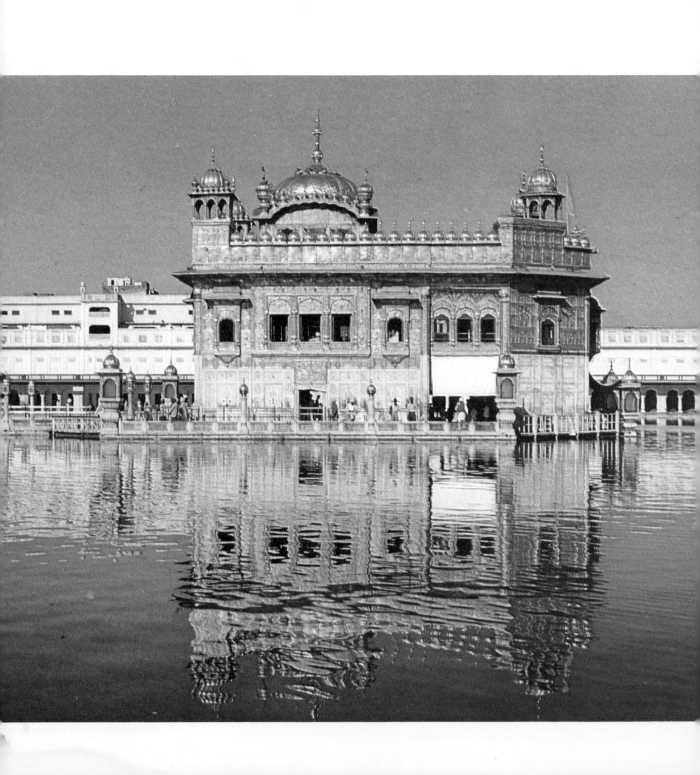

The Harimandir, or Golden Temple. The causeway leads to the west bank. In the background, amidst the temple gardens, stands the Baba Atal tower.

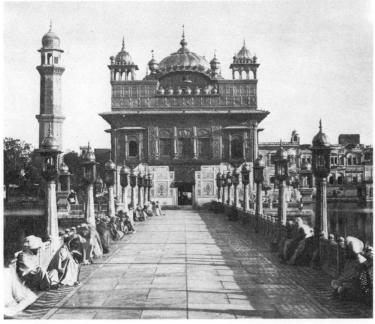

View of the front of the Harimandir along the causeway leading to the entrance gateway. The marble inlaid with pietra dura *stands out against the gilt of the upper storeys. The minaret-like tower on the left no longer has its dome.*

Opposite, the Golden Temple from across the Sacred Pool of Nectar.

140

still remembered by Sikhs as the time of the Great Massacre. Two years later, for the third time, the Afghans blew up the temple with gunpowder and threw dead cows into the pool.

In the following year, after a successful campaign against the Afghans, the Sikhs decided to rebuild the Harimandir. The pool was cleansed and religious services resumed. This is the building which still stands, though its original appearance is hidden behind later additions. These additions began after the capture of Amritsar by Ranjit Singh, who had made himself the Maharaja of the Punjab in 1802. After entering the city, Ranjit bathed in the sacred pool and made a grant to the temple so that it might be rebuilt in marble and covered in gold leaf. This act is commemorated by an inscription over the entrance to the central shrine, which reads:

The Great Guru in His wisdom looked upon
Maharaja Ranjit Singh as his chief servitor
And Sikh, and in His benevolence, bestowed
On him the privilege of serving the temple.

The main building of the temple rises from the centre of the sacred pool, approached by a causeway over 200 feet long. An archway on the western side of the pool opens on to the causeway, which is floored with white marble as is the pathway surrounding the pool. The causeway is bordered with balustrades of fretted marble, and at close intervals there are standard lamps, their great gilded lanterns set upon marble columns.

A priest reading the Granth Sahib, *the holy book of the Sikhs. The elaborate decoration of the walls, which are brightly coloured and heavy with gilt, is spoiled by the heavy modern doors. The holy book rests on a divan, and behind the reader a man waves a* chauri *or flywhisk which, besides having a utilitarian purpose, is also a symbol of royalty.*

The Harimandir to which the causeway leads stands on an island some 65 feet square. The lower parts of the building are of white marble, but the upper parts are covered with plates of gilded copper inscribed with verses from the *Granth Sahib* in the very elegant Gurmukhi script in which the Punjabi language is written. The two-storeyed building is surmounted by a low fluted dome of gilded metal, and gilded metal kiosks stand at each corner.

As in the original structure of the guru Arjun, there are four entrances, one on each side of the building. The doors are plated with finely wrought silver, continuing the glistening effect of the marble and gilded metal which gives the temple such a feeling of luxury and light.

The interior of the building, richly gilded and painted, contains the *Granth Sahib,* which is placed under a gilded canopy on the east side. At certain times of the day, passages are read from it to the accompaniment of music played on stringed instruments. At these times, pilgrims join in chanting verses from the sacred book. When readings are not in progress, a *chauri* is waved over the book. The *chauri,* a fly whisk made from yak's hair, is an ancient symbol of royalty and indicates the special respect in which the *Granth Sahib* is held.

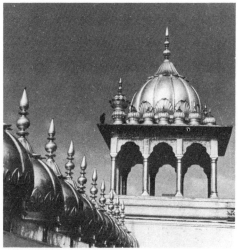

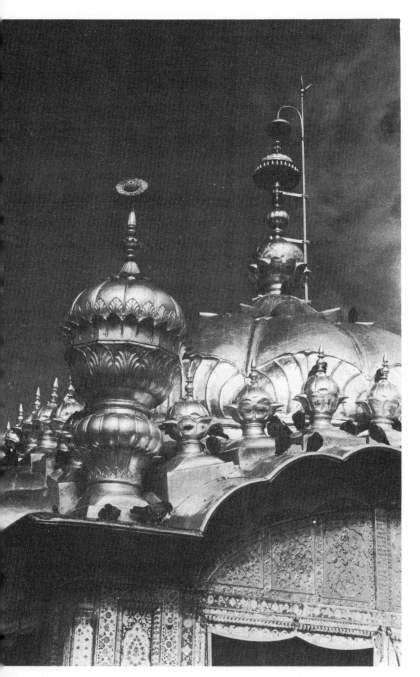

Above, domes and kiosk on the roof of the Harimandir. The shape of the domes closely resembles that of the Moti Masjid in the Red Fort at Delhi (page 163). From close up, they seem squat and heavy but from a distance the gilding lightens them.

Left, the roof of the Shish Mahal, or Mirror Palace. The mixture of decorative designs and symbols underlines the eclecticism both of Sikh architecture and the Sikh faith. On the main dome is an umbrella, a symbol of royalty of great antiquity. Such an umbrella appears on the summit of the stupa at Sanchi. On the small dome is the orb of the sun surrounded by its rays.

143

The gatehouse to the causeway. Here, too, the walls are decorated with copper panels inscribed with sacred texts and floral motifs. In contrast, the marble of the lower part is very simply decorated.

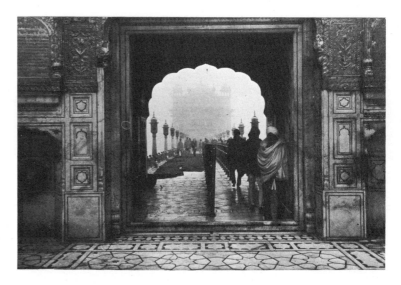

On the roof of the temple is a small but very richly decorated pavilion known as the Shish Mahal, or Mirror Room, which is said to have been used by the last guru, Gobind Singh, who was murdered in 1708. It seems unlikely, however, that the pavilion could have survived the Afghan demolitions or the reconstruction of the temple in the time of Ranjit Singh. Nevertheless, it is held in special veneration and the brooms used to sweep the floor are made of peacocks' feathers.

The gateway leading to the causeway across the sacred pool is itself very similar in design to that of the temple, though its exterior is somewhat more restrained. The doors which shut off the causeway from the outer precincts are covered with massive silver plates and the exterior of the building is of marble, the upper parts decorated with gilded copper sheets inscribed in script and with floral designs. In the upper part of the gateway is the Treasury, in which are kept some of the ritual objects used when the *Granth Sahib* is carried in procession at festival times. These include a canopy of pure gold set with emeralds, rubies and diamonds. The room in which they are kept has 31 pillars, 9 feet in height and $4\frac{1}{2}$ inches in diameter, made of silver.

Opposite the gateway across an elegant marble pavement is a building with a gilded dome and kiosks at the corners. This is the Akal Takht, the Immortal Throne, originally constructed by the sixth guru, Hargobind. Today it contains a number of relics,

The entrance gateway. The doors are inlaid with panels of silver. The method of fixing the gilded copper panels to the wall with nails can be seen on the right. The interior of the archway is similarly decorated with painted and inlaid marble and gilded copper.

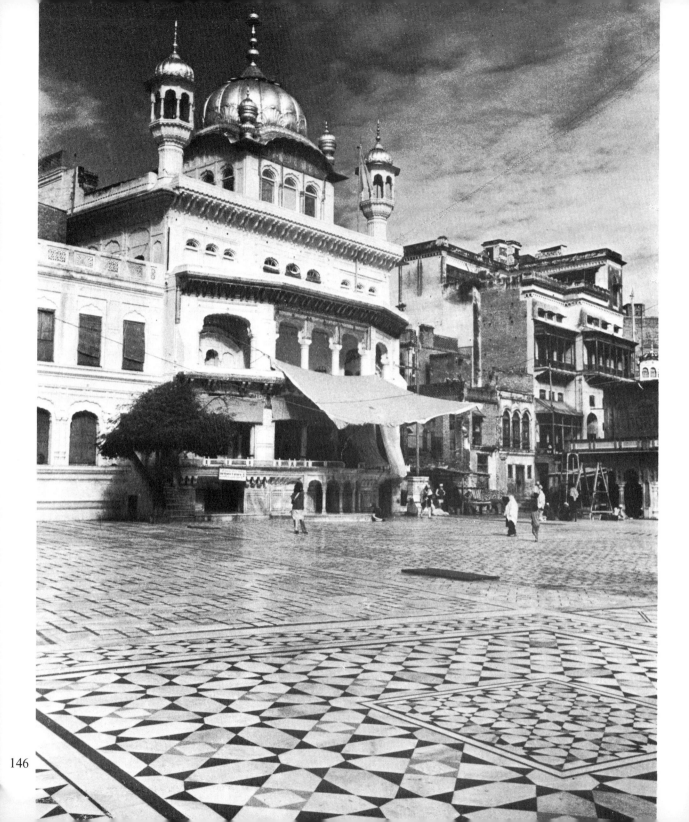

including a sword which is said to have belonged to the last guru, Gobind Singh.

Also within the temple enclosure is a garden containing a pool and a number of pavilions. Here, too, is the Baba Atal tower, standing 130 feet high. The lower room of the tower is decorated with murals illustrating the life of Guru Nanak, the founder of the Sikh faith. These murals, though of no outstanding artistic merit, are vigorous, brightly-coloured compositions well adapted to their didactic purpose. They date from the early nineteenth century, but the tower itself was erected in 1798 as a memorial to Atal Rai, a son of Guru Hargobind (1595–1644). At the time of his death, Atal Rai was seven years old and the tower therefore has seven storeys.

According to legend, Baba Atal had a friend with whom he made a bet which he promised to collect the next day. On arriving at his friend's house he was told that he had died during the night from a snake bite. Baba Atal touched his friend's body and restored it to life. At this, the people present began to worship him and went off to make offerings to his father, Hargobind. On hearing what had happened, the guru was angry with his son and reminded him that spiritual power should be displayed 'in purity of doctrine and holiness of living,' not by miracles. Baba Atal is supposed to have replied that, as a life was required and as by his unthinking act one had been withheld, he would give up his own. He then lay down by the side of a pool and died.

The architecture and the painting of the Sikhs has usually been dismissed as an adaptation of the style of other, more cultured, people, by rough peasants and freebooters with rather vulgar tastes. Not only are they said to have looted styles, they are also accused of having looted the materials with which to build their temples. In the case of the Harimandir, the looting is supposed to have been of marble from the tomb of the emperor Jahangir near Lahore, some 32 miles from Amritsar. It is only very recently that Sikh painting has been given serious study and Sikh architecture receives only passing mention in works on Indian art.

Undoubtedly the inspiration of Sikh architecture is that of the later Mughals. In the Punjab itself, there are many examples of fine Mughal buildings which, without question, must have influenced the designers of the Harimandir. It would be surprising if they had not, for the later Mughal style was one of the most seminal of art forms and its radiation area was considerable. Mughal art was a

Facing the entrance to the causeway across a small square lies the Akal Takht, the Immortal Throne – or, more properly, the throne of the Timeless God. This building is the centre of the organisation of the Sikh faith and contains a number of relics.

147

The marble pavement surrounding the Harimandir. The bold chevron and star design is carried out in black and white marble from Jaipur. The designs, too, are part of the repertory of craftsmen from this Rajput state.

court art, and it was natural that Indian rulers should be influenced by it and take it as an example from which to copy. In the early period of its influence, the copying was slavish. After the collapse of the Mughal central authority in the early eighteenth century, there was a dispersal of talent from Delhi, not only to the provincial courts of the great nobles of the empire who set themselves up as independent rulers, but also to many Hindu courts. In the Rajputana, the style was adopted by the rulers. The marble floors of the Harimandir were the work of masons from Jaipur, one of the Rajput states deeply influenced by Mughal forms, though it added local variants.

The most important influence on the Sikhs was, however, that of the so-called Kangra style. In the capital of Kangra, a state in the western Himalayas, a provincial Mughal style survived into the nineteenth century, and it is probable that, when the Sikhs captured the state, many of the craftsmen previously employed there left for the Punjab. Nevertheless, the Sikhs did not merely take over an existing and, in fact, rather sterile art form. They gave to it a special direction and flavour of their own. The marble slabs which make up the lower storeys of the Harimandir resemble Mughal work in technique, with their inlay of cornelian, lapis lazuli, mother of pearl and other stones. But, generally speaking, the colours are brighter, just as they are in the painted frescoes, and the subjects include not only flowers and semi-abstract designs with foliation and arabesques, but animals and fishes and, on occasion, human figures also.

Even the extensive use of gilded copper sheets on walls and domes, though not unknown elsewhere in India, seems to have been adopted for a purpose emerging out of the history of the Sikhs. Invaders intent upon loot find metal sheets difficult to remove. Essentially, however, the architecture of the Harimandir was designed as a statement of power just as much as the buildings of the Mughal emperors were. Ranjit Singh united the Sikh people for the first time, and the gold and marble and precious stones used to refurbish the Harimandir were a proof to all Sikhs that their religion was, at last, free from threat after decades of persecution. The Golden Temple is a symbol, glowing in richness and colour. That richness has, over the years, been constantly renewed, not always perhaps in the best of taste. But the Harimandir is not a museum. On the contrary, it is a shrine, part of the essential machinery of a living faith.

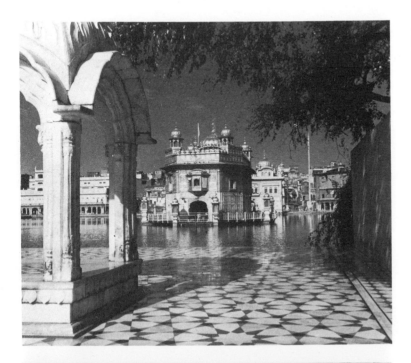

A view from across the Pool of Nectar, showing the rear of the Harimandir, the gatehouse, and above it the dome of the Akal Takht.

Part of the marble footway surrounding the Pool of Nectar.

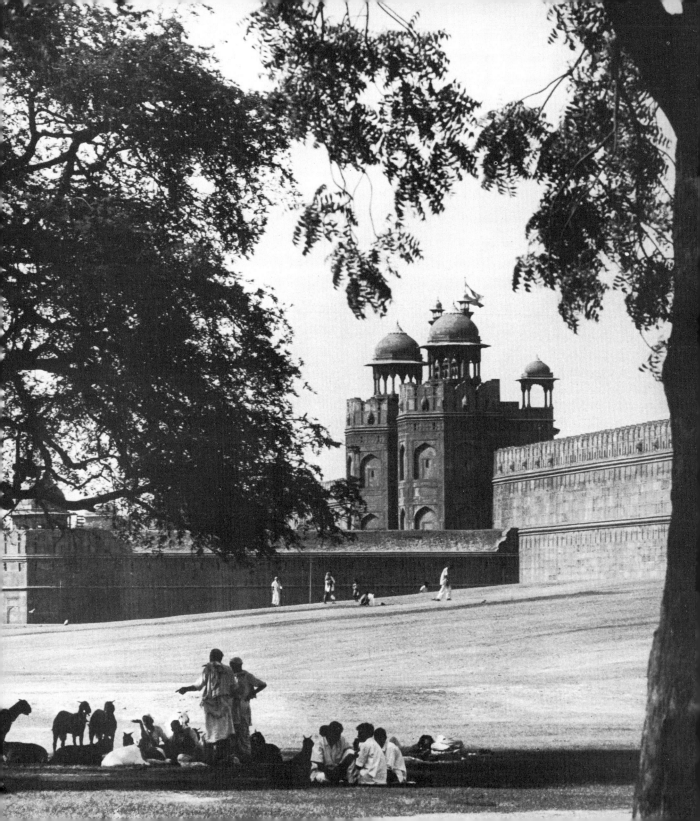

The Red Fort, Delhi

Fatehpur Sikri was the creation of the Mughal emperor, Akbar; the palace of the Lal Kila, or Red Fort, at Delhi was the creation of his grandson, Shah Jahan (reigned 1627–58). Perhaps best known for the construction of the Taj Mahal at Agra, Shah Jahan introduced into Mughal architecture the extensive use of marble. Where, before, the principal building material was sandstone and only the ornamentation marble, now there came such a passion for marble that sandstone buildings of earlier reigns – including that of Akbar – were sometimes demolished so that they could be replaced by structures in marble. The Red Fort at Delhi, however, was an entirely new construction, the result of a decision by Shah Jahan to move his capital from Agra to Delhi. In 1638 he began to lay out a new city to be named after himself, Shahjahanabad, on a site on the right bank of the river Jumna.

Within the new city and forming, in effect, a city of its own was the great fortified citadel containing the royal palace. According to contemporary records, some of the more important buildings were designed and erected under the personal direction of the emperor himself.

The fort is roughly rectangular in shape, being 3,100 feet long by 1,650 feet wide. It is enclosed by a high, fortified wall made of red sandstone, from which it takes its name. The main entrance, known as the Lahore Gate, is on the western side, and there is another on the south side, the Delhi Gate, which was designed as a more private entrance for the emperor. On the southeast corner there is also a water gate. From the two principal gateways, two roads lead, intersecting at right angles near the centre of the fort.

The ceremonial entrance of the Lahore Gate leads to a wide, vaulted arcade which makes a most impressive entrance to the palace enclosure proper. This area, which covers nearly two thirds of the space within the walls, is itself surrounded by walls, though on the eastern side, which runs along the river, these walls are part of the outer structure. Within them are the private apartments and the major public buildings. Outside were formerly the houses of servants, the barracks and other buildings.

In the main enclosure and directly opposite the ceremonial entrance is a large quadrangle. This was originally surrounded with 151

The Lahore Gate and part of the battlements. This is the main entrance to the Red Fort. The projecting barbican was not part of the original design of Shah Jahan but was added by his successor, Aurangzeb.

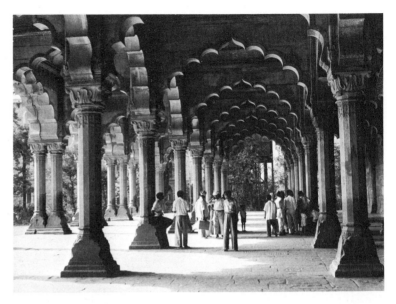

arcaded galleries which have since disappeared. At the east end of the quadrangle stands the Diwan-i-Am, or Hall of Public Audience. It is built of sandstone and measures 185 feet by 70 feet. The front consists of an arcade of nine arches with double pillars between and a group of four at each corner. The arches, like most of those in the palace, are engrailed, i.e. the curve of the arch is made up of a series of arcs. Three aisles of pillars and arches make up the interior and there are 40 pillars in all. In its original state, the sandstone of the Diwan-i-Am was covered with a very fine, ivory-white plaster known as *chunam*, so that its effect would be the same as the marble buildings of the rest of the enclosure.

At the rear of the Diwan-i-Am, set in an alcove, is the emperor's throne, and below it the marble seat of the *wazir*, or minister, through whose hands petitions were submitted to the emperor. The rear wall of the alcove, from which the canopied throne juts out into the hall, is decorated with a series of designs in *pietra dura*. This is an inlay into the marble of hard and precious stones, and it is a characteristic form of decoration in later Mughal buildings. A good deal of speculation has been aroused by the *pietra dura* work in the Red Fort. There are records of European craftsmen having been employed by the Mughal rulers, and it was at one time assumed that European craftsmen carried out these decorations. This remains possible, though satisfactory evidence is lacking. Certainly, the panel near the top of the throne alcove is quite obviously European in character, portraying Orpheus with his lute. This is, in fact, Florentine work and was probably acquired by way of trade and inserted into the design by Indian craftsmen. Luxury goods of this kind had been imported into India for some time and had some influence on Mughal art, though mainly on the minor arts. Where occidental motifs are found in architectural settings, they are generally exotic elements in otherwise indigenous designs.

On either side of the courtyard of the Diwan-i-Am is a square open space filled by formal gardens and open courts. Facing the gardens and backing on to the river front is a range of palaces. All are of marble and they have been restored sufficiently to give some impression of their original glory and opulence.

The emperor's plans for the series of palaces which make up the private enclosure of the palace comprised at least six structures set at irregular intervals along the eastern wall. From the river itself, the view remains highly romantic and picturesque. Above the ramparts, balconies, oriel windows and gilded turrets make the

Far left, detail of a pillar supporting the canopy over the throne in the Diwan-i-Am, or Hall of Public Audience.

Above left, the interior of the Diwan-i-Am, showing the characteristic engrailed arches. The building is constructed of red sandstone which was originally covered by a fine white plaster, called chunam, *polished to look like marble.*

Below left, the emperor's throne in the Diwan-i-Am. The throne and canopy are of marble inlaid with floral motifs. The emperor approached from a door in the rear and sat upon a special portable throne under the canopy.

153

Part of the wall behind the canopy of the throne in the Diwan-i-Am. The unusual shape of the decoration was necessary to accommodate the panels of birds, which are in pietra dura *and may have been imported. The arched panel at the top, which is of Florentine* pietra dura, *was undoubtedly acquired in the process of trade and was not, as has been suggested, the work of a European in the employ of Shah Jahan.*

Opposite, the Diwan-i-Khas, or Hall of Private Audience. Unlike the Hall of Public Audience, which is constructed of red sandstone, this is of marble. Again, there are engrailed arches, though this time set upon square pylons.

The Shah Burj. This rather simple pavilion on the walls overlooking the river Jumna was used by Shah Jahan as his private apartment. The shape of the central dome is an adaptation of a style probably originating in Bengal.

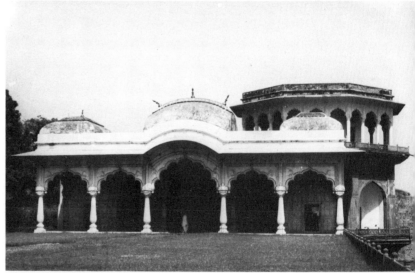

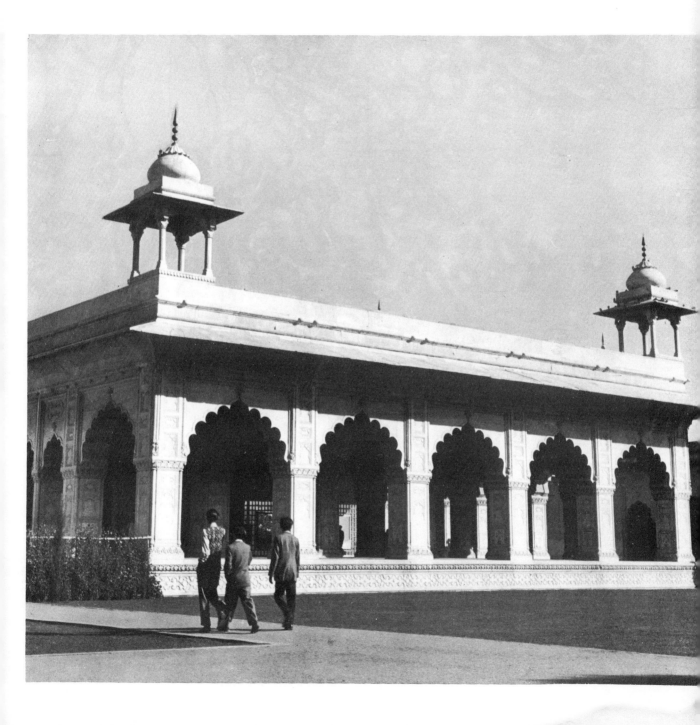

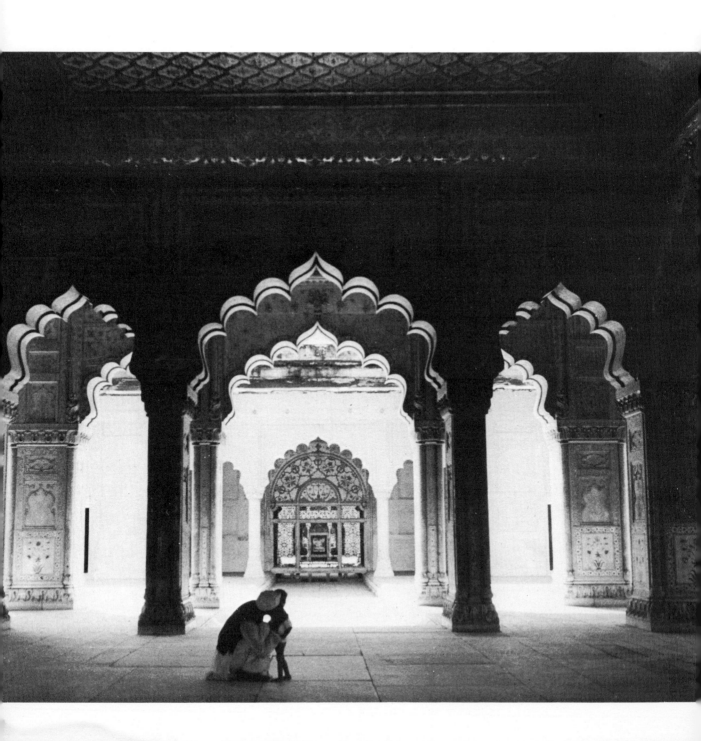

Left, the interior area of the Diwan-i-Khas, looking towards the Scales of Justice screen.

Right, a panel of inlaid marble from a pillar of the Diwan-i-Khas. The decoration is extremely simple but of great elegance. Among the flowers most frequently represented in the Diwan-i-Khas was the opium poppy.

View through the arches of the Diwan-i-Khas. The decoration is of pietra dura *and painted marble, and the themes are basically floral. The ceiling was originally covered with silver plates.*

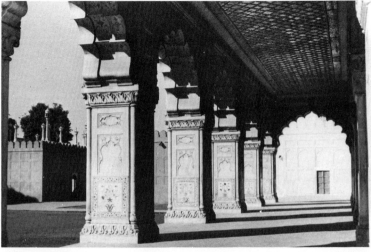

The Rang Mahal, or Painted Palace. The fountain set in the polished marble floor was designed to represent the petals of the lotus flower. The water, which was perfumed, came up from a silver lotus standing on a slender stem in the centre.

Right, the Scales of Justice screen in the Diwan-i-Khas. The screen itself is of superbly fretted marble, four inches thick. The panel with the scales is of white alabaster, and around the scales are representations of the planets.

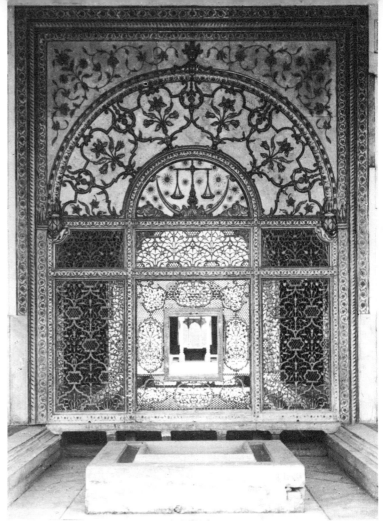

skyline. On the river front, the buildings are solid except for the window openings, and these are screened. On the inner side, facing the courts and gardens, the buildings are open, and it is on this side that the main decoration and architectural effects are found. Between the buildings, the open courts and terraces are protected on the river front by balustrades and screens of perforated marble.

As well as the strictly private apartments, there is another Hall of Audience, this time reserved for the high officials of the empire and for state transactions of a private nature. It is one of the most luxurious buildings in the palace and shows the richness of Mughal architectural style and decoration at its zenith. The Diwan-i-Khas, or Hall of Private Audience, is an open pavilion standing on a raised plinth, with façades broken by the characteristic engrailed arches to be found throughout the palace. The building is shaded by a very wide eave, above which rises a parapet supporting, at each

The Hammam, or Royal Bath. The decoration, though it repeats the ubiquitous floral motifs, relies mainly upon the texture of polished marble for its effect and, by doing so, emphasises the coolness of the building, which is uncluttered with elaborate shapes.

of the four corners, an elegant kiosk. The interior, as in the Diwan-i-Am, is divided up into square or oblong spaces by intersecting arcades of arches. But, unlike the Hall of Public Audience, the arches are not supported on pillars but on massive piers, some of which are square and some twelve-sided. The interior presents a continuous vista of curves; the arches are of curved formation, and even the straight sides of the piers are decorated with flowing curved lines and scrolls. These patterns are painted in gold and colours or inlaid in coloured stones; they cover so much of the surface that they resemble embroidered hangings. Within the overall design are panels decorated with flowers; poppies, roses and lilies appear most frequently.

The Mughal emperors possessed a number of semi-portable thrones and it was on the most famous of these, the Peacock Throne, that the emperor would sit in the Diwan-i-Khas. This throne no longer exists, as it was plundered by the Persian invader, Nadir Shah, in 1739 and broken up on his death eight years later. Parts of it are said to have been incorporated in a throne now in Teheran. It appears in a number of well-known miniatures and in descriptions by European travellers. A Mughal court poet claimed that it was so costly and 'the world had become so short of gold on account of it, that the purse of the earth was empty of treasure.' A less romantic description was supplied by the French traveller, Jean-Baptiste Bernier, who visited India six times between 1638 and 1688. From Bernier, it appears that the throne was rather like a small bed, six feet long by four feet wide, with twelve pillars

covered with gems and pearls supporting a canopy of gold. Behind were two peacocks with tails expanded, the whole inlaid with rubies, sapphires, emeralds and pearls. Between the peacocks was a parrot, allegedly carved from a single great emerald.

The Peacock Throne was not the only great treasure looted from the palace. Some years after Nadir Shah, the Marathas stripped the superb silver ceiling from the Diwan-i-Khas and melted it down.

At each end of the hall, there is written in gold on the outer arches the often quoted and arrogant-sounding couplet:

Agar fardaus bar rui zamin ast
Hamin ast was hamin ast was hamin ast

which can be roughly translated as

If on earth there is a paradise,
Then this is it, yes this is it, this is it.

With the emperor seated on his jewelled throne under a canopy of gold, surrounded by his nobles in their silks and precious stones and all under a ceiling of chased silver, the sight must have borne at least some resemblance to the Muslim conception of heaven.

The Rang Mahal, or Painted Palace, was perhaps a paradise of another kind, as it was occupied by the chief wife of the emperor. It is even more lavishly ornate in its decoration than the Diwan-i-Khas. The Rang Mahal consists of a main central hall with smaller ones at either end. The main hall is divided into 15 bays, each of them 20 feet square, by the piers supporting the arches. Originally, the outer arches were filled in with perforated marble, while a central area was also cut off by arches of lattice-work. The centre of the bays into which the Rang Mahal is divided contains a fountain fed with water by a conduit which entered the fort through a sluice gate underneath the Shah Burj. This conduit was called the Nahar-i-Bahisht, or Canal of Paradise, and supplied the fountains, waterfalls and pools scattered about the gardens and courts.

The water from the canal also supplied the *hammam* or royal bath. This building, next to the Hall of Private Audience, consists of three large rooms each surmounted by a dome. The walls are of marble, decorated with painting and *pietra dura*, and in the centre of each room is a fountain. Today, the building seems somewhat plain compared with other palace buildings, but when it was actually in use it was probably hung with rich embroideries. Originally, the baths were lit by windows in the roof containing

The Moti Masjid, or Pearl Mosque. The mosque was used as a private chapel by the emperor Aurangzeb, who built it. It is of white marble and the decoration is restrained.

Opposite, fretted marble windows in a pavilion overlooking the river. The Mughal craftsmen excelled in the carving of marble screens, giving them sometimes the complexity of fine lace.

coloured glass; with the brilliant sunshine behind them, they must have made the white marble of the walls glow with coloured light.

Opposite the royal baths lies the Moti Masjid or Pearl Mosque. This was not a part of the original conception of Shah Jahan, but an addition made by his son, Aurangzeb, in 1662. Shah Jahan apparently considered that the great mosque of the Jama Masjid, which he built outside the fort, was sufficient for his religious needs. Aurangzeb, however, wanted a private chapel within the palace enclosure, and the Moti Masjid was erected near the royal bed-chamber. The result lives up to its name, for it is made of white and grey veined marble. The domes were originally covered with gilded copper plates, and it is these domes which somehow disturb the elegance of the design. A bronze door decorated in low relief leads into the courtyard. The mosque itself is divided into three arches with two aisles behind. The decoration is restrained, allowing the texture of the marble to assert itself. Some writers have seen in the decoration of the Moti Masjid a decline in style. This is an almost entirely false judgement derived from the knowledge that the reign of Aurangzeb was followed by the slow collapse of the Mughal empire under his successors. Except for the unsuccessful treatment of the domes, the Moti Masjid remains an example of the Mughal style at its most graceful.

The new imperial style which Shah Jahan introduced into the Red Fort had many sources, among them the white marble architecture of the sixteenth-century Muslim rulers of Gujarat, where only the shell of a magnificent palace survives at Sarkhej. From the pre-Mughal Indo-Islamic architecture of Bengal came the scalloped arches, lotiform columns and the convex vaulted roof. The flower decoration of Kashmir, where the emperors retreated from the summer heat of the Indian plains, supplied many ornamental motifs. But to this eclecticism the architects of the Red Fort added good planning, the imaginative use of space, the integration of pool and garden, and above all the masterly handling of water in fountain, waterfall and pool. The Mughal style was an *imperial* style, a statement in stone and marble, in precious jewels and gilded metal, of power and the riches that went with it.

But unlike much frankly imperial art, it avoided vulgarity. The mixture of grandeur and delicacy which is the characteristic of the Mughal architects at their finest has never been better or more succinctly described than in the words of the English Bishop Heber, in 1825, 'they built like giants and finished like jewellers.'

The Pearl Mosque seen through the arches of the Diwan-i-Khas.

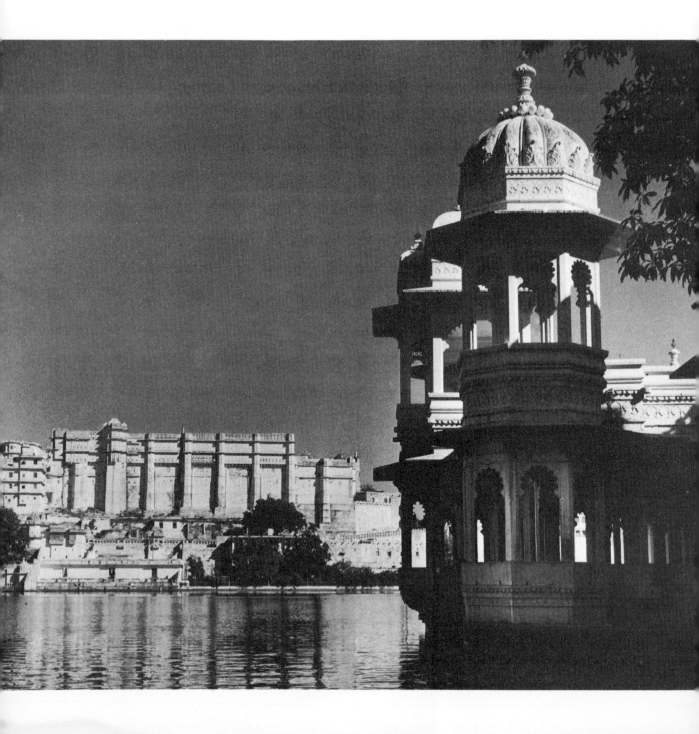

Udaipur

The collection of palaces set in and around the lake at Udaipur, capital of the former princely state of Mewar in Rajasthan, are all examples of 'cultural aggression,' the absorption or transformation of alien styles. Islam in India waged a campaign on two fronts, the political and the aesthetic, and won victories on both. Even before the coming of the Mughals, who were to give India a single central authority after many years of anarchy, the effects of Islamic architectural styles could be seen in purely Indian buildings. By the time the Mughals arrived, an Indo-Islamic style already existed, the result of collaboration between Muslim architects and Hindu craftsmen. This can still be seen in many parts of India. In Rajasthan, secular buildings erected before the coming of the Mughals made the freest use of contemporary Muslim architectural forms – keel arches, vaults and domes, encaustic tiles, and decorations of cut stucco. But all these are harmoniously married with typical Hindu forms, whether columns, brackets, balconies, the pediments of doors and windows, or the use and design of lattices.

In Mewar state, this blending of styles can still be seen in the ruins of the magnificent palace of Rana Kumbha (1433–67) at the old capital of Chitorgarh. This city was largely destroyed in the sixteenth century during clashes with the Mughal empire, and its ruler, Udai Singh, fled into the Girwar, a valley completely surrounded by hills and therefore easier to defend. In the valley was a lake, the Pichola, dug towards the end of the fourteenth century, with a pavilion on its banks. There Udai Singh built his new capital.

What remains of the city built by Udai Singh – some arcades in the bazaar adjoining the City Palace, a temple or two, and the lower walls of the palace itself – is plain and clumsy in style. How the city might have developed, if the state had been left in peace, can hardly be guessed at, as, after the death of Udai Singh in 1572, the ruinous conflict with the Mughals was renewed.

After the final victory of the Mughals early in the seventeenth century, peace came at last, bringing economic prosperity and a renaissance of art and architecture. The reconstruction of the state naturally called for visible evidence that the years of anarchy and warfare were over. The states surrounding Mewar, where the rulers had sensibly come to terms with the Mughal power and benefited

The City Palace from the Pichola lake. On the right are some of the pavilions of the Lake Palace. The towering, fortress-like walls of the City Palace face the lake and are, in effect, a continuation of the city walls and part of its defences.

I.T.—7

Right, wall of the City Palace facing the Pichola lake. The defensive purpose of the design is clearly visible. The lower parts date from the sixteenth century and were of such solid construction that later rulers were able to extend the palace upwards to its present height.

Opposite, additions made to the land face of the City Palace, mainly between 1620 and 1628. The many pavilions and balconies, some of which are of later date, were for the use of the women of the ruler's harem.

Below, elephants guarding the approach to the Jagmandir palace on an island in the Pichola lake. The palace dates mainly from the seventeenth century but has many later additions. The use of elephants as guardians of both religious and secular buildings is of great antiquity.

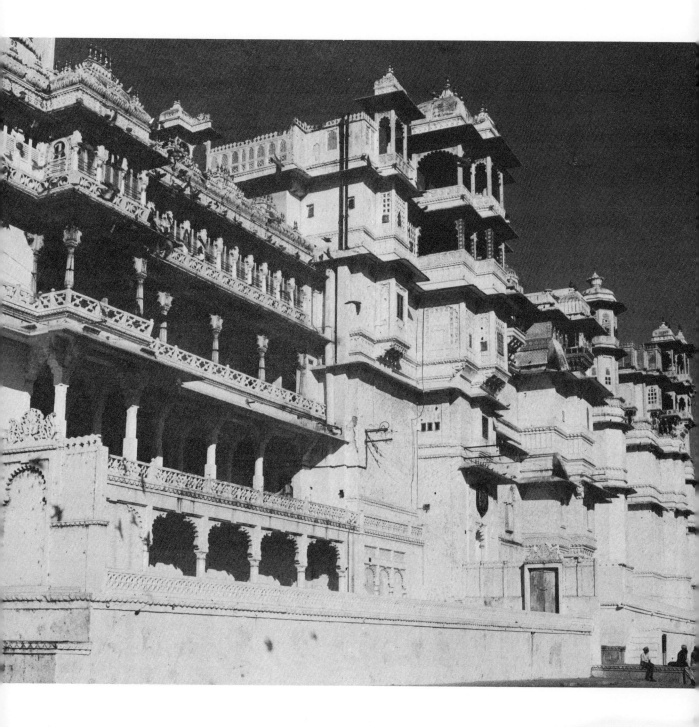

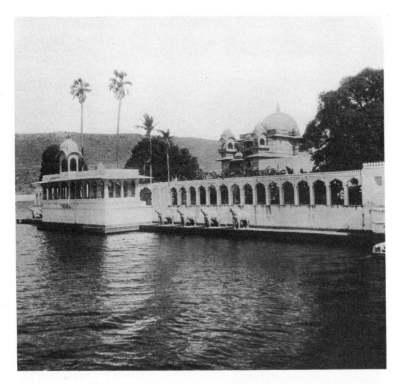

Left, another view of the waterfront of the Jagmandir palace. This palace, which is on an island in the Pichola lake, was added to from the seventeenth century onwards. The pavilion was constructed in the middle of the seventeenth century. The decorative treatment of the outside is rich, restrained, and full of curves.

Right, the Lake Palace, part of which is now a hotel, seen through an arch of the City Palace. The island on which the Lake Palace stands in fact contains a number of palaces dating from the eighteenth century through Edwardian times to a modern villa.

Marble pavilions on the roof of the City Palace. These form what is virtually a separate palace with numerous pavilions, and gardens with pools and fountains. The marble was hauled up the main walls of the palace.

168

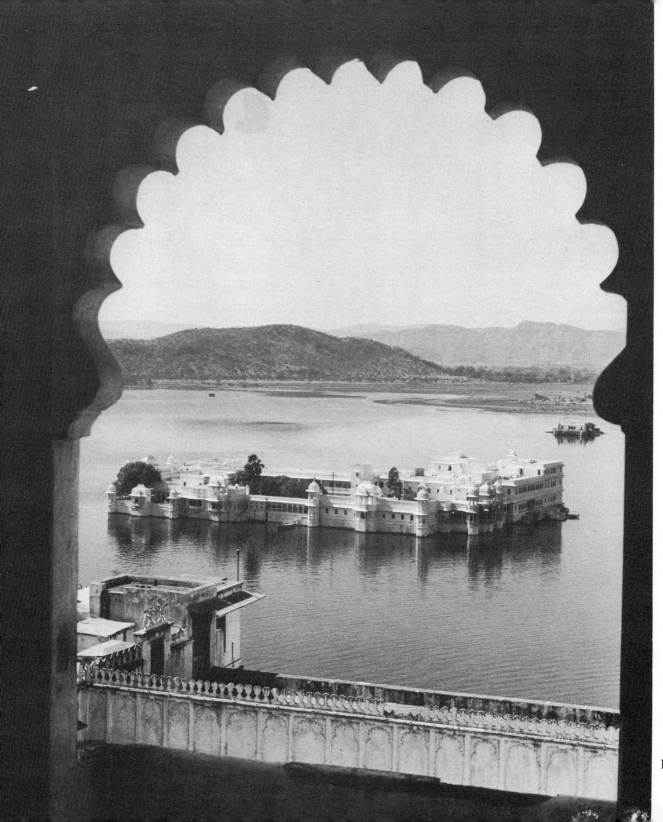

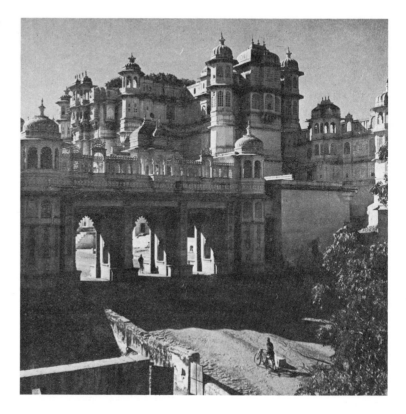

The entrance to the City Palace. This is sometimes known as the Elephant Gate, as the elephant stables were nearby, but its proper name is the Tripolia, or Three-Arched. It dates from the early eighteenth century.

from doing so, certainly displayed many examples of private and public luxury. The Rajput rulers of Amber, of Bikaner and Jodhpur, of Orchha and Bundi, had all laid out magnificent capitals for themselves and, under their patronage, architects had designed palaces and temples of great elegance. But indigenous styles had begun to give way to Mughal court art. Nevertheless, in Mewar the choice was made to build in a style which the rulers of the other Rajput states were abandoning. Amar Singh, the ruler, did not set much building in train during the six years which elapsed between his submission to the Mughal power and his death in 1620. The Great Gate to the City Palace and a small palace on the Pichola lake are among the buildings dating from his time. His successor, Karan Singh (1620–28), however, was well acquainted with Mughal art and was a friend of the Mughal prince Khurrum (later the emperor Shah Jahan) and of many of the Rajput princes who held high military rank in the Mughal army.

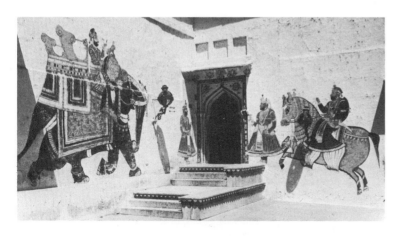

Karan Singh enlarged the Pichola lake and enclosed the town in a ring of fortified walls. The City Palace was also considerably enlarged, and a special section was constructed for the women of his household, with many towers and heavily latticed windows. He also began the construction of a palace on an island in the lake. This, named Jag-Mandir after his son and successor, Jagat Singh, who was probably responsible for completing it, is said to have been the residence of Prince Khurrum when he was in revolt against his father. A domed marble hall in the palace is decorated with marble inlaid with the same type of decoration as appears in the tomb of Itamad-ud-Daulah at Agra, which was built in 1626, the same year in which Khurrum was staying at Udaipur. There is, however, no evidence that the decorations were put up during his stay; indeed, they are probably very much later. Parts of the palace still have a particularly Hindu, rather than Mughal, look about them, for they contain pillars resembling those in medieval Jaina temples at Mount Abu.

The style of Karan Singh, though balanced and elegant, was somewhat old-fashioned compared with the trend in other Rajput states. It seems likely that, as Mewar's neighbours adopted the Mughal style of the reigns of Akbar and Jahangir, they dismissed from their employ architects practising the old-fashioned Rajput style, and that these were given employment by Karan Singh. Certainly, the buildings erected during his reign are in the same idiom as that current in Amber and Bikaner in the last years of the sixteenth century, and in Jodhpur and Bundi at the beginning of the seventeenth.

Mural of a servant girl from an inner court of the City Palace. The style of this painting is much more sophisticated than that illustrated above left. In Rajasthan there is a virile tradition of wall painting in both village and town, and it is probable that some of the murals in the palace were painted by itinerant craftsmen.

Above left, mural decorations flanking a doorway in an inner court of the City Palace. These dashing and colourful warriors serve as door guardians, and are painted with great vigour in bright reds, greens and blues.

171

Crystal furniture in a room in the City Palace. One of the late nineteenth-century rulers of Udaipur was so fascinated by the sparkle of jewels and glass that he had suites of crystal furniture specially made for him in France.

Right, a courtyard room in the City Palace. The walls, floors and ceiling are covered with mirror glass. Some of the mirror is coloured, some of it plain. Set into this glistening mural decoration are miniatures portraying former rulers and great officers of the state.

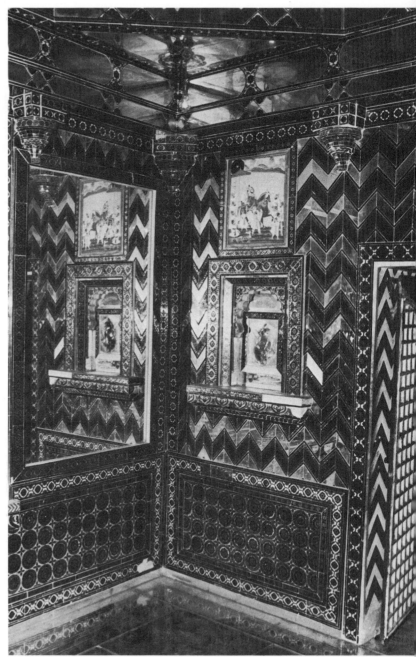

Part of the design of the ceiling of the Manak or Ruby Mahal in the City Palace. Though the ceiling appears flat in photographs, it is actually made up of a mosaic of mirror glass, angled in such a way as to catch and reflect light.

Karan Singh's successor, Jagat Singh, completed the Jag-Mandir and probably the great City Palace. According to one source, he also began the Jagnavis palace. A new taste is apparent in the upper storey of the Jag-Mandir palace. There is much greater use of curves, circular halls with domed ceilings and fluted balustrades. The decoration contains tiny animal groups, with parrots and geese particularly notable. But it was still far behind the fashion currently in favour in the surrounding states.

This general feeling of being behind the times persisted throughout the rest of the seventeenth century. It is evident in the Sabrat Bilas palace, constructed about 1670. Though it contains engrailed arches, fluted cupolas and elegant balconies, the Sabrat Bilas palace is still at least 50 years behind the architecture of the neighbouring states. There are, however, some indications that the style of Shah Jahan was having an effect, although it was not until the collapse of the Mughal central authority early in the eighteenth century that

significant changes took place.

But before that, Mewar once again suffered invasion by Mughal armed forces. In 1678–79, the emperor Aurangzeb attacked the state and occupied Udaipur. Very little damage was done, and the Mughal forces were constantly harassed and ultimately compelled to withdraw. The war, however, did cause a setback to cultural activity, and not until the reign of Amar Singh II (1698–1710) did Mewar demonstrate its renewal by taking over the splendour that had once been the symbol of Mughal imperial power. The eclectic and old-fashioned Mewar style was abandoned in favour of one based upon the techniques and sophistications of Mughal art and architecture. On top of the great palace another was constructed. Gigantic blocks of pure white marble were hauled up the sides of the palace, a feat of engineering in itself, and from them was shaped a pavilion comparable with the finest of Shah Jahan's. The decoration is restrained, and the courts that surround the palace are full of fountains and trees.

The buildings erected in the reign of Amar Singh II are completely Mughal in flavour, but those of the following reign already show a transformation of style. This new, characteristically Mewar style is particularly obvious in the superb Tripolia gate of the City Palace and some of the buildings on the Jag-Mandir island. Yet the style retains a feeling of restraint, of conservatism, even though there is a rich baroque beauty about the treatment of white marble. This conservative attitude perhaps helped to preserve the identity of the rulers and people of Mewar, for it was not until the nineteenth century, with British rule firmly established in India, that the state finally felt itself free from the threat of invasion and catastrophe. Rajput traditions were preserved more faithfully in Mewar than anywhere else, although, on another level, the industrial arts in Mewar followed the late Mughal tradition, with local variants, up to the end of the nineteenth century and even later.

Today, the lake palace is an hotel. Its architecture is a mixture of styles ranging from Mughal to modern, but its location on the waters of the lake and its low outline give the impression, when seen from a distance, of a vast, shimmering marble boat. The Jagnavis palace, on the same island, is deserted; the trunks of its marble elephants are raised in salute to no man. Across from the island, the City Palace rears out of the lake, its lower ramparts protected by the same trumpeting elephants as those at the Jagnavis.

On the land side, the City Palace stands on a slight hill. Across a

An inner court of the City Palace. In comparison with the folk art of the painted murals, the decoration of this court is almost that of the jeweller. Below, glittering peacocks spread their ornate tails. On either side of the jewelled balcony are figures of nobles.

Right, a peacock from a courtyard of the City Palace. The body of the bird is three-dimensional and is covered with brightly coloured enamel. The panel representing the outspread tail is set with lapis lazuli and other semi-precious stones.

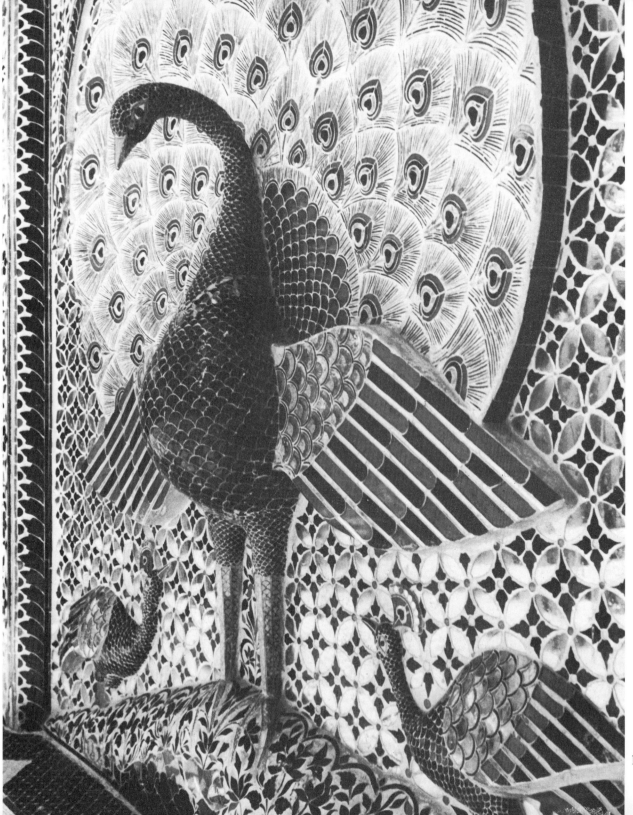

dusty square planted with feathery neem-trees stands the first gate, built by Amar Singh about 1600. Beyond it is the second gate, the Tripolia, constructed over a century later. Between the two gates are eight carved arches under which, during the course of history, various rulers were weighed against silver and gold which was then distributed to the poor. Beyond the Tripolia, another gate leads to a court known as the Rai Angan, or King's Courtyard, which dates from the foundation of the palace. From it lead other courts. The walls of these courts are decorated with large, brightly painted figures. On each side of a door stands a painted guardian. On one side there may be an elephant fully caparisoned for war; on the other, an armed man on horseback. On another wall, under a glowing tree, a serving girl stands by a painted window frame of almost rococo ebullience. The paintings have all the vigour and life of folk art, and those in the palace are only more sophisticated examples of similar works which can be seen in other parts of the town and in the surrounding villages.

Within the palace are many rooms joined by the most labyrinthine of passages. Their decoration dates from the founding of the palace to the present century. One late nineteenth-century ruler had a passion for glass exceeding even that of his predecessors, and he had the tops of the fluted pinnacles which are profusely scattered around the palace removed and replaced with superb diamond-cut *baccarat* glass globes from France. They glitter in the sun, amber, pale green, and red. Even his portrait, painted in a strongly Western academic style, is inlaid with precious stones, and he went so far as to have a set of furniture made from glass.

Such eclecticism was not reserved to Victorian rulers. Early in the eighteenth century, an open balcony was lined with tiles from Canton and Delft. The use of glass and glass mosaic seems to have had a particular appeal for the rulers of Mewar, and one room, the Manak or Ruby Mahal, is lined with chevrons of red and white glass. The ceiling and floor are mirrors. The walls of yet another room are inlaid with European glass paperweights, each set in petals of coloured glass so that they look like exotic flowers.

One of the courtyards, too, is adorned with brilliant glass mosaic and gorgeously enamelled peacocks set in frames of lapis lazuli. Everywhere the glass, both mosaic and mirror, is angled to catch the light. This constant reflection of the sun seems apposite for a ruling family whose head was known as the Sun of the Hindus and whose standard carried on it a sun in splendour.

176

An inner court of the City Palace.

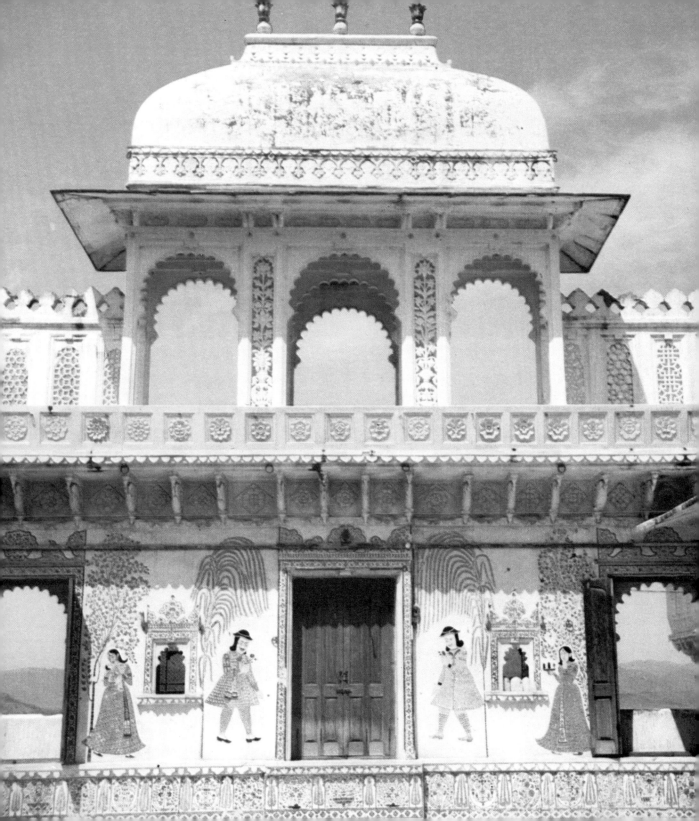

Viceroy's House-Rashtrapati Bhavan, New Delhi

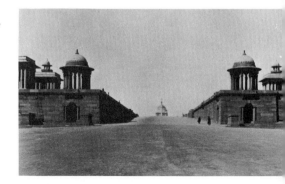

In 1911, the British decided to move their imperial capital from Calcutta to the ancient city of Delhi where, already, the capital cities of seven previous conquerors survived in various stages of collapse. The decision was a political one, and when it had been made the British were left with the question of what kind of capital would sum up, in stone, the spirit of the British empire in India. Calcutta had grown haphazardly around a fort. The viceroy's house there was a large, classical mansion in the style of Robert Adam, erected at the beginning of the nineteenth century. It was a building aggressively foreign to India, designed not so much to impress Indians–which at that time did not seem necessary–but to convince the British themselves, at the beginning of their empire, that they had really arrived, that they were in fact *rulers* with palaces just like the rulers of Europe, the only criterion that counted.

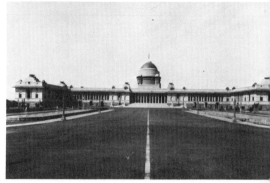

In the nineteenth century, public buildings generally reflected the taste of Victorian England. In India, the Public Works Department produced a range of buildings embodying most of the fashionable features of Western architecture from neo-Gothic to pseudo-Renaissance. These Flemish railway stations and fake Italian *palazzi* were, in fact, expressions of defiance and of contempt for Indian styles. They were, in essence, a kind of racial architecture. Yet some of them contained minor memories of India's past. Today such buildings, particularly in Bombay, convey with their demented Mughal motifs a pleasant zaniness which was not in the minds of their designers. As late as 1906, the foundation stone was laid in Calcutta for a building which was allegedly in the style of the Italian Renaissance with the addition, as the architect phrased it, 'of a suggestion of Orientalism in the arrangement of the domes and minor details.'

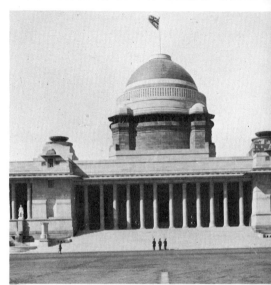

The new imperial capital, however, was to consist of more than an isolated building or two. Like Shah Jahan's new Delhi, Shahjahanabad, this was to be a New Delhi too. A whole administrative city was to be constructed next to all the other cities. Its location–or, rather, the location of the principal buildings which would form its nucleus–was to be decided by a committee. In 1912, the architect Edwin Lutyens (known primarily for his country houses), the

chairman of the London County Council, and the Liverpool City

The main approach to the palace. The structures on either side are part of the complex of government buildings designed by Sir Herbert Baker. At the edge of the rise can be seen the Jaipur column and the dome of the palace.

The main, or east, front seen from the island on which the Jaipur column stands. The apertures on either side of the steps pierce through to inner courtyards and to open corridors running to the wings of the building. The Viceroy's personal apartments were in the back, facing the gardens.

The main entrance. The flight of steps which leads through a portico to the Durbar Hall was for use only on state occasions. On either side of the portico, in openings specially designed to take them, were placed statues in white marble of the king-emperor, George V, and his consort, Queen Mary.

Engineer were asked to form the committee to select a site for the major public buildings. It was decided to erect the residence of the viceroy and the government buildings on a slight elevation south of the old city, the Raisina Hill. The government of India agreed to this site but made the rather unexpected proviso that the complex of buildings should be erected within four years. Lutyens protested that it was impossible for him to design the buildings and supervise their construction in so short a time, and suggested the appointment of a collaborator in the person of Herbert Baker. The government accepted this, and it was agreed that Baker should take over the responsibility for the design of the principal buildings, with the exception of Viceroy's House which was to be the climax of the group. This division between the two architects resulted in errors of planning which destroyed Lutyen's conception of the approach to the palace he designed for the viceroy.

Baker's buildings are undistinguished hybrids and have been described as 'very good Edwardian Government Offices trimmed with Indian features.' As functional buildings they were extremely badly designed. Their interior arrangements were made on the supposition that the government of India would always move out of Delhi in the hot weather to the summer capital of Simla. This was the normal practice in British times and Baker may perhaps be forgiven the assumption that such times were eternal. It does, however, underline the premise on which the construction of New Delhi was based. It was to be the symbol of *British* rule which, as a concession, was to have grafted on to it (in Baker's words) 'structural features of the architecture of India as well as decoration expressing the myths, symbols, and history of its people.'

Lutyens seems to have thought otherwise. His intention was to build a great classical palace, though he was prepared to give it a faint flavour of the country. The result was a very large edifice, 630 feet wide and 530 feet deep. Its cost was almost a million pounds – a comparatively small sum.

For its construction, Lutyens chose locally made brick. The exterior was faced with dull red and creamy buff sandstone from the same quarries as the Mughal emperors used. The floors and roofs were made of reinforced concrete and the latter were surfaced with stone slabs. The floors of the main rooms were covered with marble and, as suitable for a building intended essentially as a winter palace, underfloor heating was installed.

The exterior of the building has a uniformity of appearance

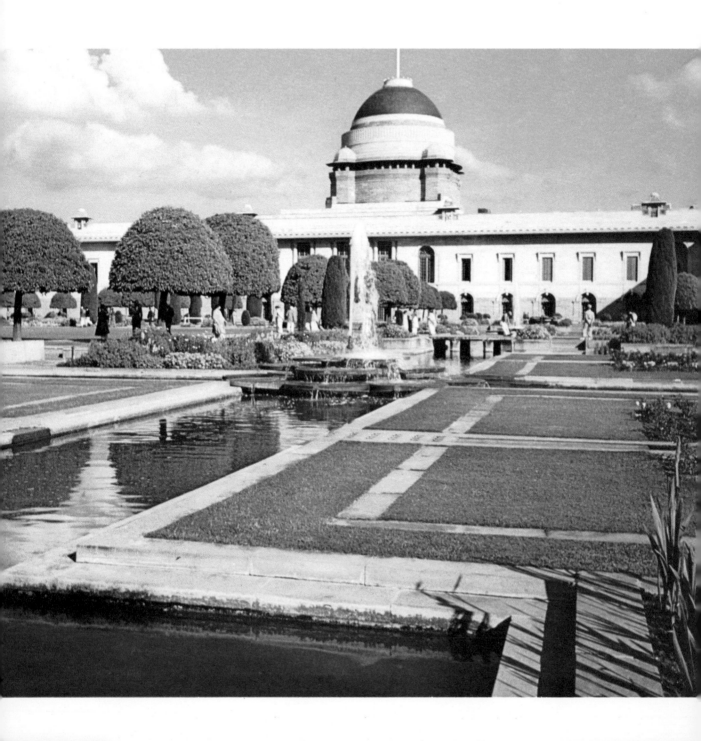

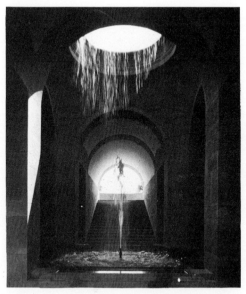

which at first sight gives the impression of a blind façade interspersed by regular rows of columns. This, however, was an ingenious device for accommodating a large number of windows of different sizes without disturbing the regularity of the façade. The formal, almost cliff-like elevation is only broken up by the deep shadow of the colonnades, and such windows as directly pierce the façade only seem to emphasise the formality of the design. Though Lutyens was very conscious of the need for shade, he did not purchase it at the expense of light, for the palace is so constructed that a surprising amount of the main floor area is either directly open to the sky in the form of open courts, or below the roofs of a series of loggias or open-sided arcades.

The approach to the main front of the palace is naturally dominated by the flight of steps leading up to the main portico beyond which are the principal state apartments, in particular, the Durbar Hall. The great dome has a certain arrogance about its simple but forceful lines. Some people have seen in it the 'aloof vigilance of an imperial government,' others a dark threat, as if in the shadows of the columned area below the drum lurked machine-guns and artillery. From a distance, however, the copper-sheathed dome shimmers in the sunlight without menace and with a considerable grace that is not apparent from close-to, when the whole façade takes on a somewhat forbidding air. The long areas of shadow behind the verandas and the dark patches thrown on the red and white sandstone by the immense overhanging eaves–a device borrowed from Mughal architecture–are austere. Even the *chhatris*,

Above, grotto in the north fort. A round hole in the roof garden of the fort is surrounded by a concealed, perforated pipe from which water drops to a wide basin 20 feet below. In the basin there is a fountain and behind are the steps leading to the roof.

Above left, the north terrace and fort. The forts, which could well have been designed for the Foreign Legion, have flower beds on top. Their purpose was to break off the thin lines of the terrace as it met what was then an empty plain. It has since been built upon.

Opposite, the garden front.

or kiosks, again of Mughal inspiration, fail to break up the skyline as, for example, they do in the cloisters of the Jama Masjid at Fatehpur Sikri; Lutyens sank them into the cornice and spaced them out so that they look like sentry boxes. The Mughals put their palaces *inside* forts. Lutyens designed a palace which, in its main elevation, looks like a fort.

The principal state apartment is the Durbar Hall, intended, with its twin thrones under a canopy, to crystallise the might and majesty of the empire. It does so, appropriately, with a distinctly Byzantine feeling, though its prototype is undoubtedly the Pantheon at Rome. For this, the central feature of the palace, Lutyens designed a circular room 72 feet in diameter with a domed ceiling 77 feet 6 inches high. The result is almost stark, though it has a certain richness not only in the embroidery of the chairs and canopy but in the use of yellow marble for the columns and a regal mixture of red and white marble for the floor.

Behind the Durbar Hall Lutyens designed four state rooms of equal size and a long state drawing room, which joined the north and south state drawing rooms like a corridor. The remaining rooms were the state library and the state supper room.

It is something of a problem for the designers of state apartments to decide on what might be called the relative values of immobile and mobile richness. Should such rooms display, by the use of handsome colours, a luxury of their own independent of what goes on inside them, or should they merely offer reflecting backgrounds for the formal ritual of state occasions? In imperial India, the uniform of military officers was particularly colourful and the dress of those tributaries of the empire, the Indian princes, was usually of extreme richness of texture and lavishly ornamented with jewels. The Durbar Hall was a satisfactory compromise. In the ballroom, Lutyens opted for plainness. There, he chose white for the walls, used a greyish-white marble, and fitted around the room a number of panels of dullish mirror to reflect the colours of the men's uniforms and the women's gowns. The same restraint was shown in the decoration of the state dining room, an immense chamber 104 feet long by 34 feet wide. The walls were panelled in teak, with portraits of viceroys and governors-general in carved surrounds. The floor was paved with marble in a grey and white star pattern, and light tones were used for curtains and for the leather of the chairs. The architect designed special furniture for this room as well as clocks to fit over the two fireplaces.

A fireback. Most of the firebacks, which were also designed by the architect, were of heraldic lions, warriors on horseback, or over-large versions of the royal cipher. This one, however, is treated with some humour, as the distinctly Indian elephant is seen having plucked a Tudor rose, which it holds in its trunk.

Left, the central staircase. These pleasant but not particularly dramatic steps give access to the main state rooms, drawing-room, dining-room, and ballroom. They are in an open court and are reached from a carriageway running across the centre block from north to south.

183

The private, as distinct from the public, apartments made not even the mildest concessions to India. The viceroy was assumed to be an English nobleman with the tastes of his class. Lutyens therefore produced what was, in effect, two or even three English country houses put together.

The viceroy lived in the southwest wing of the palace. His guests were housed in the northwest corner of the building. The viceroy's quarters were, naturally, provided with a private entrance, less splendid than the main one but still very elegant. Most of the rooms were handsomely designed in accordance with Lutyens' Edwardian taste, but though there was no restriction on cost the architect remained restrained, if not, in some cases, decidedly dull. In the nurseries, which were on the top floor of the private wing, Lutyens allowed himself some gaiety. The private stairs are an interesting mixture of Genoese seventeenth-century staircase design, with balustrades of fretted marble, Mughal in inspiration. As though to divorce the two traditions, the balustrades do not join the columns,

Right, the Durbar Hall. Natural lighting comes from the eye of the dome and from lattices in the half domes. The pillars are of yellow marble from the quarries at Jaisalmer in Rajasthan, but the floor marble was imported from Italy. Large panels of rosso porfirico *are framed in white with a black border. The canopy over the two thrones was of dark crimson velvet.*

Below, the state ballroom. Lutyens conceived this room in pale colours. The marble surround and pillars are of whitish-grey marble and the upper walls and ceiling were originally painted white. At each end of the room, separated from the dancing area by three arches, was a space for those who were not dancing, to keep them out of the way of those who were.

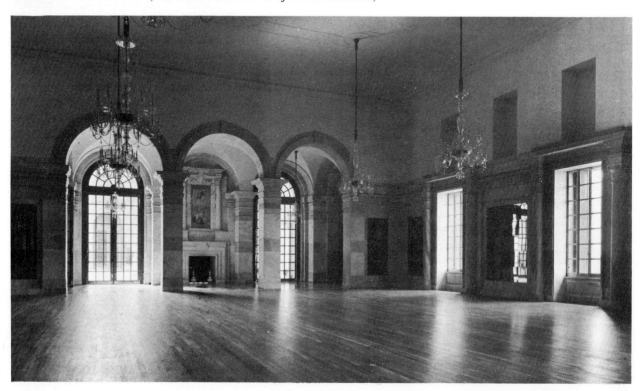

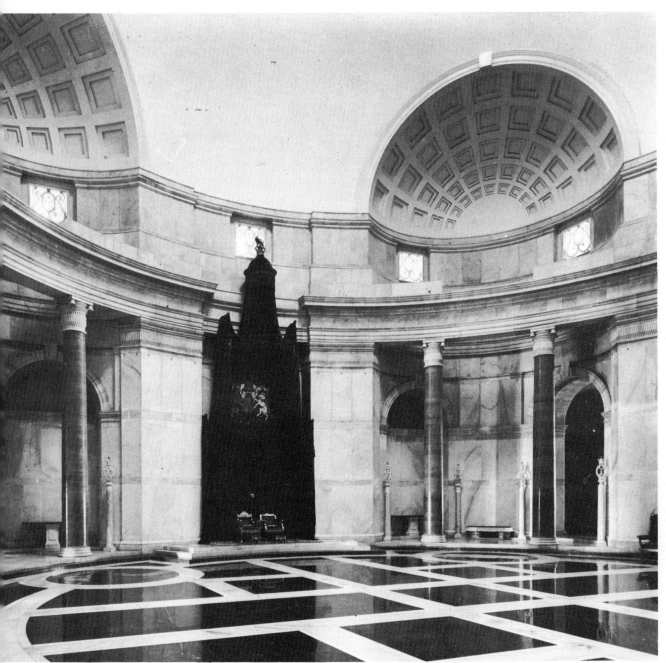

but are detached screens fitted only to the floor. The cloister led to a playground on the roof.

The setting of a palace is as important as its siting. In New Delhi, except for the restriction placed upon him by the complex of government buildings on the approaches to Viceroy's House, Lutyens could do what he liked. In the main approach, he placed a grille 1,150 feet from the main steps. The roadway to the portico, 120 feet across, widens to 220 feet at a column set in the centre. The column, also designed by Lutyens, was given by the Maharaja of Jaipur to commemorate the removal of the capital to Delhi. It is 145 feet high and a peculiarly ineffective combination of styles, topped by a six-pointed glass Star of India.

At the column, lateral roads ran out north and south into what was at the time an open plain. The outlets to the lateral roads are surmounted by gazebos in vaguely Mughal style, which give light to rooms underneath for the palace guard. Set into the outer walls are sculptured elephants. The use of elephant figures, either in the round or in high relief, as guardians of temples and secular buildings is a tradition of great antiquity in India. At Viceroy's House, they are another concession by the architect, an attempt which on this particular occasion succeeds in giving some Indian relevance to what is essentially an alien building.

Behind the palace is the garden. Here the connection with India's Mughal past is real. It is, like the gardens beloved by the Mughals and introduced by them into India, a water garden. A Eurasian character was given to it by the very English addition of small flowerbeds and mown lawns, but it is still water, in pools and canals, which triumphs.

Viceroy's House remains a magnificent structure and the last major example of architectural imperialism. The very timing of its construction enshrined one of those ironies of which history is so fond. Shah Jahan built Shahjahanabad and, at its centre, the great palace of the Red Fort as a symbol of the power and longevity of the Mughal empire. The Mughal empire survived the building of the palace by nearly a century. For the same reasons, the British built New Delhi and a palace for their viceroy 'as the assertion of the unfaltering determination to maintain British rule in India.' Within less than 20 years of the official inauguration of New Delhi in 1931, the British empire in India was at an end and the great mass of Viceroy's House had become what it is today, Rashtrapati Bhavan, the home of the president of independent India.

Above, the nursery cloister. The nurseries were on the top floor of the south wing, which contained the Viceroy's personal apartments. The cloister, open to the sky, had a high fence of carved teak, its somewhat severe design broken by four apertures containing bulbous bird cages. Steps on the left led to a playground on the roof.

Above right, the tennis court screen. The great circular apertures, with their rather dumpy supporting pylons, seem to be a bad visual pun. The trellises on either side of the entrance are hat and coat stands made of teak and brass. They, too, were designed by Lutyens.

Right, the lateral road entrance. As well as the state approach through the grille, the forecourt could also be reached by roads running parallel with the main front from north to south. The guardrooms are surmounted by faintly Mughal gazebos. The rather ponderous elephants were carved by the sculptor Charles Jagger.

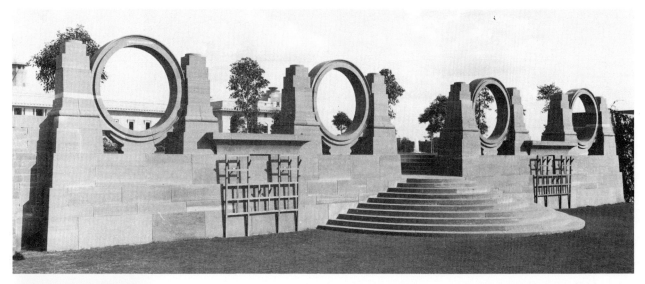

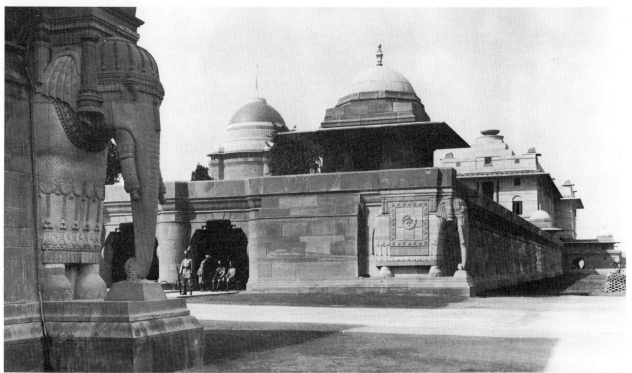

187

Further reading list

Brown, Percy, *Indian Architecture*, 2 vols.; Bombay, 1949

Butler, A. S. G., *The Architecture of Sir Edwin Lutyens,* Vol. 2; London, 1950

Ghurye, G. S., *Rajput Architecture*; Bombay, 1968

Jaenicke, A. and Goetz, H., *Mamallapuram und die Welt der südindischen Kunst*; Krefeld, 1966

Madanjeet Singh, *Ajanta*; London, 1965

Rowland, Benjamin, *Art and Architecture of India*; London, 1953

Smith, E. W., *The Moghul Architecture of Fathpur-Sikri,* 4 vols.; Allahabad, 1898

Zimmer, H., *Art of Indian Asia*; New York, 1955

Glossary

amalaka: flat, melon-shaped coping stone usually placed at the summit of the North Indian style Hindu temple.

ambulatory: processional path around a stupa or the outside of a Hindu shrine.

anda: literally, an egg; the hemispherical dome of the Buddhist stupa.

apsaras: heavenly nymph.

apse: arched or domed recess at the end of a building.

arabesque: decoration, with fanciful intertwining of ornamental elements.

avatar: usually applied to an incarnation of the god Visnu in animal or human form.

bandhas: amorous positions described in Indian manuals of sex.

barrel vault: horizontal cylindrical form of roof or ceiling.

Bhakti: devotional cult emphasising the personal relationship between the worshipper and the object of his devotion; Hindu.

bhavan: a house or garden pavilion.

Bodhisattva: Buddhist saviour.

bracket: projecting ornament or support.

Brahman: Hindu priestly caste.

burj: tower.

capital: upper portion of a column or pillar.

chaitya: a sanctuary or shrine.

chauri: a flywhisk; symbol of royalty.

chhatra: umbrella; a symbol of royalty.

chhatri: kiosks or small pavilions.

chunam: fine lime plaster or stucco used for architectural decoration and sometimes for sculpture.

cloister: covered corridor or passage, usually surrounding an open square.

corbel: a block of stone projecting from a wall to form a roof.

cusp: projecting point between small arcs of an archway.

deul: in Bengal and Orissa, a temple; sometimes applied to the sanctuary only.

devadasi: temple prostitute.

devata: a minor god or goddess.

Diwan-i-Am: hall of public audience in a Muslim palace.

Diwan-i-Khas: hall of private audience in a Muslim palace.

Dravidian: South Indian style of temple architecture.

durbar: state *levee* or reception.

dvarapala: door guardian.

dwarza: a gate or gateway.

eaves: lower portion of a roof, projecting beyond the face of the wall.

engrailed: cusped; an arch having arcs within its curve.

façade: front view or elevation of a building.

foliate, foliation: leaf-shaped decoration.

gandharva: heavenly musician.

garbhagriha: sanctuary of a Hindu temple.

gopuram: gateway of a South Indian temple.

grille: a grating or latticed screen.

gumbaz: dome.

gumpha: cave monastery.

guru: spiritual teacher.

hammam: steam bath.

hamsa: a goose.

harmika: railed balcony or small building surmounting the dome of a stupa.

Indo-Aryan: North Indian style of temple architecture.

jagamohan: in Orissan architecture, an enclosed hall or porch preceding the sanctuary.

jali: literally, a net; perforated marble or stone screen.

jama masjid: a city mosque.

jatakas: stories of the Buddha's former births in human or animal form.

Kailasa: mountain home of the Hindu god, Siva.

kalasa: a water vase, container of the elixir of life, placed on top of a Hindu temple.

kila or **qila:** a fort.

kiosk: small pavilion, generally on the parapet or roof.

Kirtimukha: a lion mask known as the 'Face of Glory'; a frequent motif in Indian temple decoration.

ksatriya: Hindu warrior or ruling caste.

lingam: phallic symbol of Siva.

liwan: pillared cloisters of a mosque.

mahal: palace.

maithuna: amorous couple.

mandapa: large open hall or porch.

mandir: temple.

masjid: mosque.

Meru: the World Mountain.

mihrab: niche or arched recess in the wall of a Muslim mosque, to which worshippers turn for prayer.

moksha: release from worldly existence.

naga, nagini: snake or water spirit.

Nagara: North Indian style.

natamandir: dancing hall.

Nataraja: lord of the dance; a form of the god Siva.

pietra dura: inlaid mosaic of hard and semi-precious stones.

plinth: the lower portion, or base, of a temple.

porch: structure in front of a doorway.

portico: a space enclosed within columns.

Purusa: the archetypal man.

qila, see **kila.**

rang mahal: painted palace.

ratha: properly, a chariot; but used to describe the temples at Mamallapuram.

sangharama: Buddhist monastery.

sastras: a manual devoted to the rules and principles of a craft; e.g. architecture, painting or sculpture.

shakti: the active power of a god, personified as his consort.

shish mahal: mirror room.

sikhara: the spire, or tower, of an Indo-Ayran temple.

simha: a lion.

stupa: a Buddhist relic-mound.

Sufi: Islamic devotional cult.

sun window or **chaitya** window: large arched opening in the façade of a cave temple.

torana: gate into the enclosure of a Buddhist stupa; also, the gateway of a Hindu temple.

Triratna: symbol of the Three Jewels; i.e. the Buddha, the doctrine, and the monastic order.

vihara: a Buddhist monastery.

vimana: term applied to the temple as a whole; i.e. the sanctuary *and* the attached halls.

yaksha, yakshi: nature spirits associated with fertility.

zenana: women's quarters of a Muslim palace, i.e. harem.

Index

190

Acknowledgements

Key to picture positions: (*T*) top, (*B*) bottom, (*R*) right. Numbers refer to pages on which the pictures appear.

Almasy 150(*TR*), 152(*BR*); Institut fur Auslandsbeziehungen, Stuttgart 125(*B*); R. R. Bharadwaj 71(*B*), 72(*L*), 103, 120; Borromeo 145, 158(*L*), 168(*B*), 171(*L*), 171(*R*), 172(*R*), 175; British Museum 9, 10–11, 12, 13, 14, 15, 16–17; J. Allan Cash 55, 63(*B*), 126(*L*), 127(*L*), 134, 160; Country Life 178(*T*), 178(centre), 178(*B*), 181(*L*), 181(*R*), 182(*T*), 183, 184(*T*), 184(*B*), 185(*T*), 185(*B*); A. Elfer 46, 48(*B*), 51, 58, 70, 110(*B*), 111, 112, 114(*TR*), 122, 125(*T*), 126(*R*); Eliot Elisofon 48(*T*), 49, 50, 67, 73, 78, 81, 89, 94, 95; Dr F. W. Funke 68; Hamlyn Group Picture Library 34; Hawksley Studio Associates 72(*R*), 127(*R*), 129, 130; M. Holford (V & A, London) 18, 20, 21, 41; M. Hurlimann 59, 65, 121; Government of India (Dept. of Archaeology) 43, 44(*L*), 74, 83(*B*), 84, 86, 88, 92, 93, 114(*B*), 115, 118(*L*), 118(*R*), 136, 155, 157(*T*), 157(*B*), 164; Government of India (Ministry of Information and Broadcasting) 87, 98(*B*), 113, 128, 170, 172(*L*), 173, 174; V. K. Jain 39, 42, 44(*R*), 52, 100, 131, 154(*B*); R. Lakshmi 107, 163; Magnum Photos 169; Monitor 27, 75, 142; E. Muench 138; Paul Popper 102(*T*), 116, 139(*B*), 152(*L*), 154(*T*), 156, 158(*R*), 159, 166(*T*), 168(*T*), 177; J. Powell 28, 29, 30, 32, 33, 35(*R*), 36(*R*), 54(*L*), 56, 57, 63(*T*), 82, 83(*T*), 85, 99, 101, 102(*B*), 105(*L*), 106, 108, 124, 132, 161, 167; G. Reitz 140; A. Sengupta 90(*T*), 90(*B*), 104, 105(*R*), 114(*TL*), 117; W. Suschitzky 24, 26, 35(*L*), 36(*L*), 54(*R*), 60(*L*), 60(*R*), 61, 62; Wim Swaan 22, 31, 64, 76, 77, 119, 139(*T*), 141, 143(*L*), 143(*R*), 144, 148, 149(*T*), 149(*B*), 180; Three Lions, New York 166(*B*); Roger Viollet 38, 40, 45, 66, 71(*T*), 91, 96, 98(*T*), 110(*T*), 133.